Prints and Printmaking

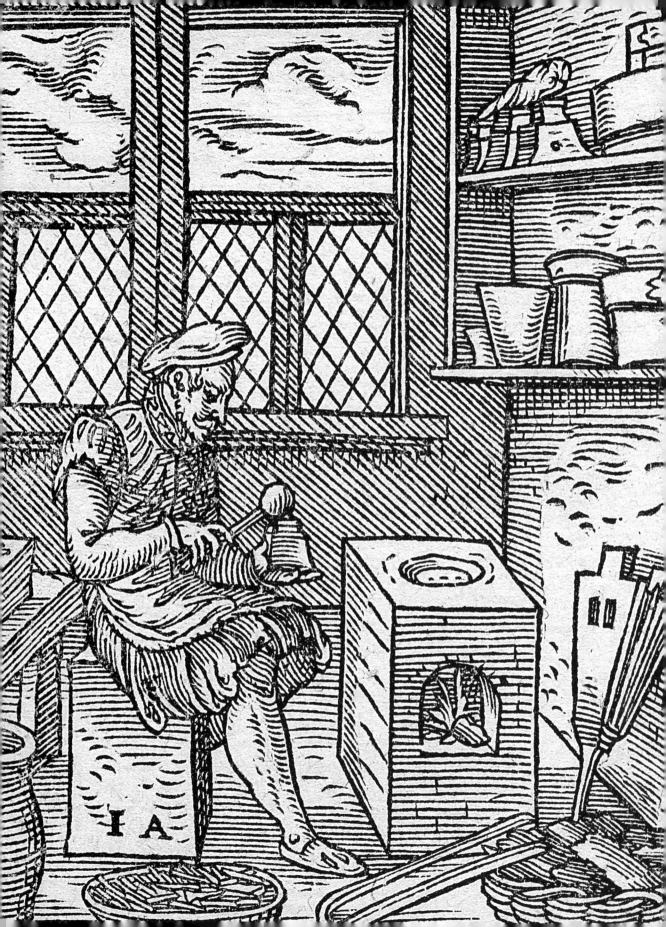

Prints and Printmaking

AN INTRODUCTION TO
THE HISTORY AND TECHNIQUES

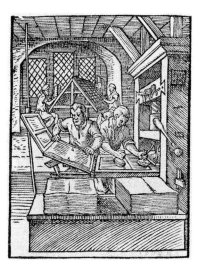
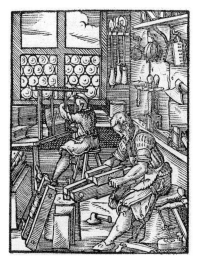
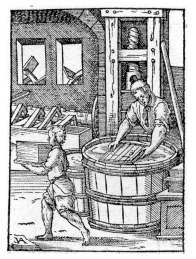

Antony Griffiths

The British Museum

© 1980, 1996 The Trustees of the British Museum
Published by The British Museum Press
A division of The British Museum Company Ltd
38 Russell Square, London WC1B 3QQ

First published 1980
Second edition 1996
Reprinted with revisions 2004, 2010, 2016

A catalogue record for this book is available
from the British Library

ISBN 978 0 7141 2608 1

Designed by Alan Bartam
Typeset in Ehrhardt by Wyvern Typesetting
Printed and bound in China

Contents

Preface

The first edition of this book was published in 1980, and it has remained almost continuously in print ever since. This steady demand suggests that the book still serves its purpose, even though it was written only three years after I first joined the Department of Prints and Drawings in the British Museum.

That it has become a standard work is probably due to succinctness, and I have never attempted to expand it into something bigger. It is meant as an introduction to a complicated subject for those who wish to acquire a basic rather than a detailed understanding. The text has been kept as simple as possible, and qualifications and ramifications have been ignored. It is definitely not intended to instruct the practising printmaker, for whom many excellent manuals already exist. It is not a guide to recognise how any particular print was made. Nor is it intended for the professional print historian. Rather it is aimed at the general reader who wishes to gain some insight into the main classes and processes of print production, and to understand when and by whom each method was used. It is restricted to prints of the western world, and neglects modern developments in favour of a fuller historical account. The illustrations are all taken from originals in the British Museum, which are so far as possible reproduced actual size. This has entailed the exclusion of most large prints. Much miscellaneous information has been cast into the form of a glossary.

The opportunity to make corrections and update the bibliography was taken in earlier reprints, of which the most recent was in 2010. Since then two substantial monographs have been published to which I would draw attention. The first is Ad Stijnman's *Engraving and Etching 1400-2000: a history of the development of manual intaglio printmaking processes*, published in London in 2012. The second is my own book, *The Print Before Photography: an introduction to European printmaking 1550-1820*, published by the British Museum Press in 2016.

I must repeat my thanks to those who contributed substantially to the previous editions of this book, and in particular to Stephen Coppel, Adrian Eeles, John Gere, Richard Godfrey, Peter Freeth, David Landau and Felix Pollak. Some of these to my great regret are no longer with us. I also repeat my thanks to Dave and Reba Williams, whose belief in the book ensured that it stayed in print at a time when it would otherwise have become unavailable.

Antony Griffiths
January 2016

What is a Print?

Many of the best-known works by some of the world's greatest artists are prints (one thinks of Dürer, Rembrandt and Goya), and most people must own at least a few prints themselves. It is, then, surprising that so little is generally known about the subject. Few people, even among professional art historians, know the difference between an etching and a lithograph, or could tell a reproduction of a print from an original. The subject is, however, complicated and there are no short cuts to acquiring a basic knowledge of the various techniques used to make prints, a knowledge of which is the essential foundation of an intelligent appreciation of the printmaker's achievements. This is, of course, also true in other fields of artistic activity. There is no point in criticizing a painting for lack of chiaroscuro if it is, in fact, a fresco, or a vase for lack of translucency if it is earthenware; similarly it is necessary to realize that a woodcut cannot reproduce the effect of chalk, nor an etched line an area of continuous tone.

A print is in essence a pictorial image which has been produced by a process that enables it to be multiplied. It therefore requires the previous design and manufacture of a printing surface. At its simplest this can be a cut potato, but the standard materials have been wood, metal or stone. These are inked and impressed on to a suitable surface, usually a sheet of paper or a closely related material such as satin or vellum; the many important applications of printing images onto textiles, ceramics or plastics have traditionally been excluded from the field of prints.

An essential feature of prints is their multiplication and this often puzzles people. How, they ask, can a print be an origitial work by (say) Rembrandt when there are other impressions exactly similar to it? But this conceptual difficulty does not seem to be felt in other fields. No one is worried by the existence of multiple porcelain figurines or statuettes cast from the same model. They are all held to be original works by an artist such as Bustelli or Giambologna. At a more sophisticated level it is sometimes held that a print is a secondary object as compared with a painting or, more particularly, a drawing: the print is simply a drawing which the artist made on wood or copper or stone in order to be able to turn out many copies of it. Therefore, it is held, a drawing on paper must be superior since it preserves the direct intention of the artist without the distorting filter of the reproductive process. This objection is groundless. Printmaking's unique possibilities, arising from the interaction between printing ink and paper, produce aesthetic effects unrealizable in any other way. These beauties, as with any aesthetic quality, may

not be immediately apparent, but the eye will soon be educated into their appreciation by an attentive study of fine impressions. Thus the great prints of the world are not reproduced drawings but works of art deliberately created through the medium of printing. It is for this reason that a Rembrandt copper plate, although directly worked by the artist himself, is of no artistic importance compared with any impression taken from it.

One other objection to prints sometimes held by students of drawings should be mentioned. Since many drawings are preparatory studies for paintings, their connoisseur tends to become interested above all in the evidence of the artist's mind at work in the creation of a composition; such concerns are absent in prints, which are accordingly dismissed. This objection is misconceived. Those who prefer drawings are welcome to do so, but they should not look for the concerns of a drawing in a print. A print is a finished composition and an end product of the creative process, and in this respect stands closer to a painting than to a drawing.

A fundamental change in the status of the print occurred in the middle of the nineteenth century. Photography was invented in the 1820s and various methods were soon developed of applying it to the production of printing surfaces. The new photomechanical technology has managed in the first place thoroughly to confuse the public mind about the status of artists' prints, and secondly to devalue the print as an art object.

The discussion of the first of these effects can be linked with an elucidation of the two possible meanings of the term, an 'original' print. Before the invention of photography every surface used for printing had to be prepared by hand by non-photomechanical processes. In this period the principal division that can usually be made among prints is between the reproductive and the non-reproductive. A reproductive print reproduced a work created in a different medium; the most obvious example is an engraving after a painting. Before the invention of photography the demand for work of this sort was enormous and generations of expert reproductive engravers were trained to satisfy it. However, the print need not be confined to such work, and occasionally the medium was taken up by a creative artist who was attracted by the range of textures and effects which can be obtained only in a print. Such artists made prints which are in no sense reproductive and which are as important products of their creative genius as their paintings and drawings. For this reason they are sometimes called 'painter-engravers' – a clumsy translation of the French *peintre-graveur*. This category of 'artist's' print is often called 'original', and is in this sense opposed to 'reproductive'.

The invention of automated photomechanical processes produced a new category of print. For all reproductive purposes it was very much cheaper and more accurate and therefore replaced the previous type of hand-made reproductive print. Since the most widespread use of prints has always been for reproductive purposes, the photomechanical print has become the sort of print which is above all familiar to the public, whether as book illustrations, as posters

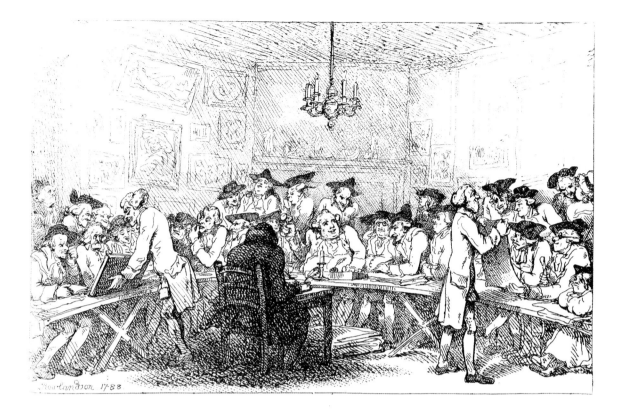

or as framed reproductions for room decoration. By comparison a non-photomechanical print has become a rarity, and many people are not even aware that such a category exists.

The question now is what terms we should use to distinguish these two classes. This is always done by opposing 'photomechanical' to 'original' prints. The only trouble with this terminology is that 'original' in this context means something quite different from what it meant two paragraphs ago when it was opposed to 'reproductive'. Unfortunately this ambiguity is too deeply embedded in the literature of the subject to be avoided, but the context should always make clear which meaning a writer has in mind.

The photomechanical reproductive print has put the artist or original printmaker at a serious disadvantage. As photomechanical reproduction became better and cheaper, the inevitably greater cost of printing by hand made it necessary to adopt more sophisticated marketing methods. In earlier centuries the number of impressions printed was limited only by demand or by the condition of the plate. Since the later nineteenth century artificial rarity has been created by the production of limited and numbered editions, usually signed in pencil in the margin by the artist. This device has helped to sell prints, but at the cost of attracting attention to irrelevancies, and pandering to the speculator and autograph collector. In fact the presence of a signature has often been taken as

1 Thomas Rowlandson, *A Print Sale*, 1788. Etching (reduced).

a guarantee that the print is an 'original' created by that artist. But this convention has been stood on its head by many artists who have happily (and perfectly reasonably) signed limited editions of high-quality photomechanical reproductions of their paintings.

The desire to help the public distinguish original printmaking from photomechanical reproduction also lay behind the misguided establishment of various committees to provide simple definitions of an 'original' print. These, very confusingly, were usually drawn up in terms of permissible and impermissible *processes* of manufacturing printing surfaces (hand-made surfaces were acceptable, photomechanically produced ones were not). They served a purpose as long as original printmakers did in fact stick to entirely non-photomechanical processes, but since about 1960 they have ceased to do so. Many of the best prints of the 1960s incorporated photomechanically reproduced imagery, and some indeed were entirely collages of such imagery. Such prints of course remain in every way 'original' because the photomechanical processes are here being used not to make a facsimile of a pre-existing work of art, but to create a new one which only finds its embodiment in the resulting print. What matters, as always, is the artistic intention and effect.

The other, less obvious, consequence of the photomechanical revolution has been to devalue the print as an art object. Photomechanical reproductions of paintings are merely adequate, but those of prints can be astoundingly good. Line-block reproductions of woodcuts and photogravure reproductions of engravings and etchings, because they use the same methods of printing and the same media of ink and paper, can sometimes be difficult to distinguish from their originals. An idea, therefore, has developed that there is no need to study a print in the original, unlike drawings or paintings which are so much more difficult to reproduce. Human factors too come into play: since impressions of prints can be seen in many collections there is less urgency to look at them than at items which are unique. But of course impressions of prints do vary, and reproductions are not substitutes for the originals. As Kenneth Clark once observed: 'The study of Rembrandt's etchings through reproduction is a kind of visual corruption, and one must return to the originals as often as possible'.

Relief Printing Processes

There are various different types of relief process used in printmaking. They are classed as members of the same family because in each the actual surface from which the printing is to be done stands in relief above the rest of the block which has been cut away. Ink is applied to the surface of the block, and is transferred to paper by applying a vertical pressure. The most important of the relief processes are woodcut, linocut and wood-engraving.

Woodcut

TECHNIQUE The material used is a wooden block, usually about an inch thick. It is always part of the plank of a tree of fairly soft wood, e.g. pear, sycamore or beech, sawn lengthwise along the grain and planed down until smooth. Before use it must be seasoned to ensure that it will not warp or crack.

The artist's design is either drawn directly on the block or on a sheet of paper which is then glued to its surface. The cutter uses a knife similar to a penknife and carefully cuts all the wood away from the sides of the lines which the artist has drawn. Chisels and gouges can be used to cut away any large unwanted areas. When finished the image will appear as a network of lines standing out in relief.

The cutting of the wood is a skilled business and from early times it was usual for the artist only to make the design on the surface of the block and then hand it over for cutting to a professional woodcutter. It is very difficult to print areas of solid black evenly, and so if shading is required the conventions of parallel or cross-hatching must be used. With cross-hatching the cutter has laboriously to cut out all the interstices between the hatchings. If a mistake is made and too much has been cut away, the cutter has to make a hole in the block and insert a new plug of wood.

The surface of the block is inked using a dabber or (from the early nineteenth century onwards) a roller; the printing ink has to be of a stiff consistency to remain on the raised parts of the block and not flow into the hollows. The printing is done in a press which is the same, or at least works on the same principle, as an ordinary printing press for type; pressure is applied uniformly and vertically but need only be light. Woodcuts can be handprinted without using a press. The inked block can simply be stamped on to the paper, or paper can be laid on the block and the ink transferred by rubbing on the back of the paper, either by hand or with a burn-

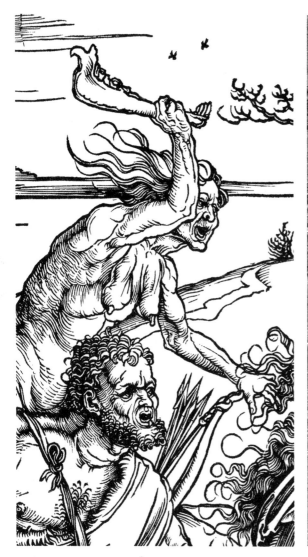 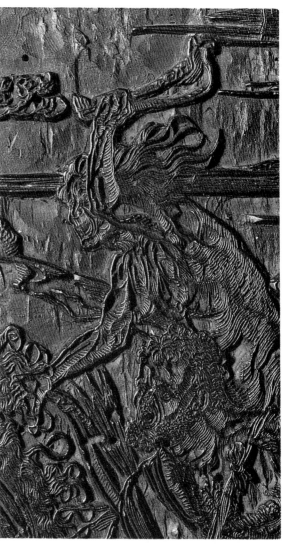

2,3 *above* Detail of **4** (*opposite*) with the equivalent detail of
the original wooden block (*above right*) from which it was
printed (both actual size). The block has been damaged since
this impression was printed: note the worm-holes and
flattened lines. The detail shows the skill of Dürer's cutters;
for example, the shading on the arm is cut at an angle into
the block so that the lines taper to a point when printed.
The print is, as always, in reverse to the printing matrix.

4 *opposite* Albrecht Dürer,
Hercules, *c*.1496/7. Woodcut
(greatly reduced).

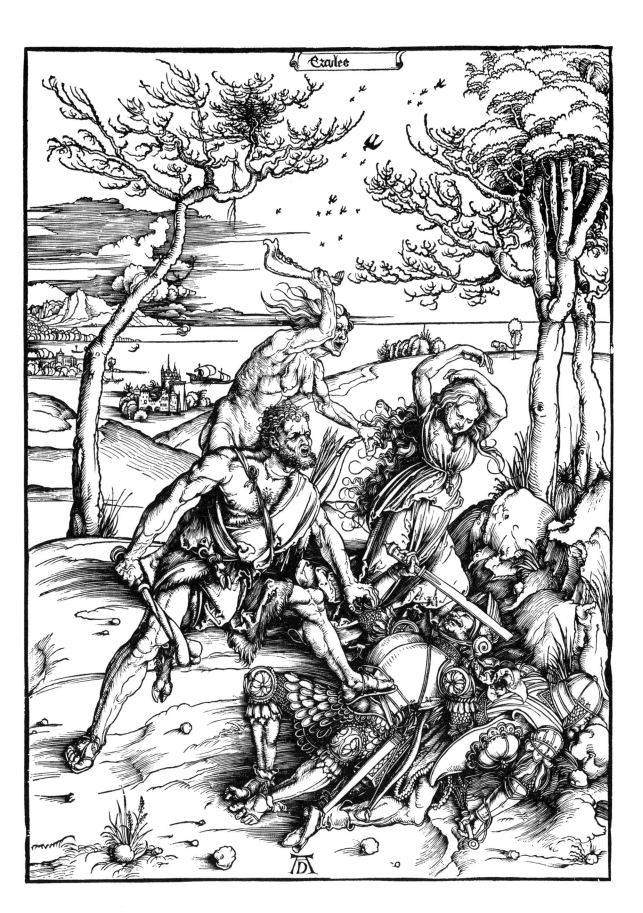

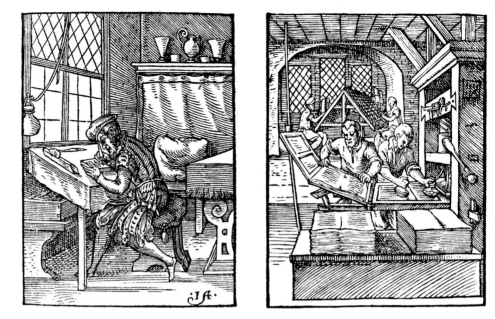

5,6 Jost Amman, *The Woodcutter* (*right*) and *The Printer* (*far right*), 1568. Woodcuts (actual size). The cutter is using a knife. In the printing shop the man on the right is inking the lines of type (and woodcut illustrations) with dabbers, while his companion is laying down a clean sheet of paper. The hinged frisket on the left will next be folded on top of the paper to hold it in position, the paper in turn hinged on top of the type and the whole slid to the right under the tympan of the screw press. This is forced down by pulling the handle horizontally.

7 *opposite* Anonymous, *Christ before Herod*, German, early fifteenth century. Woodcut (greatly reduced). One of the earliest surviving woodcuts.

ishing instrument such as the back of a spoon. Most early fifteenth-century woodcuts were probably printed by one of these methods. Twentieth-century artists sometimes preferred handprinting to the use of a press because of the expressive effects obtained by varying the pressure.

HISTORICAL The art of printing from woodblocks was invented in China at some time around the ninth century. From there it spread westwards via the Islamic world; the probable use of woodblocks in Europe can be traced to the thirteenth century. At this stage it was confined to stamping designs onto textiles, and the first prints on paper do not seem to have been made before the second half of the fourteenth century. The explanation of this delay must be found in the history of papermaking: until there was a reasonable supply of cheap paper the woodcut was a commercial impracticality, yet the earliest papermills in Italy were founded only in the late thirteenth century, and in Germany none was founded before the fourteenth century.

Some of the earliest woodcuts, in the flowing style of the International Gothic, are surprisingly ambitious and sophisticated compositions, although their authors remain anonymous. Work of a similar quality is found later in the best of the blockbooks of the 1460s (see glossary), but, in general, from about the middle of the fifteenth century the medium became fixed at a humble artistic level, being used primarily for playing cards and religious images of a crude nature. (The special groups of flock and paste prints are described in the glossary.) Hardly any of these are signed and it has so far proved impossible to group them by designers; indeed, it has been found extremely difficult even to decide which country they come from. They were turned out in huge numbers

8 Anonymous, *St Christopher Carrying the Infant Christ*, German, late fifteenth century. Woodcut, coloured by hand (actual size). A typical example of a mass-produced devotional image.

to be sold at pilgrim shrines and fairs, or by pedlars. The corollary of their massive sale and widespread distribution is that they are now extremely rare, and very few are known in more than one impression. The contrast with the history of engraving is striking: all but the feeblest fifteenth-century engravings are either signed or can be attributed to one of a handful of artists, some of them very distinguished; and, being relatively expensive, they were kept so that most survive in a number of impressions.

To an observer of the 1480s it must have appeared that the woodcut was condemned to remain a minor popular art. Its revival in the 1490s was due to the book trade. Early printed books were rarely illustrated, but in the 1490s publishers realized that there was a market for illustrated books. For book illustration woodcut was, commercially, the obvious method: it could be printed in the same press and at the same time as type, whereas an engraving would have to be separately, and therefore more expensively, printed in a different press.

The first great illustrated book was the folio *Weltchronik* of 1493, published in Nuremberg by Anton Koberger, Dürer's godfather, for which he commissioned Hartman Schedel's text as well as Michel Wolgemut's illustrations. Albrecht Dürer (1471-1528), as an apprentice, played some part in this book but realized that the woodcut had even more potential. His own great series of designs, from the *Apocalypse* of 1499 to the *Great Passion* and *Life of the Virgin* published in 1511, were printed with a facing text, but many other prints were issued as single sheets. Their brilliance established the woodcut as a major art form. In technique too they mark a major advance, for Dürer trained his cutters to replicate every line of his drawing and thus realize designs of a far greater complexity and sophistication than had previously been thought possible in woodcut.

Dürer's example was decisive, and the first thirty years of the sixteenth century saw the greatest efflorescence in the history of the woodcut, both in single-sheet designs and in book illustrations. It extended not simply to Dürer's pupils in Nuremberg such as Hans Springinklee and Sebald Beham, but to almost all the leading German artists of the period: to Albrecht Altdorfer and the Danube School, to Lucas Cranach in Saxony, to Hans Baldung Grien in Strasburg and to Urs Graf (famous for his 'white-line' technique of design) and Hans Holbein in Switzerland. The most fascinating development was at the court of Maximilian, the Holy Roman Emperor. Maximilian's notional authority was greater than that of all other kings and princes of the Christian world, but he was in reality politically powerless and chronically bankrupt. So he was forced to proclaim his importance as cheaply as possible and struck upon the ingenious idea of doing this through various gigantic series of woodcuts. Hans Burgkmair at Augsburg was the main artist involved, but Dürer and many others were also employed. Maximilian's early death meant that most of these projects were abandoned unfinished, but they remain the most impressive attempt at royal self-glorification through the print, a task more usually entrusted to the medium of painting or tapestry.

The upheaval of the Reformation in Germany gave birth to a flood of propa-

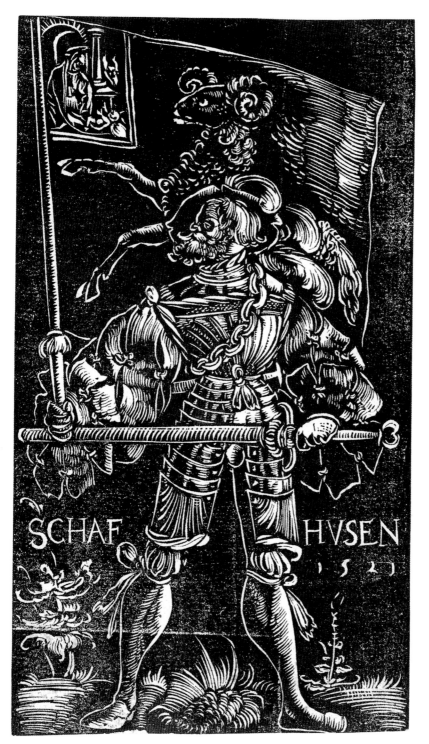

9 Urs Graf, *Standard Bearer of Schaffhausen*, 1521. Woodcut (actual size). A rare example of a 'negative' or 'white-line' woodcut where the design is carried by the lines incised into the block.

ganda broadsheets, but the quality of woodcuts (as of German art in general) declined, as did the quantity. In the second half of the century there were two notable book illustrators in Jost Amman in Nuremberg and Tobias Stimmer in Strasburg, but the business of the woodcut illustrators received an almost deadly blow in the final years of the century when publishers decided to abandon the woodcut in favour of intaglio illustration. The reasons for this must be related to the greater density of detail which intaglio allowed and its ability to include engraved lettering within the image. The woodcut was henceforth thrust back into the uncharted domain of the popular broadsheet and chapbook.

The history of woodcutting in the Netherlands parallels that in Germany. Although many of the blockbooks seem to have been Netherlandish in origin, the fifteenth-century illustrated books were not distinguished. But in the early years of the sixteenth century, inspired by Dürer's example, Lucas van Leyden, Jacob Cornelisz. van Oostsanen, Pieter Coecke van Aelst, Cornelis Anthonisz. and others produced some superb designs, which are only little known because their prints are so rare.

Italy and France were the only other countries to have a distinguished woodcut tradition. Italian fifteenth-century single-sheet woodcuts are very rare and it is uncertain whether this is due to the accidents of survival or to lack of production. The only significant Florentine tradition is to be found in the illustrations to some sermons by Savonarola and a series of *Sacre Rappresentazioni* published from the 1490s onwards. The Venetian tradition began with two outstanding oddities: the anonymous illustrations to Francesco Colonna's *Hypnerotomachia Poliphili* of 1499, and Jacopo de' Barbari's huge bird's-eye view of Venice of 1500. It continued with the landscape woodcuts designed by Domenico Campagnola, and the remarkably varied group of prints, some of which are on the scale of wall-decorations, designed by Titian between 1510 and the 1540s. He inspired a crop of emulators in Venice and one remarkable artist, Giuseppe Scolari, in Vicenza, who produced nine original and powerful cuts in the final decades of the century. Otherwise the woodcut found little following in Italy, with the outstanding exception of the numerous chiaroscuro cuts, which are described in the section on colour printing.

As in Italy, French fifteenth-century single-sheet woodcuts are rare; the splendid series of Books of Hours produced in Paris and Lyons in the 1490s was illustrated with metalcuts. The origin of the main sixteenth-century French tradition is to be found in Switzerland with Hans Holbein, whose *Dance of Death* and illustrations to the Old Testament, both superbly cut by Hans Lützelberger in Basle in the 1520s, were first published much later in Lyons in 1538. These directly inspired the designs of Bernard Salomon who kept the Lyons publishers supplied with book illustrations until his death in 1561.

The collapse of the woodcut tradition after 1600, both for single-sheet prints and book illustrations, extends across Europe, and only occasional attempts to revive it can be found in the seventeenth and eighteenth centuries. Between 1632 and 1636 Rubens employed Christoffel Jegher to cut nine blocks, but these

were the only woodcuts among the numerous prints which issued from his studio. A few remarkable cuts that try to imitate the lines of pen drawings were made in Holland by Jan Lievens (1607-74) and Dirk de Bray. In the eighteenth century William Hogarth made an interesting attempt to use woodcuts to widen the circulation of his *Four Stages of Cruelty*. Two of the designs were cut by J. Bell and published in 1751, a month before the engravings of the same subjects. The project did not succeed and the other two designs were never issued. This failure demonstrates the inadequacy of the woodcut for eighteenth-century requirements, while the commercial needs of the nineteenth century were met by the wood-engraving.

The woodcut was only seriously taken up again in France in the late nineteenth century. The outstanding works of Paul Gauguin and Edvard Munch inspired the artists who formed the group called *Die Brücke* in Dresden in 1905: Ernst Ludwig Kirchner, Erich Heckel, Karl Schmidt-Rottluff and the later recruits Emil Nolde and Max Pechstein. Their initially lyrical but later increasingly neurotic and tense compositions, hacked directly into the block and heavily

10 Emil Nolde, *Dancers*, 1917. Woodcut (greatly reduced). Note the embossing on the dancers' dresses, and the texture of the block visible on the background. © The Nolde Foundation Seebüll.

indebted to primitive art, caused great offence at the time, but are now classics that have inspired many twentieth-century woodcut artists. The woodcut has continued to find its greatest following in the German-speaking countries, but has been widely practised elsewhere.

Linocut

The twentieth century saw the introduction of materials other than wood. The most popular alternative has been linoleum (whence the term 'linocut'), which is easy to cut and inexpensive. For this reason it has often appealed to amateurs and been used in schools as an introduction to making prints. Technically its main difference when compared with wood is the pliant softness of the material and its lack of an obvious grain which allows flat areas of colour to be printed. Linoleum seems first to have been used by various artists before the First World War. Among the earliest practitioners were Erich Heckel in Germany and Horace Brodzky in England, who exploited the expressive possibilities of black-and-white linocutting. Most later linocuts, however, have been printed in colours, and the most notable though brief flowering was in England in the late 1920s and 1930s in the prints of Claude Flight and his associates of the Grosvenor School of Modern Art. In France it was taken up by Matisse and by Picasso, who made a few cuts in 1939 and a much larger series in the years from 1958 when he adopted the reductive method of colour printing from linoleum. Instead of cutting a separate block for each colour, he used only one block which was progressively cut and printed onto the same sheet of paper (see p.117). In recent years linoleum has become less easy to obtain. Those who have made colour relief prints have tended rather to use wood blocks in the expressionist manner, or have adopted colour printing in the Japanese manner.

Wood-engraving

TECHNIQUE Wood-engraving is in essence only a particular form of the woodcut developed in the late eighteenth century, although in effect and appearance it is quite different.

In wood-engraving a very hard wood is used, usually boxwood; since box has only a small diameter, large blocks have to be made by bolting smaller ones together. The wood is cut across the grain ('end-grain') rather than along it, as in woodcut. As a consequence the tool used is different: instead of being cut with a knife, the wood is engraved with a *graver*. This is a small steel rod of square or lozenge section, with its point sharpened obliquely. It is almost identical with the *burin* used in line-engraving (see p.38), except that for wood-engraving the handle is usually tilted at a slight angle to the blade. The handle is held against the palm and the graver pushed before the hand, directed by the thumb held near the point of the blade. In this way a clear V-shaped incision is cut into the wood. Gravers of differing end-section (given names such as

tint-tools, spit-sticks and scorpers) are used for making lines of special character, and a multiple tool for producing a series of parallel lines. Furthermore, sections of the block can be lowered with scrapers in order to make them print more lightly, as grey rather than black.

The method of printing is the same as for the woodcut. The use of the word 'engraving' in the name of this process often creates confusion; it refers only to the method of cutting the block and does not imply that it is printed in the intaglio method (see pp.31ff.).

The close grain of the end-block allows the wood-engraver to cut very fine lines, thereby creating work with much greater detail than the woodcutter. The trained reproductive wood-engraver of the nineteenth century was capable of cutting a fine mesh of lines which when printed gave an optical effect similar to that of an area of watercolour wash: this enabled the designer actually to make a tonal rather than a line drawing on the block, something which would have been quite beyond the ability of a woodcutter to cut. Although the typical wood-engraving looks completely different from a woodcut, there is a middle ground where the two techniques can be used to similar effect and the visible distinction more or less collapses.

HISTORICAL Wood-engraving grew out of the European woodcut tradition. After 1600, when woodcut had been largely abandoned for book illustration, it was still often used in a minor way for vignettes and tail-pieces. The best-known

11,12 Edward Calvert, *The return home*, 1830. Wood-engraving (actual size) and the original block from which it was printed (*right*). Since 1830, the letters at the bottom have been cut away.

13 John Jackson, *The wood-engraver's hands.* 1839. Wood-engraving (reduced). The block is held steady on a soft pad.

French cutter of such decorative ornaments was J. B. M. Papillon who published the first historical treatise on the woodcut in 1766. In England the Oxford University Press was already using end-grain engraving on boxwood for initial letters in the late seventeenth century. Thomas Bewick of Newcastle (1753-1828), usually considered the founder of wood-engraving, was the first to realize its full potentialities in the beautiful small vignettes of birds, animals and landscapes with which he illustrated the books he himself had written. His success was due to his own artistic genius, but a technical prerequisite was the eighteenth-century development of smoother papers; the detail in work of such finesse could not have been printed on the old coarse papers.

Bewick's techniques were brought to London by his pupils such as John Jackson and Luke Clennell, who is famous for his facsimile renderings of the pen-and-ink illustrations by Stothard for Samuel Rogers' *Poems*. For the first thirty years of the nineteenth century the medium was mainly employed for similar high-quality book illustration. The most surprising and beautiful prints, however, were the seventeen wood-engravings made by William Blake to illustrate Dr Thornton's school book *The Pastorals of Virgil* (1821), which inspired a few exquisite prints by his disciple Edward Calvert. They remained otherwise unnoticed at the time but exercised a greater artistic influence during the twentieth century than any other of Blake's works.

The period of wood-engraving's widest use and greatest significance only began after 1830 with the great expansion of journalism and book publishing brought about by the increase of popular education and the technical revolution of steam-powered printing presses. For works published in editions of many tens of thousands, wood-engraving was the only process of illustration available that could combine cheapness with abundance of detail. Thus in Europe and America an entire industry was created of engravers who could rapidly translate a drawing or a photograph into a network of lines on a block of wood. If a large

14 Hans Lützelburger after Hans Holbein, *Death and the old man* (from the *Dance of Death*), *c.*1522/6. Woodcut (actual size).

15 *far right* Luke Clennell after Thomas Stothard, *Nymphs* (illustration to Samuel Rogers' *Poems*), 1810. Wood-engraving (actual size). This and 14 show how woodcut and wood-engraving can be used to almost indistinguishably similar effect.

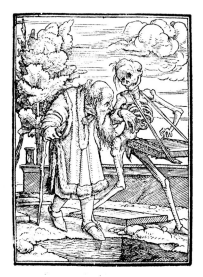

illustration was required in a hurry, the composite block could be taken apart and apportioned among a number of engravers. This encouraged the formation of large workshops, the most famous of which were those of the Dalziel brothers and Swain. Various technological inventions helped the industry: from the 1830s blocks could be multiplied and the danger of damage avoided by printing from stereotypes, and later from electrotypes (see glossary), while in the 1860s it became usual to transfer a design photographically onto the block and thus preserve (rather than cut through) the original drawing.

Although much of this work was humble and is now of little interest, the technique was also used in many of the masterpieces of Victorian book illustration. The forerunner of the famous flourishing of the illustrated book in the 'Sixties' was Moxon's 1857 edition of Tennyson on which most of the Pre-Raphaelites collaborated. Although J. E. Millais, Holman Hunt and D. G. Rossetti only occasionally designed illustrations, some fine Victorian artists such as Birket Foster and Arthur Boyd Houghton specialised in it.

Work of similar standard can be found abroad. The first masterpiece in France was Curmer's 1839 edition of *Paul et Virginie*, illustrated by Tony Johannot and Ernest Meissonier, and it was followed by the numerous books illustrated by such artists as Honoré Daumier and Gustave Doré. The finest work in Germany was Kugler's *Geschichte Friedrichs des Grossen* (1839–42) with illustrations by Adolf Menzel. In 1849, after the Berlin revolution, Rethel produced a remarkable series entitled *Auch ein Totentanz*, exceptional for the nineteenth century in looking like woodcuts rather than wood-engravings. In the United States a brilliant group of wood-engravers was mainly employed on magazines such as Harper's Bazaar and Scribner's, and at the end of the century Timothy Cole gained a world-wide reputation for his reproductions of Old Master paintings.

Throughout the western world the flood of publications illustrated with wood-engravings increased steadily during the nineteenth century, but within a decade of the introduction of photomechanically produced relief blocks in the mid-1880s the whole industry was dead. The most advanced designers of the 1890s, such as Aubrey Beardsley, made their black-and-white drawings not for the wood-engraver but for the process engraver to turn directly into a line-block.

Although this was the end of the reproductive wood-engraving, the twentieth century saw a remarkable revival of the technique in the hands of artists who have taken up where Bewick and Blake left off, and exploited its intimate scale and detail to produce prints to their own designs. These artists were closely linked with and patronized by the private press movement. This began with Edward Burne-Jones' collaboration with William Morris in the 1890s in such works as the Kelmscott *Chaucer*, though in this case the blocks were not cut by Burne-Jones himself. They were followed by Ricketts and Shannon at the Vale Press and by Lucien Pissarro at his Eragny Press, and the fashion spread to Europe and America. The heyday of the private press movement was between the two World Wars, when numerous small presses were set up and bibliophiles competed to form complete sets of their products.

16 Arthur Boyd Houghton, *The Chronicles being read to the
King*, *c.*1861/2. Drawing in pencil on a block of boxwood
(slightly reduced). This drawing was preserved because the
design was photographically transferred to another block,
which was cut and used to print **17**.

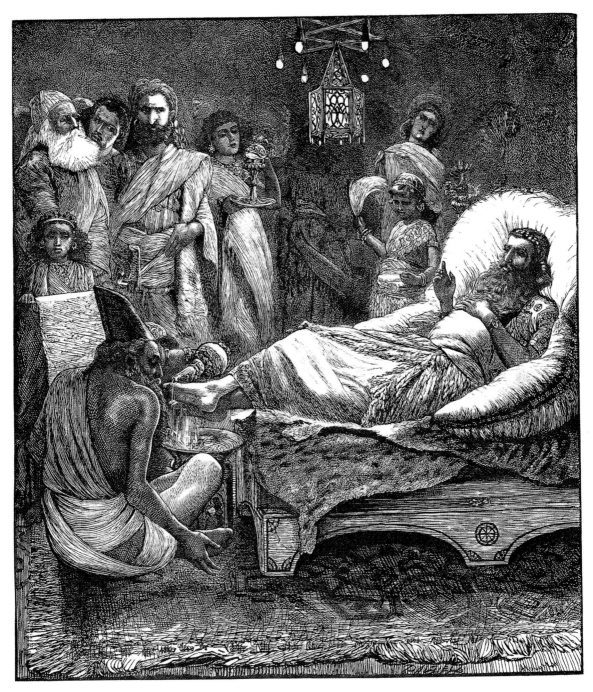

17 Dalziel Brothers. Wood-engraving after **16** (slightly
reduced). Houghton has drawn with unusual precision on the
block and the engraver has followed him closely. Note how
the design had to be drawn in reverse; the King, for
example, raises his left hand in the drawing.

18 Anonymous, *Calvary*, German, *c.*1450/60. Metalcut in the
dotted manner, coloured by hand (reduced).

Metalcut and Relief Etching

Various other relief printing methods which used a metal plate rather than a wooden block have found popularity at certain periods, and they can be grouped together in this section.

The most frequent method was to cut the plate to the same effect as wood. This was often done from the fifteenth to the nineteenth centuries for frequently reused decorative elements, such as borders and title-pages in book illustration. The advantage of metal over wood is that it is much less liable to damage and wear, and sometimes it is found that a metal block was cast from a wooden original. In this first type of metalcut the metal is simply an alternative medium to wood and from an inspection of a print it can be almost impossible to tell from which sort of block it was printed.

In the fifteenth century a more distinctive use of metalcut was invented in order to create a particular decorative effect. The plate was first engraved with the outline of the subject and then the large plain areas of surface (which would print as an unrelieved black) were broken up using punches and stamps. These prints in the 'dotted manner', or *manière criblée*, were produced in the second

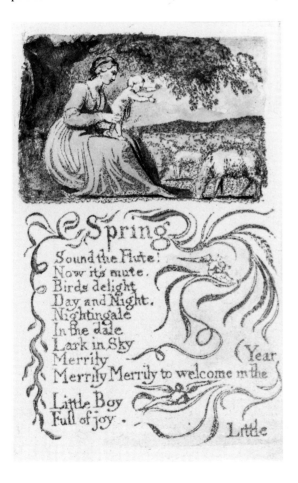

19 William Blake, *Spring* (from *Songs of Innocence*), 1789. Relief etching with hand-colouring (actual size).

half of the century in Germany and France and are often, even if crude and barbaric at first glance, rather beautiful. It is likely that they were produced by professional metalworkers rather than woodcutters. A similar process was also used in France in the years around 1500 for a series of splendidly decorated Books of Hours, and lived on well into the sixteenth century as a method of producing initial letters.

With the exception of a few metalcut book illustrations and landscapes made by Elisha Kirkall in the 1720s, the next known use of relief-printed metal plates (although in this case etched rather than cut) was made by William Blake in the famous series of illuminated books which he wrote and printed between 1788 and 1820. A controversy continues to flourish about exactly how he made them. All agree that the basic principle was that unprotected areas of the plate were eaten away by acid, leaving the design standing in relief. To be able to do this he had to get his text in reverse on the plate with some sort of resist so that the acid only ate away the background. Could he have written backwards in resist, or did he write the correct way round on something else, and then transfer the design to the plate? Individual pages were either printed in colours or hand-coloured by Blake or his wife, and each of the rare copies of the various books shows sometimes surprising variations in colour. The process was extraordinarily laborious but the results are superb, the text and illustration having a unity unprecedented in the history of the printed book.

Intaglio Printing Processes

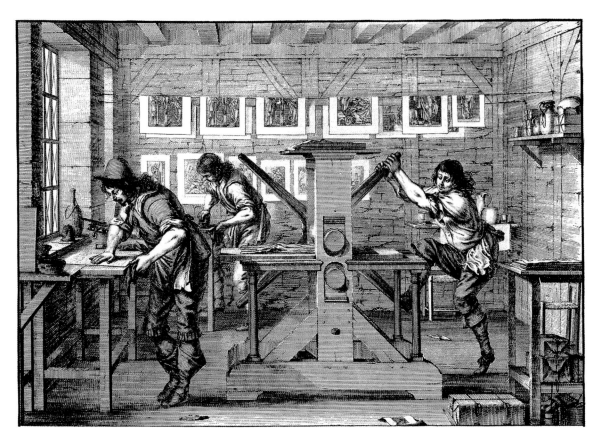

The class of intaglio prints is defined by its particular technique of printing from a metal plate one or two millimetres thick, usually of copper but occasionally of iron, steel or (more recently) zinc. Incisions are made in the plate in various ways, and it is the different techniques used to make these marks that distinguish the various processes of the intaglio family, of which the most common are engraving and etching. But in whatever way the lines are opened in the plate, the method of printing is the same.

Unlike woodcuts and wood-engravings which are inked so that the ink lies on the uppermost surface, intaglio plates are wiped clean so that the ink is left only in the incisions. They are then printed under great pressure so that the paper is forced into the grooves to pull out the ink.

20 Abraham Bosse, *Intaglio printing*, 1642. Etching (greatly reduced). The man at the back is inking the plate; his colleague is completing the wiping with the palm of his hand. The printer has positioned the plate on the bed of the press, covered it with the paper and blankets and is turning the wheel to force it between the rollers. In the background, printed sheets are hung up to dry.

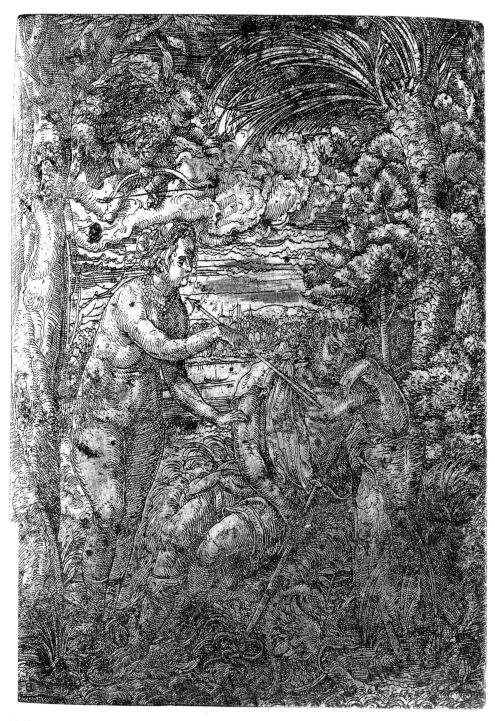

21 Hans Burgkmair, *Venus and Mercury*, *c.*1520. The etched steel plate (actual size).

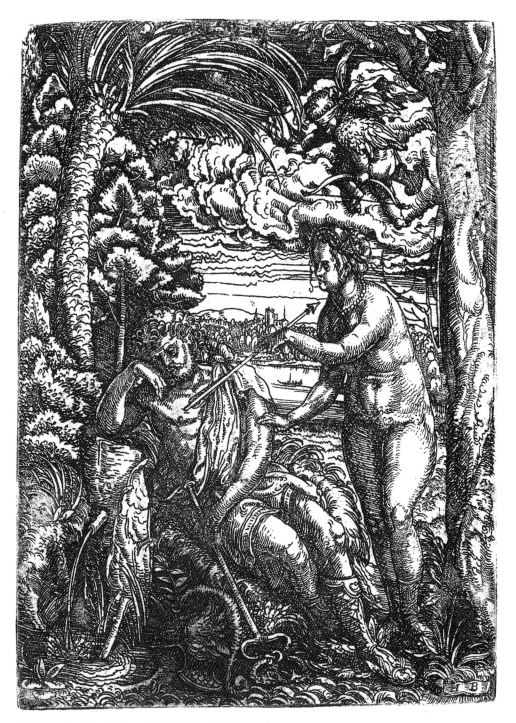

22 Impression from **21** (actual size). When this impression
was printed, the rust marks were not yet too obtrusive.

The plate is first warmed on a hot-plate and covered with printing ink applied with a dabber; the ink has to be thoroughly worked in so that it penetrates and fills all the lines in the plate. The plate is then carefully wiped with muslin to clean all the ink off the surface, but without going so far as to drag any out of the lines. This is a laborious and skilled process; the printer has to use a series of muslins, each one finer than the last, before the surface is sufficiently clean and ready to print. An intaglio press works on a similar principle to the old-fashioned clothes-mangle: a sliding bed passes horizontally between two rollers as the operator turns the wheel. The inked plate is placed face upwards on the bed of the press, a sheet of dampened paper is positioned on top of it, and several specially resilient blankets (to even out the pressure) are laid over both. As the bed passes between the rollers, the paper is forced into the grooves in the plate and drags out the ink. Finally the sheet of paper is hung up to dry. Before another impression can be printed the plate must be reinked and re-wiped. Even the most skilled printer will take several minutes to print each impression and for this reason intaglio is a more expensive printing process than relief, where inking can be simply done with a dabber or roller.

The great pressure of an intaglio press produces the most obvious feature of intaglio prints, the *plate-mark*. This is the line of indentation in the paper where it has been pressed around the edges of the plate. The way the ink lies on the paper also distinguishes an intaglio print; in all other printing processes it lies flat, but in intaglio it stands out from the paper as ridges, perceptible to a delicate touch with the finger tip. (This is seen at its most extreme on an engraved letter head or visiting card.) Repeated wipings and the pressure between the rollers flatten a copper plate quickly, and as it wears the quality of each impression deteriorates. It is therefore important, where possible, to see an early impression of any intaglio print.

The printer is the unsung hero of all the printing processes, but plays a particularly important part in intaglio printing; the difference between a well and badly printed impression from the same plate can be astonishing. In general, the more densely worked the plate the more complicated is the inking. The most difficult are mezzotints, and, in the case of the very large ones by John Martin, it is recorded that the printer could manage only eight to ten impressions a day. A good printer could also nurse a plate into producing more impressions before wearing it out, and the question of who should be the printer is sometimes mentioned in eighteenth-century contracts between artist or publisher and engraver. Occasionally the printer's skill was acknowledged by the addition of his name to the lettering on the plate.

By deliberately leaving films of ink on the surface ('surface-tone') a printer can also create different effects from the one plate. Etchings, when they were intended to be works of art in their own right, were frequently printed by the artist himself, and may then exhibit such refinements of inking. The first master of this art was Rembrandt, who occasionally completely transformed the appearance of his prints by these means. In the so-called 'etching revival' of the nine-

teenth century this was much admired, and 'artistic' printing of etchings became standard; the best printers, such as Delâtre in Paris and Goulding in London, became celebrated figures in their own right. One practice they commonly adopted was *retroussage*. A fine muslin was passed lightly over the already inked and wiped plate in order to pull some of the ink out of the lines, which in this way lost some of their sharpness of definition (see **23** and **24**). These refinements were always regarded as suspect by some and were mocked by Walter Richard Sickert, who thought that any good etching should be wiped absolutely clean so that the pristine whiteness of the paper came through.

Another element, important in all printing but particularly so with intaglio, is the choice of paper, which can radically affect the appearance of a print. Although in the fifteenth and sixteenth centuries illustrations in books had been occasionally printed on vellum or blue paper and a few single-sheet prints on silk, it was not until the seventeenth century that artists explored this field with any enthusiasm. Hercules Segers led the way by sometimes printing on cloth, but the greatest figure was (again) Rembrandt, who experimented with vellum, a variety of imported yellowish Japanese papers, a thin 'Chinese' paper and a rough oatmeal paper. Although some of his contemporaries such as Everdingen and Backhuysen also used Japanese papers, these experiments only became popular again in the nineteenth century with etchers such as Whistler, who amassed a large collection of old and exotic papers. This was to a large extent a reaction against the poor quality of the nineteenth-century machine-made papers, and in recent years, especially in America, artists have again begun to take enormous trouble over the choice of hand-made papers. One by-product of this interest in paper has been the creation in the early 1970s of a new art form – objects of hand-moulded paper formed from dyed paper pulp.

23,24 Maxime Lalanne, *Copy after Claude* (detail), 1866. Etching (enlarged two times). Two impressions from the same plate. The first (*above left*) has been clean-wiped; the second (*above*) has been printed with heavy *retroussage*, which has dragged some of the ink out of the lines.

Overleaf
25 *left* Rembrandt, *The Presentation in the Temple*, c.1645. Etching with drypoint (actual size). This impression has been clean-wiped and printed on white paper.

26 *right* Another impression from the same plate as **25**. This impression has been printed with heavy surface tone on a yellowish Japanese paper. Rembrandt has deliberately left films of ink on parts of the plate in order to heighten the drama of the scene.

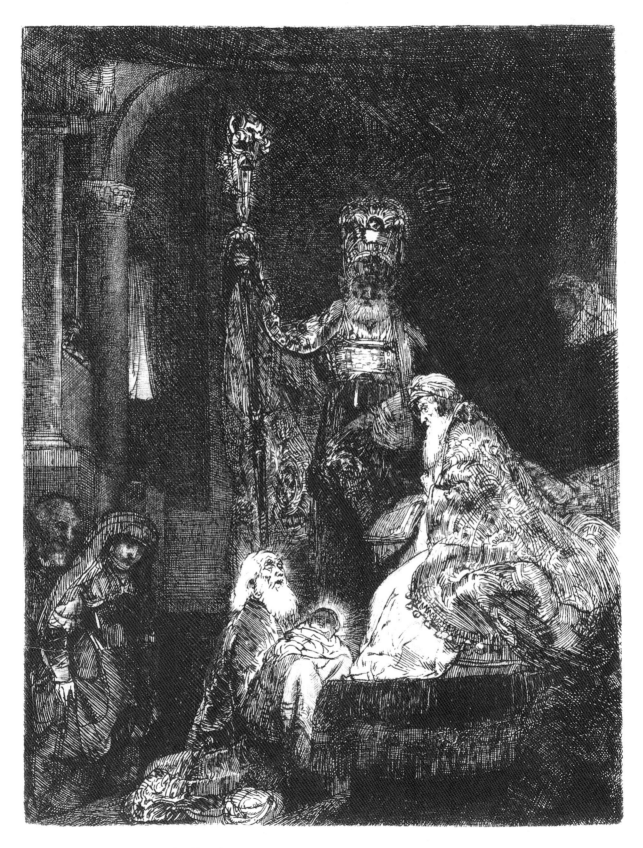

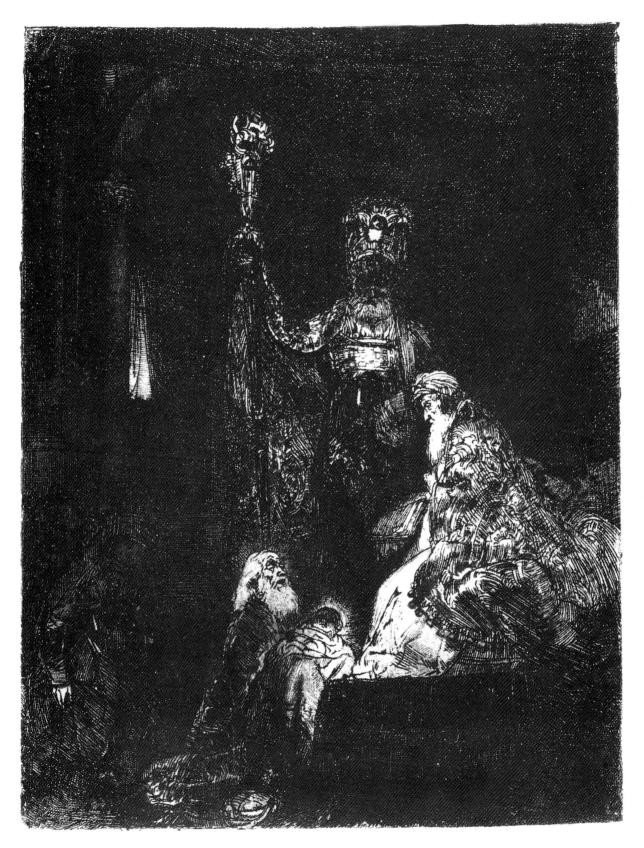

Engraving

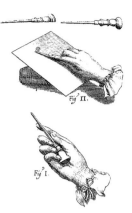

27 Abraham Bosse, *The burin and how to hold it*, 1645. Etching (reduced).

TECHNIQUE Engraving is the principal and oldest member of the class of intaglio processes. The tool used is a *burin*, also known as a *graver*; this has already been described in the section devoted to wood-engraving (p.22). It is held in the palm of the hand and pushed forward with the forefinger lying along the blade. In its passage it cuts a clean V-shaped groove; the curls of copper thrown up in front and at the sides of the furrow are cleaned away with a scraper. Mistaken incisions can only be repaired by the laborious process of knocking up the copper from the back of the plate and smoothing down the surface with a scraper and burnisher before recutting the line.

Engraving is a highly skilled craft. It requires much practice to cut a regular, even groove, whether straight or curved, and a long apprenticeship to learn the various systems of laying parallel lines which give engraving its peculiar clarity and brilliance. Moreover it can be a very lengthy process; in the late eighteenth and early nineteenth centuries an engraver might spend years on a large plate. For these reasons it has rarely since the sixteenth century been handled by any except professional printmakers, who have usually been employed in making reproductions of drawings or paintings.

One advantage of engraving over other intaglio methods for this purpose was that so much copper was extracted from the plate by the V-shaped gouge that a plate did not wear out so quickly in printing. This, however, ceased to be the case when a more minute and detailed style of engraving became popular in the eighteenth century. The engraver had no choice but to stand in attendance on the printer and rework vital areas as they became worn; nevertheless the maxi-

28 Edward Goodall after J. M. W. Turner, *The Feluca* (from Samuel Rogers' *Italy*), 1830. Engraving and etching (actual size). This gives an idea of the minute working typical of a steel engraving, although the detail is lost in reproduction.

mum number of impressions obtainable did not exceed two or three thousand. In the 1820s the situation changed with the widespread introduction of steel plates which could produce a virtually unlimited supply of impressions without wearing. Because steel is so difficult to engrave the plates were usually etched and so a typical 'steel engraving' in fact consists almost entirely of etched lines laid in the regular manner of an engraving. A final upheaval took place with the invention of steel-facing (see glossary) in 1857. The engraver could again work on copper but have the original sharpness of his design preserved under a thin coating of steel, which could be replaced if it ever gave signs of wearing.

The only type of print likely to be confused with an engraving is an etching; the ways of distinguishing the two are described in the section on etching (p.58). The use of a steel rather than a copper plate can sometimes be spotted by the manner of engraving. Steel, being so hard, required the use of a fine line and closely massed parallels rather than broad, open and deep lines. It was therefore used mostly for small and highly detailed plates, many of which were intended as book illustrations.

Note: The word 'engraving' is often confusingly used as a generic term to cover all intaglio prints, not just those made with the burin. This usage is loose but cannot be called wrong because it is so well established. In the same way, the word 'engraver' is regularly used for all types of intaglio printmaker. In this book the word is used in its strict sense. Authors sometimes use the term 'line-engraving' as a way out of this difficulty. An even wider use of the term 'engraving' to cover all prints, including even woodcuts and lithographs, is sometimes found. This is even more confusing, and since it is unnecessary is best avoided completely.

HISTORICAL The history of engraving before 1800 is the history of well over three-quarters of all European print production; this section cannot help being even more summary than the others.

The art of engraving or incising into metal reaches back into antiquity; it was used by the Greeks, Etruscans and Romans to decorate such metal objects as bronze mirror-backs, and flourished throughout the Middle Ages as a method of embellishing gold and silver. But the idea of using engraved plates to make prints from did not occur before the fifteenth century and probably began with the goldsmiths' desire to keep records of their designs. The credit for this invention belongs to the Germans, and the earliest impressions on paper were made in the 1430s, half a century later than the earliest woodcuts. Initially they were printed by simply rubbing the paper on the back; the roller press came later, but certainly by the end of the century. For the first forty years engraved prints remained tied to the style of goldsmiths, the most important artists being the Master of the Playing Cards and the Master ES. Though most prints of this time have religious subjects, there can already be found secular interests in such things as folk legend, figures from everyday life, animals and ornamental designs, which cannot easily be paralleled in contemporary woodcuts. A new period

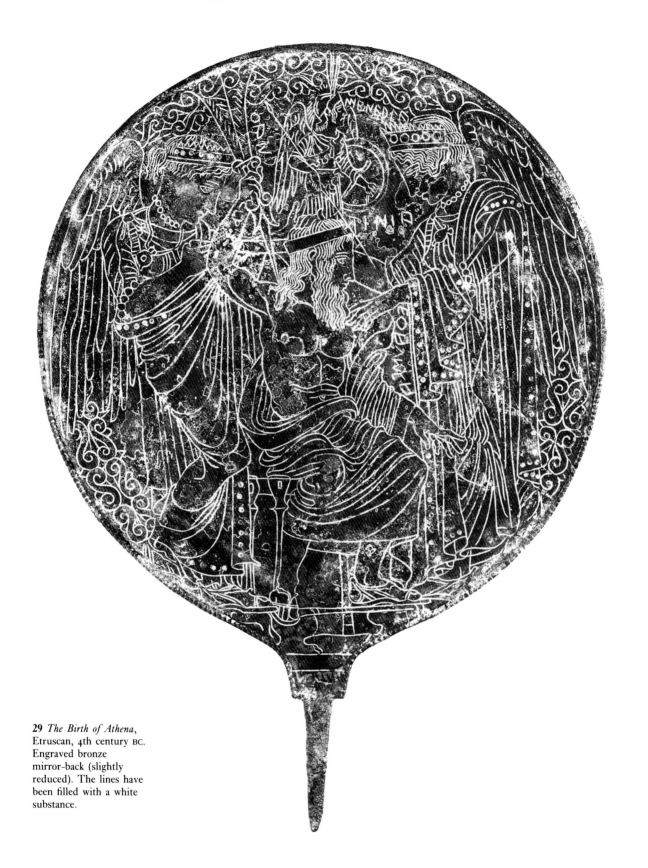

29 *The Birth of Athena*,
Etruscan, 4th century BC.
Engraved bronze
mirror-back (slightly
reduced). The lines have
been filled with a white
substance.

30 Master ES, *St John the Evangelist*, *c.*1460/70. Engraving (actual size).

31 Martin Schongauer, *Lady holding a shield with a unicorn*, *c.*1480/90. Engraving (actual size).

opened in the 1470s when the medium was taken up by painters, of whom Martin Schongauer (*c.*1450-91) and the Master LCz were the most distinguished. This development reached its highest point in the work of Albrecht Dürer (1471-1528), whose engravings astonished his contemporaries, and are still astonishing today. Dürer, like Schongauer, never regarded engraving (or indeed woodcut) as a minor art, and seems to have lavished more thought and care on these compositions than he did on any except a few paintings. Some of the great German sculptors of the period were also encouraged to turn their hand to this medium and a few very rare and superb prints by Veit Stoss survive to this day.

The art of printing engravings was introduced into the area of the lower Rhine within a few years of its invention in the upper Rhine region. The small group of early prints by artists such as the Master of the Gardens of Love (who derives his name from two prints which wonderfully preserve the atmosphere of Burgundian courtly dalliance) was followed by the splendid works of the Master FVB and the prolific Israhel van Meckenem (before 1450-*c.*1503), who link the German and Netherlandish traditions. The Netherlandish equivalent to Dürer was the child prodigy Lucas van Leyden (?1494-1533). Like Dürer, Lucas was a painter who put as much effort into his prints as into his paintings. The earliest prints are as remarkable for their unusual subject-matter as their beautiful technique; in his later years he evidently became familiar with the prints of Marcantonio Raimondi for he began to ape his manner.

The Italian tradition developed independently of the northern, and somewhat later. Vasari ascribed the invention of engraving to the Florentine goldsmith Maso Finiguerra (1426-64), but, although Maso is a well-documented figure, no prints have yet been attributed to him with any degree of confidence. The earliest surviving Italian prints were made in Florence probably in the late 1440s, and historians have divided the production of the period from about 1460 to 1490 into two styles, the 'fine' and the 'broad' manners, depending on the manner of working. Early Italian prints present a very different aspect to northern ones; they are usually hatched with parallel lines, printed in a light brown ink, and show a distinct range of subjects, with astrological, mythological, poetical and other secular themes predominating. One small group of round prints, known as 'Otto' prints after a nineteenth-century collector, was designed to decorate the lids of small boxes; another curious group called *nielli* is described in the glossary. Only one great Florentine painter is known to have personally engraved a plate. This was Antonio Pollaiuolo, whose single print, *The Battle of the Nude Men*, stands out as one of the most ambitious and influential engravings ever made. Alessandro Botticelli designed engraved illustrations for a 1481 edition of Dante's *Inferno*, and certainly supplied further designs for others to engrave, but the details are wrapped in obscurity. Outside Florence some notable prints were made in Ferrara, but the greatest figure was Andrea Mantegna (*c.*1431-1506), a native of Padua who spent most of his career at the court of Mantua. Seven prints are traditionally accepted as being from his own hand,

33 Lucas van Leyden, *The Temptation of Christ*, 1518. Engraving
(actual size).

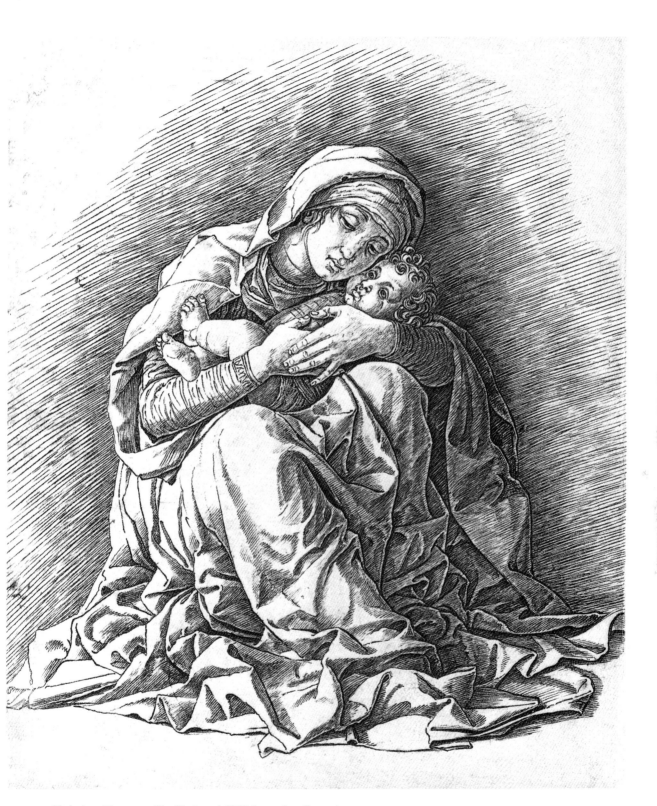

34 Andrea Mantegna, *The Virgin and Child*, late 1480s. Engraving
(reduced). The extraordinary soft and crumbly lines that Mantegna
sought in his prints can be seen in this early impression, especially
on the Virgin's face.

while many others are assigned to his studio. His technique was adapted from the Florentine broad manner, but his compositions had a dramatic power and formal inventiveness that exercised a widespread influence both in Italy and north of the Alps. In Venice Jacopo de'Barbari, whose huge woodcut map of the city has already been mentioned, began engraving in the 1490s, and in the new century Giulio Campagnola made some beautiful prints infused with the spirit of Giorgione, using a novel technique of stippling (see p.81).

The most significant figure of the period was Marcantonio Raimondi (*c.*1480–before 1534). Beginning as a rather provincial engraver in Bologna, he moved to Venice in about 1506 and published engraved piracies of Dürer's woodcut series of *The Life of the Virgin*, which are said by Vasari to have so annoyed Dürer that he went to Venice to complain to the magistrates. The story seems to be true, for after 1506 Marcantonio stopped copying Dürer's monogram although he happily continued to pirate the rest of his compositions. In 1510 he arrived in Rome, and it is his association with Raphael in the decade before Raphael's premature death in 1520 that established his reputation and set the pattern for the future development of engraving. Raphael himself never made a print in his life, but he saw how Dürer's work was known everywhere through his prints, and he realized the potential of prints for broadcasting his own new style. So he took Marcantonio into his employment and set up his factotum Il Baviera to publish them. He supplied Marcantonio (and Ugo da Carpi, his cutter of chiaroscuro woodcuts) with purpose-made drawings, devised a system of regular cross-hatching for him to imitate, and doubtless supervised his every step and corrected his proofs. Thanks to Marcantonio's great technical skill, the suitability of engraving for reproducing designs was decisively demonstrated, and it is the combination of designer, engraver and publisher that dominates the future history of the medium. It has been customary to deplore the fact that later engraving, in comparison with fifteenth-century work, was so largely reproductive rather than 'original', but the entire history of western art would have been quite different if engravings had not rapidly disseminated every stylistic innovation all around Europe.

None of this came to pass overnight. In Germany, Dürer had distinguished successors in the school of 'Little Masters', so named because of the small size of their plates. The best of these artists were the brothers Barthel and Sebald Beham, Georg Pencz and Heinrich Aldegrever; Albrecht Altdorfer too, in his engraved work, may be counted as a member of this group. In the Netherlands Lucas van Leyden was followed by Dirk Vellert and Frans Crabbe. Both these masters make as much use of etching as they do of engraving, but the middle of the century sees a parting of the ways of the two techniques. Henceforth the artist who is making an original design in intaglio will almost invariably use etching, while engraving becomes the preserve of the reproductive specialist. The causes of this division are discussed in the section on etching, but an important proviso must be made at this point that the reproductive engraver, especially from the beginning of the eighteenth century, often combined etching

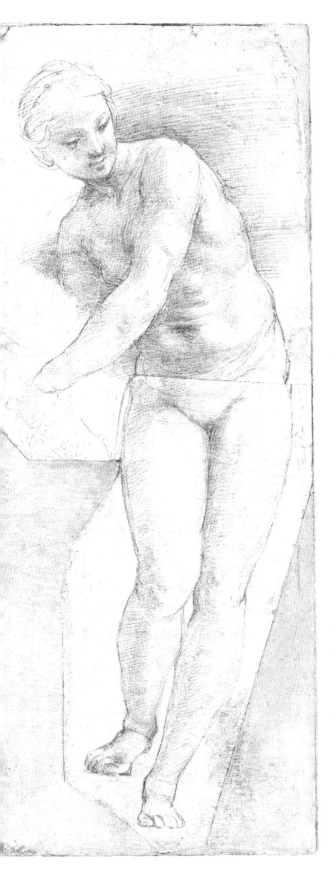
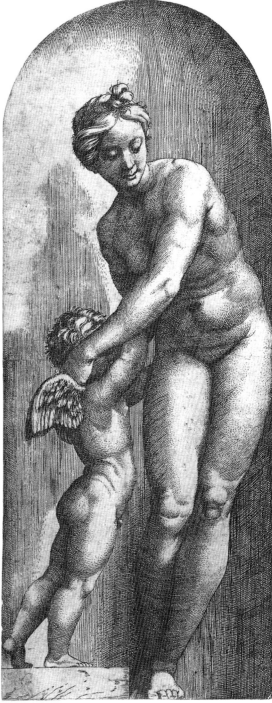

with engraving, and that it is by no means unknown for a reproductive 'engraving' to be in fact entirely etched. For this reason it is impossible to make a hard and fast distinction between the history of engraving and that of etching.

Marcantonio is the starting point of a whole school of engravers scarcely less skilful than himself: his contemporary Agostino Veneziano, Jacopo Caraglio who worked with Parmigianino, Giorgio Ghisi and members of the Scultori family who were closely connected with Giulio Romano and his school in Mantua. The successor to Il Baviera as the principal Roman print publisher was Antonio Salamanca, who entered into partnership in 1553 with Antonio Lafréry, an immigrant from Besançon. Lafréry's prints were predominantly views of the classical city and sculpture meant for the tourist market; this tradition continued uninterruptedly in Rome up to the time of Piranesi and even beyond. Lafréry employed a number of craftsmen, many of whom did not bother to sign their work; plates were held in stock, a published catalogue (of 1572) informed customers what was available, prints were run off as ordered and plates were constantly reworked or re-engraved when worn out.

This functional attitude, and the evident profits to be made, impressed Hieronymus Cock on his visit to Rome in 1546, and when he returned to Antwerp in 1548 he hastened to introduce the system to the north. A different market needed different products and Cock showed great flair in commissioning series of drawings from the leading artists of the period (of whom the most famous is Pieter Bruegel the elder) to be turned into prints by his employees, to train whom he had to entice Giorgio Ghisi from Mantua. The most popular subjects were scenes from the Bible, allegories of the virtues and vices, landscapes and portraits. Many of these series were bound into book form or were intended as book illustrations in the first place, and, as engraving ousted woodcut as the preferred method of illustration, this market became increasingly important. Cock was followed by Philip Galle and his dynasty, by Adriaen Collaert, Pieter de Jode, the three Wierix brothers and the Passe dynasty, and in the second half of the sixteenth century and early seventeenth century an unprecedented flood of engravings poured from Antwerp over the rest of Europe.

Other engravers took their skills abroad and by the early years of the seventeenth century dynasties of printmakers of Antwerp origin had established themselves in most of the major cities of Europe. The most successful were the three Sadelers, who left Antwerp, one to become court engraver to Rudolf II in Prague, the other two to settle in Munich and Venice; Theodor de Bry moved to Frankfurt where his business was continued by the Merian family; Domenicus Custos married into the Kilian family in Augsburg; while Thomas de Leu introduced the Flemish manner to Paris. Cornelis Cort founded no dynasty but had a great influence; after his move from Cock's shop to Italy in 1565 many of the leading painters of the time, especially Titian and Girolamo Muziano, employed him to engrave their compositions, and many Italian engravers such as Agostino Carracci modelled their manner on his.

These professional engravers were enormously prolific (the Wierix brothers

alone produced over 2,000 prints) and highly competent, but their choice of subject-matter was restricted and their manner tended to be dry. Neither of these strictures could be applied to Hendrik Goltzius of Haarlem (1558-1617). Goltzius began his career as a printmaker and, despite the handicap of a withered hand, became such a virtuoso as to be able to imitate the style of all the major figures of the past. His own personal contribution was a technique of modelling form with systems of intersecting arcs, which swelled in thickness towards the centre; when allied to the bombastic mannerist style of composition which he had learnt from Bartholomeus Spranger, this produced prints of unparalleled visual splendour. After Goltzius abandoned engraving in favour of painting in 1599 he was succeeded by others scarcely less brilliant: Jacob Matham, Jan Muller and Jan Saenredam. In Italy, the French engraver Claude Mellan used the swelling line technique to produce an extraordinary *tour de force*, the *Veil of St Veronica*, represented in one continuous spiral line which began at the point of Christ's nose.

In Antwerp Rubens had begun to have his compositions reproduced by local engravers such as Cornelis Galle in 1610; dissatisfied with the results he first turned to engravers of Goltzius' school in the United Provinces but soon decided to train his own school instead. The first of these engravers was Lucas Vorsterman who, working between about 1618 and 1622, established a style based on Goltzius' but more painterly in effect and less tied to mannerist formulae. This

37 Hieronymus Wierix,
*Mary Magdalene at the foot
of the Cross*, 1590s (?).
Engraving (actual size).

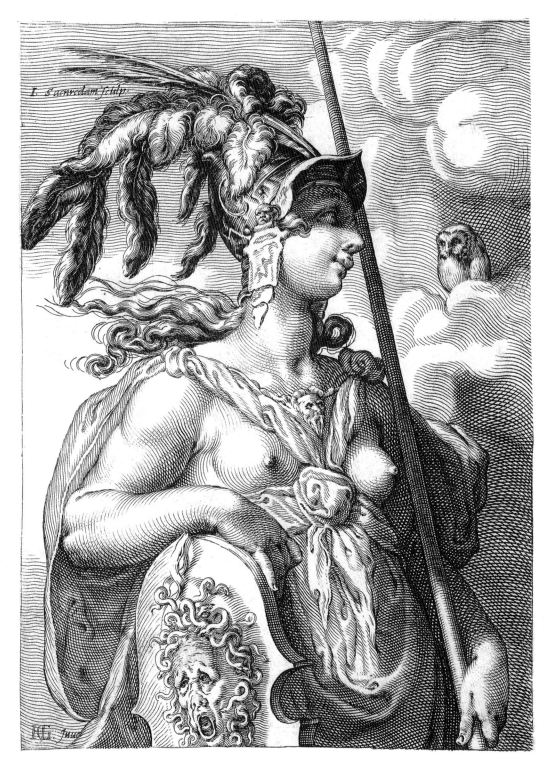

38 Jan Saenredam after Hendrik Goltzius, *Pallas Athena*,
1590s. Engraving (actual size). A characteristic Mannerist
engraving. The remarkable stylistic revolution in Dutch
seventeenth-century art is shown by the fact that Jan's son,
Pieter, was the famous painter of church interiors.

39 Jan van de Velde,
Sunset, *c*.1620. Engraving
(actual size).

was followed by the other chief members of the Rubens workshop, Paulus Pontius and the brothers Boetius and Schelte Adams Bolswert; the first two specialized in figure compositions and portraits, the latter is best known for his splendid landscapes.

One isolated engraver devised a quite independent style to meet a particular requirement. This was Hendrik Goudt, an amateur created a Count of a papal order in Rome, who made seven engravings after the paintings of his friend Adam Elsheimer between 1608 and 1613. To capture their concern with the contrast of light and dark, Goudt closely worked his plates with a mass of straight parallel lines; these printed a vibrant black from which the unworked areas of light stood out in sharp contrast. The only engraver successfully to follow this style was Jan van de Velde, who used it in a few prints either after his own designs or those of Willem Buytewech.

After the middle of the seventeenth century, as a consequence of the prolonged Spanish-Dutch wars and the new prosperity in France, the centre of European printmaking shifted decisively from the Netherlands to Paris. Although in the sixteenth century France could only boast one original engraver, the royal goldsmith Jean Duvet, it dominated European printmaking from about 1640 until the Revolution of 1789.

Two main traditions can be distinguished in the seventeenth century. The first is reproductive; but, whereas earlier reproductive prints had, as often as not, been reproducing drawings made expressly to be engraved, the French

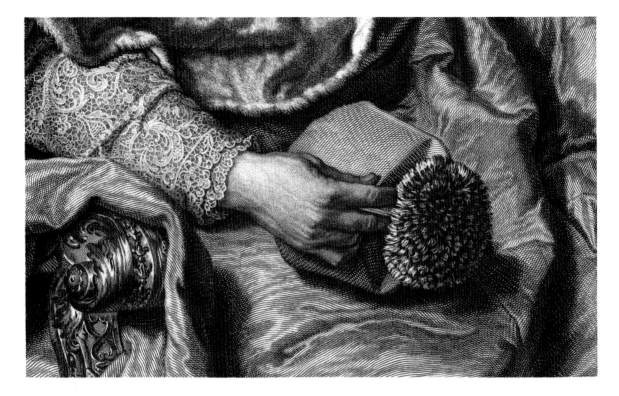

40,41 Pierre-Imbert Drevet after Hyacinthe Rigaud, *Cardinal Dubois*, 1724. Engraving (*opposite*, much reduced) and detail (*above*, actual size). The detail demonstrates Drevet's amazing ability to capture the effect of the most varied textures.

prints were almost invariably after paintings by the leading artists of the day. One feature of this was the forging of close links between an artist and his engravers. The first to do so was Simon Vouet, whose main engraver became his son-in-law, and who controlled the marketing of their plates himself. He was followed by Philippe de Champaigne, Charles le Brun, Hyacinthe Rigaud and in the eighteenth century Jean-Baptiste Greuze. Another feature, an innovation which was credited at the time to Charles Audran, was the considerable use made of etching to lay in foundations which were then strengthened or completed by burin work; typically landscapes and drapery were etched, while faces and flesh were engraved.

The second tradition was of portrait prints; its founder was Robert Nanteuil (1623-78), who engraved with a classic restraint and sureness of judgement, usually after his own chalk drawings. His successors, among whom were such outstanding engravers as Antoine Masson, Gérard Edelinck and the three members of the Drevet family, often worked after paintings as well, but maintained his purism by refusing to admit any etching into their prints. This began to break down in the eighteenth century. Although the tradition of the large portrait continued for the presentation plates that engravers had to make in order to be admitted as members of the Académie Royale, some engravers such as Étienne Ficquet began to specialize in minutely worked small heads, while the great series of medallions after the drawings of C. N. Cochin the younger are entirely etched.

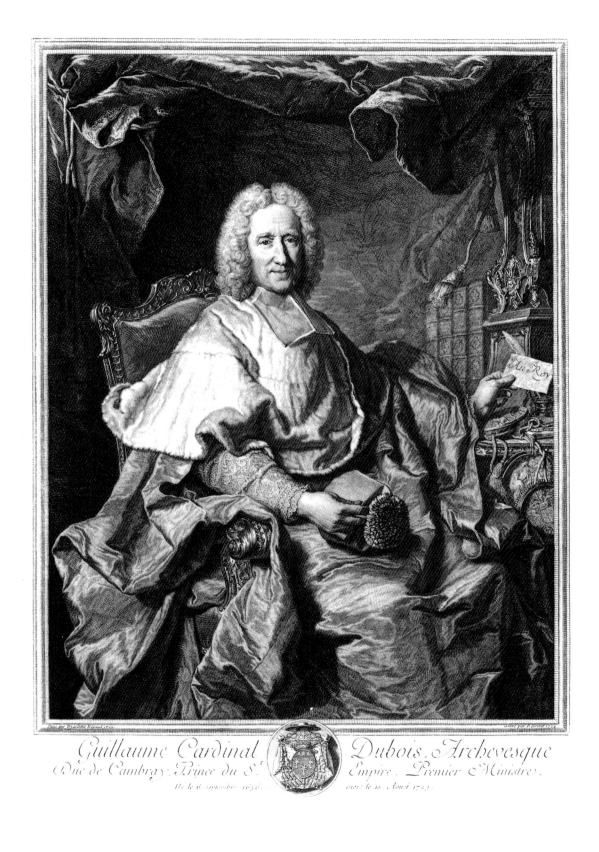

Guillaume Cardinal Dubois, Archevesque
Duc de Cambray, Prince du S.t Empire, Premier Ministre.
Be le 6 Septembre 1656. mort le 10 Aoust 1723.

In the eighteenth century a third tradition gradually established itself, which is perhaps France's most original contribution to the art of the print. This is of the highly finished engraving, usually of some subject taken from contemporary life, designed to be framed and hung on the wall. These seem to have their origin in the success of the *Recueil Jullienne*, the two huge volumes of engravings after Watteau's paintings, published posthumously in 1736. Many were after paintings by the foremost artists of the time such as Boucher and Fragonard; as many again were engraved from specially made gouaches drawn by minor masters like Pierre-Antoine Baudouin and the Swede Nicolas Lavreince. The engraving was usually done over an etched foundation, which was often printed and sold as a work of art in its own right, and frequently specialists in the two techniques would collaborate over one print (*cf.***45-48**). These prints, although unfashionable today, show superlative skill. The French system of art education gave training in draughtsmanship to the printmaker as well as to the painter; with the additional technical apprenticeship in such shops as that of Le Bas, the French engravers stood unequalled in Europe.

During the century and a half of French domination print production in the rest of Europe was far from insignificant. The strongest challenge came from England, a country whose engravers (although not the mezzotinters) had remained provincial until the eighteenth century. The central figure was William Hogarth (1697-1764), who was the first artist in this country to make paintings specifically to be engraved, and who forced through the first copyright act to establish artists' rights over their designs. He had his subjects from high life, such as *Marriage à la mode*, engraved by imported French experts, but in his most original series, such as *Industry and Idleness*, which he engraved himself, he intentionally used a simplified technique to reinforce the impact of his message and to reduce the price of the individual impression. The main line of British reproductive engravers was trained by the Frenchmen who came over to work for publishers in the 1730s. The first English engraver to achieve an international reputation was William Woollett (1735-85), whose prints were marketed abroad by John Boydell. Boydell was the first of the great publishers who dominate the closing period of the history of the reproductive engraving; it was his boast at the end of his career that he had turned Britain from a net importer into a net exporter of prints. His fortune (and position as Lord Mayor of London) was largely built on popular stipples and topographical prints, but he earned a larger place in the history of art by commissioning grand 'history' paintings from British artists to be engraved for such ambitious schemes as his illustrated Shakespeare.

William Blake was apprenticed into the tradition of reproductive engraving and many commissioned plates prove his mastery of it. However, when in later life he wished to make engravings from his own designs, he threw over this system in favour of an entirely original manner composed of parallel, flowing lines. This is seen at its best in the twenty-one illustrations to the Book of Job (1826) and the seven plates for Dante left unfinished at his death.

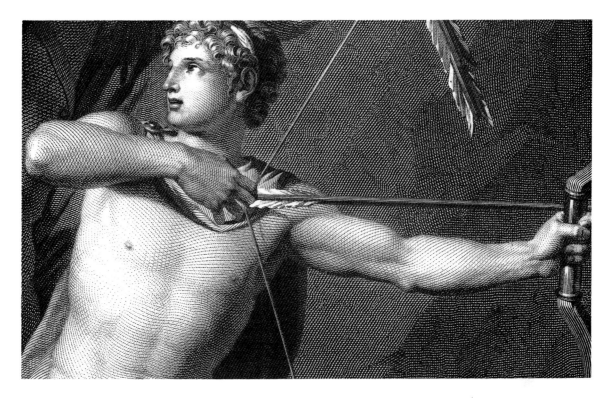

The end of the eighteenth century saw one remarkable development which reached across Europe. A new breed of rich art lover who was an amateur both of painting and of engraving demanded high-quality plates after famous paintings. This was the period of neo-classicism and engravers devised astonishing systems of laying crossing lines with precise regularity (the so-called 'dot-and-lozenge' style). Very high prices were paid for such works and as a result reproductive engravers abandoned the practice of preparatory etching and devoted years to the laborious tooling of one immaculate plate. The most famous of these virtuosi was the Neapolitan Raphael Morghen (1758-1833) but the most impressive was the Frenchman Charles Bervic (1756-1822), who only completed sixteen plates in his whole career. This system became the approved method for instruction in the numerous academies of engraving which were then springing up all over Europe. It survived in them until the end of the nineteenth century, by which time it looked like an absurd affectation. These works, the most valuable prints of their day, are now held in unfair contempt.

Engravings of the second and third quarters of the nineteenth century usually belong to one of two classes. The aristocrats of the profession devoted their time to huge plates after the popular paintings of the day. Pure line-engraving took too long, and so these plates were usually made in a mixture of techniques, in which mezzotint predominated (see pp.83ff.). Such prints sold in large numbers at high prices and by the mid-century it was possible, at least in Britain, for an artist to earn more from the sale of a painting's copyright than from the

42 Charles Bervic after Jean-Baptiste Regnault, *The education of Achilles* (detail), 1798. Engraving with some etching (actual size). An example of the 'dot-and-lozenge' reproductive engraving; only part of the background is etched.

painting itself. At the other end of the scale in size, engravers were employed on book illustrations. Although the mass market was the province of wood-engraving, there was a large demand for small, exquisitely worked engravings for illustrated annuals, keepsakes and suchlike. The best such prints were the various series of views of Britain and the Continent that were engraved after the drawings and under the supervision of J. M. W. Turner. From the 1820s such prints were often engraved or etched on steel plates, but the invention of steel-facing in 1857 made this no longer necessary.

From the mid-nineteenth century the revived fashion for etching challenged the engraver's supremacy by popularizing a new class of reproductive etching, but it was the perfection of photomechanical techniques in the 1880s which put a quick and inglorious end to an ancient profession. In the twentieth century a few artists, mostly working in Paris and influenced by the example of Stanley William Hayter, revived the burin as a method of non-reproductive printmaking, but it has found no widespread popularity.

Etching

TECHNIQUE Etching is the most important intaglio technique after engraving. Its essential principle is that the metal of the plate is removed by eating into it with acid rather than by cutting it out with a tool as in engraving. The plate is coated with a ground impervious to acid through which the artist draws so as to expose the metal. The whole plate is then immersed in acid until the lines are sufficiently bitten. Finally the ground is removed and the plate inked and printed in the usual intaglio way (see pp.31-35).

Such is a summary of the process. The various stages may now be described with greater elaboration. The plates are usually copper or zinc, although various other metals have been used. Etching grounds are composed of various waxes, gums and resins; the old handbooks provide many different recipes, but the only essential requirement is that the ground can be drawn through and remain impervious to acid. The plate is warmed and the melted ground laid evenly over the surface with a dabber (a cloth-covered pad filled with ground) or a roller. The ground is often darkened ('smoked') with a bunch of lighted tapers so that the lines drawn through it with the etching needle (a simple metal point) can be more easily seen as shining exposed metal.

The act of drawing is similar to putting pen to paper, but the medium does impose certain restrictions. It is impossible to wipe and print a plate where the lines have collapsed so as to leave pools of ink. Therefore the artist cannot expose areas of copper wider than a thick line. Nor can lines be drawn too close together because the acid will bite under the remaining ground and the ridges of copper between the lines will collapse. If the etching ground has been imperfectly laid, the acid will attack the plate indiscriminately and with disastrous effect; this is known as 'foul-biting'.

To bite a plate in an acid bath calls for experience, as the etcher has to judge

the strength and temperature of whatever type of acid is used (which varies according to the metal) in order to decide how long to leave the plate in the bath; this can vary from minutes to hours. To ensure an even biting the bubbles that form on the plate have to be brushed away with a feather. The biting can be completed in one operation, but if lines of varying depth are required the plate is removed from the bath when the lightest lines are bitten. The etcher varnishes these over ('stopping out') and puts the plate back for a second biting. This process can be repeated as often as is necessary. Another method of graduating the depth of biting is to bite the plates unevenly, either by brushing acid on some parts more than others or by tilting the plate in the bath.

At any stage the ground can be taken off a plate in order to print a proof to check progress. In these cases a second ground can be laid, but this has to be transparent in order to allow the etcher to see his earlier working. It is also possible to re-lay a ground very delicately so as to leave all but the lightest lines uncovered; this was sometimes done in order to re-bite and strengthen the lines as they wore down during the course of a plate's publication.

Although etching is the most complicated of the intaglio processes to describe, it is the easiest for the amateur to try; he simply has to draw lines on a waxy surface, while the hard work of cutting the copper is done by the acid. The laying and biting of the plate is more complicated, but this, like the printing, can be, and very often has been, handed over to a professional. For these reasons, etching has always been the preferred medium of non-professional printmakers and in particular of artists who are primarily painters or draughtsmen. It is however extremely unpredictable, and it is never clear how the impression will come out until a proof is actually printed. This has alternately delighted and exasperated artists. Samuel Palmer wrote that etching had 'something of the

43 de Fehrt, *An etching workshop*, 1767. Etching (reduced). The activities depicted are (from right to left): laying the etching ground; knocking up a plate from the back to eliminate an error; smoking the grounded plate; pouring acid off a plate after it has been etched by building a border of wax round it; drawing on the plate using a mirror to reverse the image; two other methods of etching the plate – either pouring acid down it or running it up and down over the surface; an engraver completing an etched plate with burin work. The large screens are used to diffuse the light coming through the window.

44 John Sell Cotman, *Castle at Dieppe*, 1822. Etching (greatly reduced). The tonal variations in this print are achieved entirely by laying series of short parallel lines at varying intervals, and etching them to different depths by stopping out. There is no cross-hatching.

excitement of gambling, without its guilt and its ruin'. Jasper Johns put it differently: 'Within the short unit of an etching line there are fantastic things happening in the black ink, and none of those things are what one had in mind.'

An etched line is usually easy to distinguish from an engraved one. Because the ground can be drawn on with little effort, an etched line usually exhibits a much greater freedom than is possible for the engraver who must laboriously plough through the copper, turning the plate itself whenever a curved line is needed. The etched line can also be distinguished by its blunt rounded ends, whereas burin and drypoint lines taper into a point as the burin or needle comes to the surface of the copper. Under a magnifying glass an etched line will be seen to be irregular in outline because the acid bites unevenly. Furthermore, the acid makes a rounded cavity, not an angular cut as does a burin, so that the ink lies on the surface in a mound rather than a sharply defined ridge, with a consequently less brilliant effect. Nevertheless it must be admitted that there are often cases where it is very difficult to distinguish between the two processes. This is particularly acute in the sixteenth century when some artists were drawing with the etching needle in exactly the same way as they were handling a burin, and when the two techniques were often combined on the one plate.

Etching has commonly been used in combination with drypoint and aquatint. This is discussed in the following sections.

HISTORICAL Etching was invented as a method of decorating armour and was already known in the fourteenth century. This sort of decoration involved painting the design in resist and then etching away the background in order to leave the design standing out in relief. Since such a design cannot be printed in intaglio, it is not perhaps surprising that the idea of etching plates in order to

58 *Etching*

45-47 James Heath after
Francis Wheatley, *The Riot
in Broad Street*, 1790.
Detail (actual size). The
three details show (*from top
to bottom*): the preparatory
'etched state'; the next
stage with some engraved
lines added; a later state
with more engraving,
although the plate is still
not entirely finished.

48 *below* Ten times
enlargement of a detail of
47 to show the difference
in character between an
etched and an engraved
line: the man's shoulder is
engraved, the background
is etched.

49 Augustin Hirschvogel, *Landscape with a church*, 1545. Etching (reduced).

print from them did not occur until some seventy years after the invention of printing from engraved plates. The earliest dated etching, of 1513, is on a plate by Urs Graf, of which only one impression survives. In the first decades of the sixteenth century various artists experimented with the new technique, from Daniel Hopfer of Augsburg, who occasionally practised as an armourer, to Albrecht Dürer, who produced six etchings between 1515 and 1518. In the Netherlands Lucas van Leyden, Dirk Vellert and others used etching merely as a less laborious method of achieving the effect of engraving; when, as sometimes happened, the two techniques are combined on the one plate, they can be very hard to distinguish.

Early etchings often have a somewhat experimental character and it took many years in northern Europe for the medium to develop its own traditions. One reason for this is that early etchings were made on iron rather than copper plates; the original iron plate from Burgkmair's *Mercury and Venus* of *c.*1520

survives in the British Museum (see **21**). This seems to have been simply a legacy of etching's origins in the armourers' shops, but was responsible for the coarse line and effect of many plates. Copper plates only came into general use towards the middle of the century. The most interesting tradition of etching in northern Europe in this period was of landscapes; this was begun by Albrecht Altdorfer (*c*.1480-1538) in Regensburg and continued by his followers, Augustin Hirschvogel (one of the first etchers to use a second bite) as well as Hans Lautensack. Besides this there was a significant use of etching for popular or run-of-the-mill prints, where its relative speed of manufacture as against engraving gave it an advantage commercially.

In Italy, Marcantonio made occasional use of etching in his engravings, but the first to take it up seriously was Francesco Mazzola, called Parmigianino (1503-40), who has the distinction of being the first 'painter-etcher', in the sense that he was primarily a painter. His earliest plate can scarcely date before the

50 Van Duetecum after de Vries, *An idealized view of the shop of Hieronymus Cock*, 1560. Etching (reduced). Although superficially looking like an engraving, this plate is in fact entirely etched; the contour line of the acid can be seen in the sky.

mid 1520s. Parmigianino was a graceful and fluent draughtsman who supervised the reproduction of many of his drawings in the form of engravings by Jacopo Caraglio and chiaroscuro woodcuts by Antonio da Trento. It is not therefore surprising that he was the first to be drawn by etching's ability to capture the freedom and spontaneity of line of drawing. He had a follower in Andrea Schiavone and a successor in Battista Franco. Several decades later come the four etchings made by Frederico Barocci in the early 1580s, which show an unprecedented stippled manner of modelling flesh.

Some of the most interesting etchings of the 1540s were made in France by members of the so-called school of Fontainebleau under the inspiration of the Italians Rosso Fiorentino and Francesco Primaticcio. Although little is known about the individual etchers, they all seem to have been closely connected with the works going on for François I at the Château of Fontainebleau, and their existence provides invaluable evidence of the self-consciousness of the stylistic innovations being practised there.

The seventeenth century was the golden age of etching. All over Europe painters succumbed to a new fashion for the medium. Many, such as Caravaggio and Guercino, made only one or two prints before deciding that etching was not for them, but others continued to produce a substantial volume of work.

51 Parmigianino, *The Annunciation*, *c*.1528/9. Etching (actual size).

The origins of the seventeenth-century revival in Italy go back to the few etchings of Annibale and Lodovico Carracci, who inspired Guido Reni, the most influential etcher of the period. His delicately etched plates, usually of religious subjects and influenced by Parmigianino, set a fashion which was followed by his pupil Simone Cantarini and others. A different style of etching was practised in Naples by the Spanish-born artist José de Ribera, whose plates are drawn with a sensitivity often in surprising contrast to the brutality of the subject-matter. The major etchers in Rome were not native born either. Both Salvator Rosa and Pietro Testa seem to have used their prints largely as a means of self-advertisement. Rosa admitted in a letter that the inscription 'Rosa pinxit' under one plate was untrue; he had not in fact painted the picture, but hoped that someone reading the lettering would be encouraged to order it from him.

Two other etchers showed much greater interest in printmaking as an art form in its own right. The first was the Genoese Giovanni Benedetto Castiglione (1609-65), most of whose plates were made in Rome. One interesting aspect of his prints is the awareness that they show of the works of his near contemporary Rembrandt, with whom Castiglione shared an interest in experimentation. Castiglione seems to have invented a new printmaking process, the monotype (see glossary). The second etcher was Claude, born in Lorraine, but who lived all his adult life in Rome. All his etchings are of landscapes or marines; in late impressions they are often hard and coarse, but fine early proofs show the unprecedented atmospheric effects that he was striving to obtain.

France also had an important tradition of etching. The first significant figure was Jacques Bellange (active 1595-1616), who spent most of his career as the court painter to the Dukes of Lorraine at Nancy. No documented painting by him survives but his drawings and his astonishingly convoluted mannerist etchings have preserved his name and reputation for posterity. The next great etcher of the French school also came from Nancy, although his style was largely formed in Italy. Jacques Callot (1592-1635) is the first important etcher who was not a painter. To ensure that his plates would print enough impressions to secure his livelihood and to simulate the effect of the then much-admired line-engraving, he developed a new sort of etching needle, the *échoppe*, which has a sharp but rounded end. Used on a hard etching ground which forces the acid to bite a much sharper line than it does on more conventional etching grounds, this tool can imitate the swelling line of a burin. In this way Callot could etch his plates deeply enough for them not to wear out too quickly and also preserve the gradations of tone by a deft use of stopping out. Callot was in Italy between 1608 and 1621 working in Florence for the Grand Dukes of Tuscany before returning to spend the rest of his life in Nancy.

Stylistically his closest follower was the Florentine Stefano della Bella; it is characteristic of the internationalism of the period that many of della Bella's prints were commissioned by Parisian publishers and that he spent ten years of his life in Paris (1640-50). In France Callot had several imitators, but his most important follower was Abraham Bosse (1602-76), whose closely observed

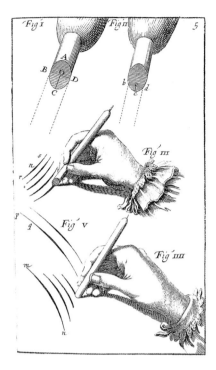

52 Abraham Bosse, *The échoppe and how to use it*, 1645. Etching (reduced).

53 *above right* Jacques Callot, *A peasant holding a basket*, 1617. Etching (actual size). This plate and **52** were both made using the *échoppe*.

interiors give a vivid view of the France of Louis XIII and the early years of Louis XIV. Bosse is also famous as the author of the earliest treatise on etching, aimed at the amateurs who were becoming interested in the medium. This goes so far as to say that the aim of etching is to give the appearance of engraving, but in fact Callot's manner fell gradually out of favour after Bosse's death. Its main practitioners were Israel Silvestre, who made numerous topographical prints, and, later in the century, Sebastien Le Clerc, the book illustrator. Other French printmakers were unaffected by Callot. Among them were the prolific Perelle and le Pautre families, and Jean Morin, who made a famous series of portraits after Philippe de Champaigne as well as some beautiful landscapes.

Printmakers were much patronized by Louis XIV, who employed them to make hundreds of plates designed to perpetuate the *gloire* of his reign. These were generically known as the *Cabinet du Roi*, and the plates varied in their medium. The most important, such as the frontispieces after Poussin's designs to books published by the Imprimerie Royale, were engravings. Many others, such as the famous plates after Le Brun's cycle on Alexander the Great, use a mixture of etching and engraving. Others still, such as the huge plates of his victories after van der Meulen, were entirely in etching.

One seventeenth-century etcher who stands somewhat apart but who is of particular interest to English readers is the Bohemian Wenzel (or Wenceslaus) Hollar (1607-77). An emigré from Prague, he was trained in Frankfurt in the shop of the Merian family, who had by this time taken up etching rather than engraving for most of their reproductive work. He was brought to England by

64 *Etching*

the Earl of Arundel in 1636, and, except for eight years in Antwerp during the Civil War, spent the rest of his life here. He was an etcher of the widest scope, and his 2,700 plates include every subject imaginable from copies of paintings and drawings in his patron's collection to interiors of old St Paul's. Occasionally he etched plates to his own designs and when faced with a congenial subject such as a muff or an English landscape produced results of remarkable beauty.

It was in the Netherlands that etching saw its greatest triumphs. This was largely due to the genius of Rembrandt, who dominates the history of etching in the same way as Dürer dominates engraving. Although throughout the previous century in the Netherlands there had been a sporadic use of etching by the major masters (Pieter Bruegel, for instance, made one print), the main tradition of printmaking in Antwerp and the Catholic south was firmly tied to engraving. Most of the numerous prints produced by Rubens' school and followers were engraved, the outstanding exception being the series of portraits of contemporaries by Anthonie van Dyck, known as the *Iconography*. Van Dyck seems to have begun by etching these himself with astonishing sensitivity, but, after completing or beginning only eighteen plates, for some reason lost interest and handed the project over to professionals who completed it in engraving.

In the Protestant north, etching managed at an early date to establish its independence from engraving. There were engravers who had great reputations, most notably Cornelis Visscher. But the extraordinary aspect of Dutch etching in the seventeenth century is the number of the major painters of the day who tried their hand at it. The vogue began with Willem Buytewech and Esaias van de Velde, who stand at the beginning of the Dutch landscape tradition, and was handed on to their successors, such as Allart van Everdingen and Jacob Ruisdael. The Italianizing landscape painters also etched, and there are numerous prints by Bartholomeus Breenbergh, Jan Both, Nicolaes Berchem, Karel Dujardin and Herman Swanevelt; even Aelbert Cuyp etched a few cows. Adriaen van Ostade with his followers Cornelis Dusart and Cornelis Bega showed the possibilities of rustic genre, and Reynier Zeeman and Simon de Vliegher those of the seascape.

Rembrandt himself had a remarkable precursor in Hercules Segers (c.1589-1635), whose extremely rare etchings, almost all landscapes, were usually printed in a coloured ink on coloured papers and were frequently also hand-coloured after printing. Although Rembrandt never used colour in his prints, he seems to have been inspired by Segers' experimental approach to break through all the established conventions of etching. His etchings – over three hundred in number – show an extraordinary development from the tight and often small plates of the 1630s to the grand landscapes and religious subjects of the 1640s with their complete mastery of tonal shading. In the years until he made his last print in 1659, he increasingly used drypoint which allowed him an even wider range of effects. The experiments with different inkings and papers which have already been mentioned (see pp.31ff.) are another aspect of Rembrandt's delight in making full use of the technical possibilities of printmaking, and it may be said that, quite apart from their beauty and emotional power,

54 Karel Dujardin,
The two mules, 1652.
Etching (actual size).

his prints retain, like no others, an ability continually to surprise the viewer. Rembrandt's style of etching has proved enormously influential, not only on his immediate followers, Jan Lievens and Ferdinand Bol, but on all succeeding generations, and in many periods etchers have been content to be his imitators.

In the eighteenth century the most interesting etchings were made in Italy, and, more particularly, in Venice. Antonio Canaletto made a series of beautiful views, published in about 1746, which capture the play of light by use of parallel shading rather than cross-hatching. He was followed by his nephew Bernardo Bellotto, most of whose etchings were made in Dresden. The dating of two

splendid series, the *Capricci* and the *Scherzi*, by Giambattista Tiepolo is still not securely established. His son Gian Domenico also made numerous etchings; most were after his own or his father's paintings but there is one famous set of his own design of scenes from the *Flight into Egypt*.

The genius of the period was Giambattista Piranesi, a Venetian by birth and an architect by self-description, who moved in 1740 to Rome and made his living selling etched views of the city to tourists. His plates are enormous, both in dimension and scale, and his vision of grandeur collapsing into picturesque ruin still conditions people's response to the city of Rome. Equally famous are the set of sixteen *Carceri* (Prisons) and his other architectural fantasies. Even in his plates of archaeological specimens, he managed to combine precision with dramatic presence by using the widest range of biting, from the deepest to the finest lines, ever seen in etching.

In France, the centre of European printmaking, the tradition of artist's etchings continued with a few pretty plates by Jean-Honoré Fragonard, Gabriel de

55 *far left* Rembrandt, *The blind fiddler*, 1631. Etching (actual size).

56 *left* Rembrandt, *The goldsmith*, 1655. Etching and drypoint (actual size). This impression is printed on Japanese paper.

Saint-Aubin and others, but the principal use of etching was made by the great school of book illustrators of the period. A few, like P. P. Choffard, the vignettist, etched their plates personally; more often specialist reproductive etchers worked after designs supplied by designers such as H. F. Gravelot, C. P. Marillier and Charles Eisen. Similar work may be found in such heavily French-influenced countries as England and Germany, where Daniel Chodowiecki deserves to be mentioned. It was in Germany too that the increasing vogue for the Dutch seventeenth century inspired a new interest in original etching. Some, such as C. W. E. Dietrich and F. E. Weirotter were little more

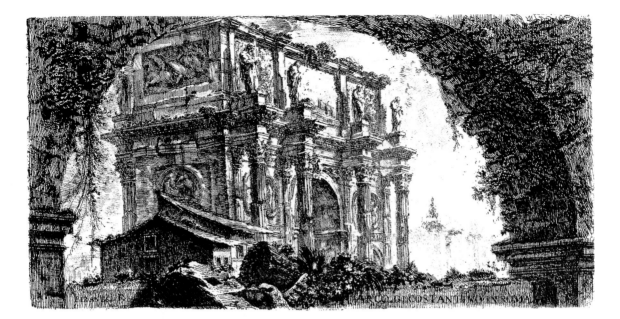

than imitators, but an artist like C. W. Kolbe reworked Dutch motifs into entirely new creations that are some of the most imaginative works of German Romanticism. In England the few original etchers, such as Paul Sandby, were much less significant than Gillray and Rowlandson, the great masters of the flourishing tradition of etched satire.

The greatest printmaker of the century, the Spaniard Francisco Goya (1746-1828), was also the most isolated. Spain had no tradition of etching worthy of mention, and Goya at first drew his inspiration from the etchings of the Tiepolo family, although he later changed his etching style completely and used the newly discovered aquatint process to add tone to his designs. He seems to have turned to prints in order to reach a wide public, and produced them in series which savagely attacked the cruelties and stupidities of the society in which he found himself. His first series, the *Caprichos* of 1799, ran into trouble with the Inquisition, and the later *Disasters of War* was never published, but from the time of their recognition by the French Romantics in the 1830s his prints have exercised an enormous influence.

The first half of the nineteenth century marks something of a pause in the history of etching. Although many fine prints continued to be made, the medium suffered competition from the newly invented technique of lithography which offered the artist an even easier method of making his own prints. The origin of the so-called 'Etching Revival' which dominated the second half of the century and the early decades of the twentieth century lies in the landscapes of Jacque, Daubigny and others related to the Barbizon school, made in the years from about 1840, and the rural figure subjects of Jean-François Millet. The other influential figure was Charles Meryon, whose morbid views of Paris were made between 1850 and his collapse into madness in 1866.

The increasing interest both among artists and such influential critics as Baudelaire resulted in the foundation of the *Société des Aquafortistes* in 1862, which marked the true beginning of the etching 'revival'. Specialist publishers such as Cadart sprang up, and printers such as the famous Auguste Delâtre perfected all the tricks of artistic inking. The best and most interesting prints were those by Edouard Manet, Camille Pissarro and Edgar Degas, although they all stood outside the mainstream of the movement, but work of every quality found eager buyers. Even the reproductive engravers' dignity was shaken by a new breed of reproductive etcher, led by Jules Jacquemart and Léopold Flameng, who took advantage of etching's new prestige to steal their market.

The fashion was transported from France to Britain by James McNeill Whistler, who fired the enthusiasm of his brother-in-law Seymour Haden. A distinguished tradition of artists' etching had in fact flourished early in the century with remarkable works by John Crome, J. S. Cotman and other members of the East Anglian school, and had been kept alive in the intervening years by the members of the Etching Club. The most famous of these is Samuel Palmer, whose dark and closely worked illustrations to Virgil's *Eclogues* stem from Blake's wood-engravings. However, Whistler's brilliance together with Haden's eloquence won the day for the French cause; Alphonse Legros was appointed Professor at the Slade in 1870, and Haden was elected first president of the Society of Painter-Etchers on its foundation in 1880.

Whistler was the most influential etcher of his time and for many years was considered by his admirers as second only to Rembrandt himself. His early works which established his reputation, the *French Set* of 1858 and the *Thames Set* made in 1859-61, show his sensitivity to place expressed through line. When he took up etching again in Venice in 1879-80, he developed a quite different and original manner in which the atmosphere of a spot was conveyed as much through films of ink left on the plate in wiping (always done by Whistler himself and his friends) as by any etched lines on the plate. In his last set of etchings of Amsterdam, made in 1889, he achieved a synthesis of his styles, combining work on the plate with wiping to produce his final masterpiece.

Haden was a much less considerable artist. He was in fact an amateur, a surgeon by profession, but treated etching with a seriousness which communicated itself to the entire movement. Etching became a business for the committed and its high priests, Frank Short, Muirhead Bone, D. Y. Cameron (all three, like Haden, knighted for their achievements) and others, treated a narrow range of subjects with a dour earnestness. An exceptional artist like Walter Richard Sickert (1860-1942) escaped from these limitations through his wide European culture and others, like Graham Sutherland and F. L. Griggs, followed the example of Samuel Palmer by evoking a personal pastoral or medieval utopia, but the general effect of the work of this period is one of dull proficiency. None of this hindered a wild financial speculation, fed by such innovations as signing and numbering impressions, which pushed prices absurdly high before the crash of 1929 made everything unsaleable.

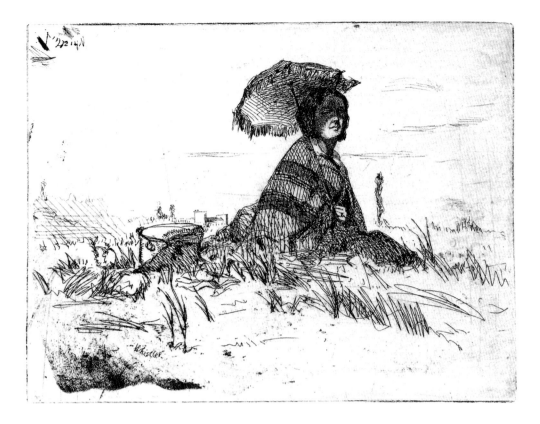

58 James McNeill Whistler, *En plein soleil*, 1858. Etching (actual size). There is an area of foul-biting in the lower left corner, and some trial lines at the upper left.

The unprecedented popularity of etching was a phenomenon found everywhere in the early decades of the twentieth century, although outside Britain the specialist printmaker never dominated the painter-etcher to the same extent. The best work was made in France, and Pablo Picasso is undoubtedly the greatest etcher of the past century. His first etchings belong to his blue and pink periods, and a few more were made with Braque in the Cubist years of 1910-12. His greatest prints however come from the 1920s and 1930s, and show his delight in taking full advantage of the possibilities of the different techniques of printmaking as well as his amazing mastery of line and command of expressive distortion. Matisse, too, made some very simple and beautiful etchings, and many of the artists who came to work in Paris from all over the world were encouraged to make etchings, notably at the atelier of Roger Lacourière.

Many fine works were made in Germany and the Netherlands (where James Ensor had begun to make his fantastic etchings in 1896), but some of the most interesting prints are to be found in America. Beginning in the shadow of Whistler, the first American etchers to create something new were the landscapists of the first two decades of the century like Childe Hassam, and the illustrators of urban life of the Ash-Can school such as John Sloan and Reginald Marsh. Between the two World Wars a consuming interest in the American scene led to the tense masterpieces of Edward Hopper, which can hold their

own with the best European work of the time, and the dramatically lit urban scenes of Martin Lewis.

The years since the Second World War have seen the supercession of the small black-and-white etching, which has dominated so much of European printmaking, by the large, highly coloured print intended to be hung on the wall. The best-known etchings of the 1950s were the coloured intaglio works (often using a combination of many intaglio techniques) produced by the leading members of the school of Paris like Pierre Soulages. In the 1960s in Britain and America etching suffered with the popularity of screenprinting and lithography, but was kept in public view by David Hockney and Jim Dine, and in the 1970s became the favoured graphic medium of the artists of the Minimalist school.

Drypoint

TECHNIQUE Drypoint is the simplest of the intaglio processes. The line is scratched directly into the copper plate with a sharp metal point (the drypoint needle). As the needle scores the copper, it throws up on both sides of the line a ridge of metal known as the burr. This burr is responsible for the most characteristic effect of a drypoint print: the curled copper holds a quantity of ink which prints as a rich feathery smudge.

In technique drypoint stands closest to engraving. Both work directly into the metal, but the difference is that in engraving the metal is actually dug out of the lines and any burr on the surface of the plate is scraped off before printing, whereas in drypoint it is simply thrown to the side and left on the plate. This difference in technique produces a different effect. The engraver's burin has to be pushed through copper and makes a line that is anything but spontaneous and free. A drypoint needle can be handled in the same sort of way as an etching needle and its line shares the same nervous quality. It is for this reason that drypoint is usually considered as a variety of etching, and is often used by artists to retouch areas of an etched plate.

Although drypoint sounds simple it has many drawbacks. The needle is almost as difficult to control as a burin, while commercially there is the grave disadvantage that the line, being only a shallow scratch, quickly wears down. The drypoint's chief beauty, the rich burr, wears even more quickly, and will often only last for twenty or thirty impressions. In the nineteenth century artists often got round this by steel-facing their plates. Opponents of this practice claimed that it made the burr print very much more weakly and, although this charge was hotly disputed, there is no doubt that in some cases at least (for example the early prints of Picasso) it is perfectly true.

If the burr has worn down or been scraped away by the artist, a drypoint can be very difficult to distinguish from an etching. Sometimes the character of the line will give the answer; for example, a rounded end will betray etched lines, a very closely worked area of shading drypoint. But often there is no method of finally settling the question.

59 Ten times enlargement of the tree trunk at the left of **64**, showing heavy burr. The thin white line in the centre of the solid black burr is where the ridge of copper thrown up on either side of the drypoint line has pressed into the paper.

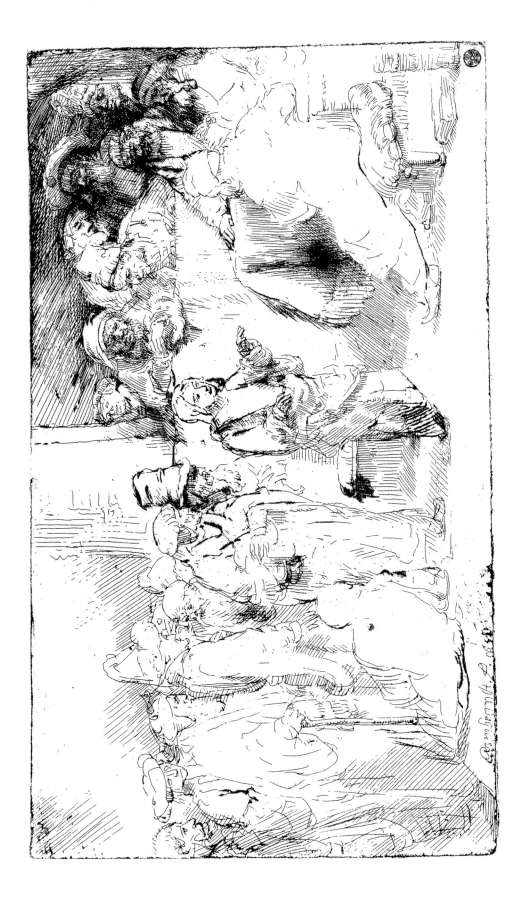

60 *above* Rembrandt, *Christ disputing with the doctors*, 1652. Etching and drypoint (actual size).

61 *right* Detail of **60** (enlarged). The contrast between the etched lines and the drypoint with the smudgy burr is very clear.

62 *far right* Detail of a late impression of **60** (enlarged). The burr has worn away, revealing how shallow the drypoint lines are; by contrast, the etched lines show little or no wear.

63 Master of the Housebook, *The three living and the three dead*, c.1490. Drypoint (actual size).

64 Rembrandt, *Clump of trees with a vista*, 1652. Drypoint (actual size). An outstanding example of the beauty of pure drypoint.

HISTORICAL It is unusual to find prints which are entirely worked in drypoint. More commonly etchers used drypoint to retouch areas of their etched plates which needed more work but not enough to make it worth laying a new etching ground. Engravers, too, often began by scratching outlines of their design onto the plate in drypoint. These types of use do not strictly belong to a history of drypoint, and this section will only mention the few artists who have made plates entirely in drypoint.

The earliest is the remarkable Master of the Housebook, named after a book of drawings at Wolfegg, who worked around 1480 in the region of the middle Rhine. His very rare prints, which are mostly preserved in Amsterdam (he is also sometimes known as the Master of the Amsterdam Cabinet), are all drypoints, and are exceptional in fifteenth-century art in their freedom and appearance of being sketched from life. The other early master to make drypoints was Albrecht Dürer. The three he made, all in 1512, make great play with the rich velvety tone which can be got from the burr. Despite this striking success he abandoned the medium and the reason must be that he discovered how quickly the burr and the lines wore out, a fact which, to a man of Dürer's business-like approach, made drypoint a waste of time.

Drypoint was occasionally used in sixteenth-century Italy, mainly to supplement etching, but was only seriously taken up in the seventeenth century by Rembrandt, a man whose mind was anything but business-like and who delighted in obtaining striking effects in prints. Beginning as an etcher, he used drypoint increasingly from the later 1630s on his etched plates. In the 1650s drypoint came to dominate and five plates (two landscapes, a portrait and the very large *Three Crosses* and *Christ Shown to the People*) were executed entirely in it. The last two are arguably his greatest prints, but can also be seen as extraordinary technical *tours de force*. They show complete control of a medium which no-one had ever dreamed of using on such a scale, and demonstrate how the artist can dig the needle in more deeply to throw up more burr or scrape it down where he wishes to lighten the tone. Rembrandt also found several unusual printing surfaces, especially Japanese paper and vellum, ideal for bringing out the burr, and used them whenever possible.

In the seventeenth century most drypoints were made by his immediate followers and pupils such as Lievens and Bol and, in the eighteenth century, by his imitators such as Arthur Pond in England and Norblin de la Gourdaine in France. But it is unusual to find drypoints anywhere in this period and the medium only became widely popular in the middle of the nineteenth century. It was taken up in the first place by Seymour Haden who used it in many landscapes in the manner of Rembrandt (of whose works he himself owned a fine collection), and many other British etchers followed him in this, often smothering the design in a mass of richly printed burr.

In Europe drypoint never became so exclusively tied to landscape. The leading master in France was Paul Helleu, whose portrait drypoints of the 1890s are, at their best, sensuous and, at their worst, flashy. Chahine and the Italian

Boldini also made portraits in his manner, but a finer artist was Mary Cassatt, the American domiciled in France, who made many drypoints of her habitual theme of mother and child. In the early years of the twentieth century Picasso made a handful of drypoints during his blue and pink periods.

The German tradition was more original and blossomed in the first decades of the twentieth century. The two leading German 'impressionists', Lovis Corinth and Max Liebermann, made many good portraits and even better land-scapes in drypoint. From another starting point the Expressionists used the jagged directness of the drypoint line to convey the immediacy of their responses. These two German traditions meet in Max Beckmann, whose drypoints of the First World War convey the horror in lines of extreme sensitivity.

Crayon-manner and Stipple: the dot processes

The intaglio printmaking processes so far described can only produce lines of varying thickness; they cannot easily manage areas with considerable tonal grada-tions. In the case of etching and drypoint it is possible only by shading and cross-hatching. Engravers could extend their range by building up systems of lines of varying width, alternating with thin lines of cross-hatching, which enabled them to give the effect of the most varied textures. But an easier way of conveying tone is by building up areas of dots of varying density. This has found favour at certain periods, and various methods have been practised, all of which are now long defunct. It seems best therefore in this section to combine the technical and historical narratives.

65 Giulio Campagnola, *Child with three cats*, *c*.1510. Stipple over an engraved outline (actual size).

The earliest method was invented by the Venetian Giulio Campagnola (c.1482-after 1515). Using flicks of the burin he built up images modelled in dots over a line foundation; in one case, the *Venus Reclining in a Landscape*, he dispensed altogether with the engraved foundation. This technique perfectly echoes the broken outline and soft atmospheric modelling of the paintings of Giorgione and his school and, although Campagnola had a few followers, it scarcely outlived the first decades of the sixteenth century.

A limited use of stippling with the graver to model flesh areas was introduced by Dürer and lasted into the eighteenth century, especially among the French portrait engravers. Nanteuil always used flicks of the graver for the lightest areas of the face, only breaking into line in the shadows. In Italy a similar technique was used by the portrait engraver Ottavio Leoni (1575-1630). Another portrait specialist, Jean Morin (c.1605-50), used the same principle but, by flicking his dots onto an etching ground rather than directly into the plate, achieved effects of a much greater *sfumato*. He had been anticipated in this by Federico Barocci and Jacques Bellange (see above pp.62-3). In Holland, Jan Lutma, a goldsmith by profession, made a few curious portraits around 1680 by punching dots with a smith's punch directly into the plate.

The earliest recorded use of the *roulette*, a tool consisting of a spiked wheel, was by Ludwig van Siegen in 1642, but since this is intimately connected with the history of mezzotint it is described in the section on mezzotint. It was however the same tool, or adaptations of it with different arrangements of spikes, together with the *mattoir*, a tool with a rounded spiked head, which were used in the classic dot processes of the eighteenth century.

66 Detail of **67** (much enlarged), showing the combination of etched lines and stippling on the Virgin's left hand. Bellange's hands are usually odd; where is her fifth finger?

67 *opposite* Jacques Bellange, *The Madonna with the rose*, c.1615. Etching (actual size). The flesh has been stippled with flicks of the needle.

Carge. fecit

68 *above* Gilles Demarteau after François Boucher, *Mother with two children*, *c*.1760. Crayon-manner (slightly reduced).

69 *right* Louis-Marin Bonnet, *Tools for crayon-manner*, 1769. Etching and crayon-manner (reduced). Figures 6 and 7 are mattoirs; 8 and 9 are two views of a roulette. Below are the characteristic areas of tone that they produce.

The remarkable development of tonal processes in eighteenth-century France was stimulated by the demand for printed facsimiles of drawings. Since the drawings reproduced were mostly *sanguines* (red or brown chalk drawings on rough-textured paper) it was necessary to devise a method of imitating their crumbly and irregular grain. The inventor of the so-called crayon-manner in 1757 was an engraver, J. C. François (1717-69), who developed new types of roulettes and mattoirs which he used not directly onto the plate but onto an etching ground, in order to soften the effect. By printing on a suitable paper in a red or brown ink he produced extraordinarily accurate facsimiles of drawings, which can still occasionally deceive the unwary. He was followed by an even more skilful craftsman, Gilles Demarteau, while a third, Louis-Marin Bonnet, devised a new development, colour printing from multiple crayon-manner plates, which he christened the pastel-manner (see p.119). Crayon-manner, being so closely dependent on the vogue for sanguine drawings, could not outlive that particular fashion and died with the eighteenth century.

STIPPLE was developed in England by William Wynne Ryland (1733-83) out of the French crayon-manner, of which it is really a simplified version. The engraver uses a point to build up a mass of dots on an etching ground, but makes no attempt to reproduce the effect of a drawing. Ryland had learnt the crayon-manner in Paris in the late 1750s, but only found success in England after 1774 when he developed stipple to reproduce the paintings of Angelica Kauffman. The popularity of these prints inspired many emulators, the most

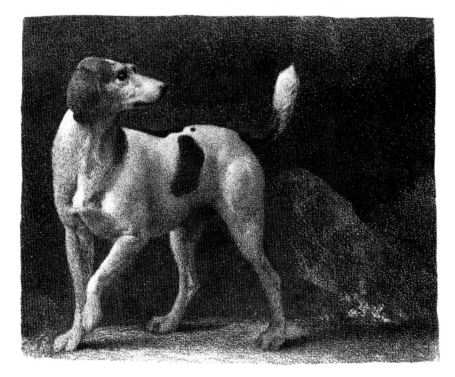

70 George Stubbs, *A foxhound*, 1788. Stipple (actual size). Although mainly stipple, the background of this plate has been worked over with a mezzotint rocker and roulettes.

82 *Crayon-manner and Stipple*

famous of whom was Francesco Bartolozzi, who made many stipples in England after the paintings and drawings of his fellow Italian G. B. Cipriani. Stipple was mostly used for so-called 'furniture' prints, designed to be framed and hung as elements in schemes of interior decoration, partly because it could easily be printed in colours. Moreover its softness lent itself admirably to *galant* or romantic subjects. It was later taken up in France, but did not last long into the nineteenth century. When, in the 1880s, eighteenth-century colour stipples became very fashionable among collectors, the technique was revived by a host of imitators in prints of vaguely eighteenth-century subject-matter and appearance; however this revival did not outlast the collapse of the collecting market in 1929.

Note: Fifteenth-century metalcuts were often decorated with punched dots in the style known as manière criblée. *Since these were printed in relief rather than in intaglio and the dots were used in a decorative rather than a tonal way, they are described in the section on metalcut (see pp.29-30).*

Mezzotint

TECHNIQUE Mezzotint is a distinctive printmaking process, being the only one in which the artist works from dark to light rather than from light to dark. The process itself is simple. The copper plate is first 'grounded' – that is, it is systematically worked over with a spiked tool (a *rocker*) until it is thoroughly roughened. If inked in this state, it will print a rich black. The engraver then smoothes out ('scrapes') graduated highlights with a scraper or a burnisher. The more burnished the area is, the less ink it will hold and thus, when the plate is printed, the design will emerge from the basic blackness.

The work of grounding the plate is laborious but not difficult. The rocker has a rounded blade with cutting teeth of varying finenesses, depending on the quality of grain required. The blade is held at right angles to the plate and the cutting edge rocked regularly up and down its surface; the direction is usually regulated by running the rocking tool along a fixed pole. To lay a uniform ground this process has to be repeated at different angles across the plate (often as many as forty).

The scraping of the grounded plate is a tricky job, but, although usually left to professional mezzotinters, is not so difficult that it has not occasionally been attempted by non-professionals. The inking and printing of the plate is however exceptionally complicated (see p.34).

The process of grounding a mezzotint plate raises a burr in the same way as drypoint. This burr is responsible for the superb depth of tone which can be seen on early impressions of mezzotints, but, again as in drypoint, this quickly wears out. Since nothing is flatter than a worn mezzotint, professionals regularly 'refreshed' plates by regrounding worn areas.

The possibility of refreshing plates must have suggested the other use to

71 *opposite* John Jones after George Romney, *Serena*, 1790. Stipple. Enlarged detail of another impression of colour plate 7, printed in sepia (*not printed in colours*).

72 Diagram of a mezzotint rocker, showing how it is worked over the plate in different directions.

73-75 (*clockwise*) John
Jones after Sir Joshua
Reynolds, *Miss Frances
Kemble*, 1784. Mezzotint
(greatly reduced). Three
progress proofs of the same
plate, showing an
impression from the
completely rocked
('grounded') plate before
any working, the first state
after the initial scraping,
and the sixth state after
considerable scraping. On
the verso of the last print
Jones wrote, 'Sixth proof
of 1st plate. In this state
the plate was destroyed by
the villainy of the printer
and begun all over again'.

which the mezzotint rocker can be put – that is to lay a partial ground on certain areas only of a plate. This was usually done over a plate which already carried a design etched in outline; the mezzotint ground could then be added in varying strengths to create shadows. This use of mezzotint for adding tone is very similar to the way in which aquatint was normally employed.

HISTORICAL The first step towards the mezzotint technique was taken by a German soldier, Ludwig von Siegen, who announced his discovery in a letter in 1642. Examination of his prints shows that he used a fine roulette to build up a design on the plate. He was therefore working from light to dark, rather than scraping down from dark to light.

The development of true mezzotint required the invention of the rocking tool, which made it possible to ground the entire plate and then scrape out the highlights, working from dark to light. This is credited to Prince Rupert in the late 1650s, when he had retired to Frankfurt after the Royalist defeat in the English Civil War. Most of his plates have an obviously experimental character, but the largest of them, *The Great Executioner*, after a painting of the school of Ribera, is superb and still remains one of the greatest mezzotints. Prince Rupert was chary of publishing details of his invention, but gave instruction to enough printmakers to ensure that the technique was eventually publicized.

The first of these professional pupils or assistants was Wallerant Vaillant. He settled in Amsterdam in 1665, and mezzotint was soon popular in Holland. One of the most interesting of the Dutch mezzotinters was Cornelis Dusart, van Ostade's pupil, who was equally distinguished as an etcher. He and some others made original designs in mezzotint, but most used it for reproducing paintings. William Sherwin, who made the earliest dated English mezzotint in 1669, was also instructed by Prince Rupert, and the growth of the British tradition was boosted by the arrival of many of the leading Dutch mezzotinters, such as Abraham Blooteling who worked in London between 1672 and 1676, mostly copying Lely's paintings. The first English mezzotinter to establish an international reputation was John Smith, so much so that the technique became known abroad as *la manière anglaise*.

The main reason for this success was the suitability of mezzotint for reproducing portraits; in France this market was firmly in the hands of engravers but there was no such tradition in England. Portrait painters strove to attach the best mezzotinters to their service not so much to make money out of their prints as for the sake of publicity. John Smith actually lived in Sir Godfrey Kneller's house for a time, and when the two quarrelled Kneller hastened to Smith's leading rival, John Simon. The best-known mezzotinter of the 1730s and 1740s, John Faber the younger, was a much weaker artist, but the standards rapidly improved in the 1750s when a large number of mezzotinters arrived from Ireland. This so-called 'Dublin-group', of which James McArdell was perhaps the outstanding member, dominated the profession until the mid 1770s.

They were greatly helped by the growth of the British school of portrait

76 Wallerant Vaillant, *A young man reading*, 1670s. Mezzotint
(reduced).

painting, and many of them worked for Sir Joshua Reynolds. Over four hundred prints after his paintings are known, and he, like so many other painters, was closely involved in supervising their production. From the 1770s the leading portrait mezzotinters were Valentine Green, Thomas Watson and John Raphael Smith, but the medium had by then become so popular as to be used for other purposes. Many of Joseph Wright of Derby's paintings of candle or moonlit interiors were mezzotinted by William Pether and Richard Earlom. Earlom also specialized in reproducing Old Master paintings, and published facsimiles of the drawings in Claude's *Liber Veritatis* in 1777. At the end of the century William and James Ward made many prints after the paintings of their brother-in-law George Morland, and there was a flourishing tradition of mezzotints of horses, bulls and other animal subjects particularly popular in England. Meanwhile the tradition of portrait mezzotints continued into the nineteenth century with Charles Turner, S. W. Reynolds, Samuel Cousins and the others who worked for Sir Thomas Lawrence and his successors.

Two series of mezzotints produced in the nineteenth century deserve special mention. The first is the *Liber Studiorum*, published by J. M. W. Turner between 1807 and 1819. This was produced in direct emulation of Claude's *Liber Veritatis* and was intended to display Turner's command of all types of landscape composition. The technique was based on Earlom's in his publication of Claude in 1777; Turner himself made sepia drawings and etched the subjects in outline, and then turned the plates over for partial mezzotinting to professionals. Much more beautiful though are the few unpublished plates of pure mezzotint (the so-called 'Little Liber') which Turner made himself. The second series, containing true mezzotints, is by David Lucas after John Constable. Constable published the twenty-two plates with a text under the title *Various Subjects of Landscape* in 1833 as a document of his artistic aims, and goaded Lucas by correcting proofs over and over again into producing his best work and indeed some of the finest English mezzotints.

The use of steel plates, with their much less rich burr, is responsible for the anaemic appearance of many mezzotints made after about 1820. In the nineteenth century mezzotint was often combined with other processes. Although in earlier periods mezzotint grounds had occasionally been laid over etched or stipple foundations, engravers now took delight in attacking the plate with every known intaglio technique. Such method is usually simply called 'mixed'. It did not survive the invention of photomechanical processes. In the early years of the twentieth century mezzotint enjoyed a certain popularity and has occasionally been practised in more recent years.

On the Continent the only centres where mezzotinting was practised at all commonly in the eighteenth century were Augsburg, Nuremberg and Vienna, where the founders of the school, Johann Gottfried Haid and Johann Jacobe had both been trained in London. Mezzotints were also occasionally made in France, the best being those by Philibert Louis Debucourt in the 1790s.

77,78 *above* J. M. W. Turner, *The fifth plague of Egypt*, 1808.
Etching (reduced); *below* the later state of **77** after a
mezzotint ground had been laid over Turner's outline etching
by Charles Turner (not a relation).

Aquatint

TECHNIQUE Aquatint is historically the most important of the intaglio tonal processes after mezzotint. It can produce an effect similar to a watercolour wash. The key to it is a special variety of etching ground (an aquatint ground) which consists of minute particles of resin which are fused to the plate and act as a resist to the acid. Since this ground is porous, the acid bites into the plate in tiny pools around each particle. These tiny depressions retain the ink when the plate is wiped, and when printed give the effect of a soft grain. The particles can be of varying fineness; if large the individual pools of ink will be visible to the eye, but if very small they will produce a film of tone which looks very similar to a watercolour wash. The aquatinter can vary his effects by biting to

79 David Lucas after John Constable, *Summer afternoon – after a shower*, 1831. Mezzotint (reduced).

different depths, either by using a stopping-out varnish or by laying grounds which vary in thickness or use grains of different degrees of fineness. The resin is cleaned off the plate before printing.

Normal aquatint grounds only produce areas of one tone. They can only produce a gradation for modelling form if the artist burnishes areas down in the manner of a mezzotint. Nor can aquatint produce a line. For these reasons it has normally been used in conjunction with etching. A plate is given an etched outline in the usual way, and then a new aquatint ground is laid on top and bitten to the required levels, after stopping out those areas which are to stay white. In the late eighteenth century the laying of the aquatint ground was often entrusted by the etcher to a specialist aquatinter.

Two methods are most commonly used to lay the resin ground on the plate. The first is the dust-box in which the ground is blown into a cloud and allowed to settle in an even film on the plate. The particles are fused to the copper by heating the back of the plate. The second method uses alcohol to dissolve the resin; the solution is spread evenly over the surface of the plate, and, as the alcohol evaporates, the resin is left as a grain on the surface. The artist can of course use many other techniques that give similar effects, and especially in the twentieth century many aquatint-like effects have been achieved using a bewildering variety of techniques. One method is to press sandpaper into an ordinary etching ground, or even directly into the plate.

The main difficulty in making an aquatint is that the design on the plate has to be negative, since the areas that the artist paints with his stopping-out varnish are those which will remain white. To reverse this, and to ensure that the brushed areas will be bitten, recourse has to be made to the *sugar-lift* or *lift-ground* aquatint. The artist brushes the design onto the plate with a fluid in which sugar has been dissolved. The entire plate is then covered with a stopping-out varnish and immersed in water; as the sugar swells it lifts the varnish off the plate, leaving the original brush drawing exposed as bare copper. These areas are then covered with an aquatint ground and bitten in the usual way, while the stopping-out varnish protects the rest of the plate. As an alternative, the aquatint ground can be laid on the plate at the very beginning, before brushing on the drawing. When this process is used over a drawn rather than a brushed line, as happened occasionally in the nineteenth century, it is sometimes known by the French term, as etching *à la plume*.

Two other tonal processes, distinct from but related to aquatint, should also be mentioned in this place. A *sulphur print* is produced by dusting powdered sulphur onto the surface of a plate which has been spread with a layer of oil. The particles of sulphur corrode the plate in a uniform tone, which can be burnished to give gradations. Sulphur prints can be distinguished from true aquatints by the absence of the rings or pools of ink which form around the resin particles.

A plate can also be brushed directly with neat acid; the term *lavis* (see glossary) has sometimes been used for this process. It is useful for giving a tone

to small areas for creating tonal variations within an aquatint ground, but cannot easily be controlled over large areas. Its characteristic sign is a 'high-tide' mark at the edges of the washed areas. It was much used by Goya, and has become popular since the Second World War. In America it is often referred to as 'open-bite' etching.

HISTORICAL The modern development of aquatint stems from a series of experiments conducted by various different artists in the third quarter of the eighteenth century. However, for centuries before this date printmakers had been striving to get tonal effects on etched plates by using a variety of idiosyncratic aquatint-like processes. The chronicle of these experiments has not yet been written, largely because they were so isolated and inconsequential. But a brief list must include Marcantonio, who used some sort of file to add tone to his *Judgement of Paris*, Daniel Hopfer and Rembrandt, who used corrosive sulphur. The most remarkable curiosities are a few isolated portrait prints made in the 1650s by the Dutchman Jan van de Velde, the fourth of a dynasty of artists bearing this name; these are true aquatints made with a resin dust ground, but they remained isolated and had no following whatsoever.

The history of aquatint in the second half of the eighteenth century is wrapped in obscurity. Many different printmakers were making many different

83 Abraham Genoels,
A circular landscape, c.1690.
Lavis (acid wash) over an
etched outline (actual size).

84 Francisco Goya, *Que Pico de Oro*, 1799. Etching and
aquatint (actual size). The aquatint was bitten to three depths
and then modified by extensive burnishing.

experiments, and each of them kept very quiet about what he was doing so as not to betray his secrets to rivals. The best claim to have invented the standard process using grains of resin belongs to the partnership of the Swede P. G. Floding and the Frenchman Charpentier in 1761. They were followed by J. B. Delafosse in 1766 who worked with and for the amateur, the Abbé de Saint-Non. None of these succeeded in publicizing their discoveries effectively, and so it was left to a third man, Jean Baptiste Le Prince, to take the credit for the invention, even though he only made his discoveries in 1768-9. He tried to sell his secret, but it was only bought by the French Academy in 1782, the year after his death, and made available to anyone who was interested.

Le Prince and his contemporaries used the process to imitate their own wash drawings, but the limited popularity of such drawings in France restricted the demand for aquatints. The process could, however, be adapted for colour printing in imitation of gouache; these are the finest French aquatints and are here described in the section on colour printing (p.119).

In Italy the earliest aquatinter, Giovanni David of Genoa, is significant only as the possible inspirer of Francisco Goya (see p.68), the greatest master of the process. Goya usually laid his aquatint over an etched foundation, often combining it with the use of acid washes and the burnishing tool. One plate, *The Colossus*, is so unusual, being entirely burnished aquatint, that it has traditionally been described as a mezzotint. Goya shows his greatest mastery of the medium in the few plates in which he dispensed altogether with the etched foundation and built up the design entirely in layers of tone.

The strongest tradition of aquatinting is to be found in Britain. The earliest English aquatints were exhibited by Peter Perez Burdett in 1772, but the artist responsible for spreading knowledge of the process widely was Paul Sandby. Sandby seems to have hit upon the idea of laying a ground dissolved in alcohol on the plate; he may also have discovered the lift-ground technique using sugar. His early aquatints and those of Gainsborough are bold and give the effect of gouache drawings, but in later years aquatint in England came to be used to build up even gradations of tone to give the appearance of a waterolour wash laid over an outline drawing. This technique was ideal at a period when most watercolours were executed simply in transparent washes over a pen outline, particularly since the aquatints could easily be hand-coloured after printing to complete the effect. It was, therefore, the technique pre-eminently employed for illustrating the great series of colour-plate books which enjoyed a remarkable vogue in Britain between about 1790 and 1830. Most of these books were topographical, but others treated subjects as diverse as fox-hunting and Chinese tortures.

In the last decades of the nineteenth century aquatint was used more frequently in artists' prints, the finest examples being by Degas, Pissarro and Mary Cassatt. In the last century it became popular as etchers became less willing to confine their work solely to line, and was often used in unconventional ways to produce new effects. In many prints the tonal techniques employed are so

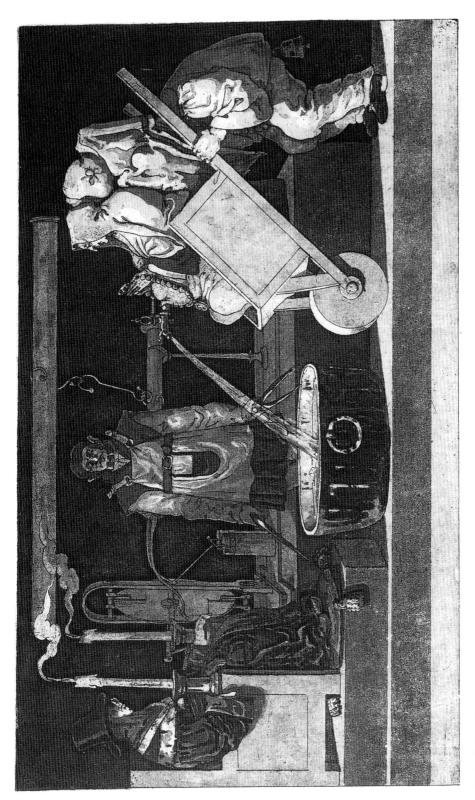

85 Louis-Jean Desprez,
Operation for hydropsy,
c.1790/4. Aquatint over an
etched outline (reduced).

86 Emil Nolde, *Brutale Kraft* (Brutal Strength), 1905.
Etching with tonal effects similar to aquatint,
but created by completely unorthodox – and now
unreconstructable – methods.
© The Nolde Foundation Seebüll.

complicated and idiosyncratic that it becomes impossible to recognize from a print the precise technique that was used, or, even where the technique is known, to assign it a satisfactory descriptive label.

Soft-ground Etching

TECHNIQUE This technique produces a facsimile of a chalk or pencil drawing. The plate has a special soft etching ground laid on it; this differs from a normal ground in that it has tallow added to prevent it hardening. A piece of soft paper is then fixed on top of it, on which the artist makes the drawing. Where the pencil presses into the ground, it adheres to the paper, which is carefully pulled away together with the attached ground leaving the design exposed on the copper. The plate is then bitten in the usual way, and an almost perfect facsimile of the original drawing is transferred to the copper. As always, the ground has to be cleaned off the plate before printing. Soft-ground etchings and crayon-manner prints (see p.81) can be readily distinguished from lithographs by the presence of a plate-mark. If this has been cut away, a crayon-manner print can be distinguished by the regular repetition of the pattern caused by the use of a tool. A lithograph will have a smooth surface, whereas a soft-ground etching, being printed from an intaglio plate, is rough to the touch.

HISTORICAL The process seems to have been invented in about 1758 by J. C. François, as a development of the experiments which had led to his invention of the crayon-manner. In 1761 he tried to sell his secret, and so had to reveal it to a number of prospective purchasers. From them knowledge spread to others. In England, Benjamin Green knew it in 1771, and Paul Sandby described it in 1775. Thomas Gainsborough used it in conjunction with aquatint in the 1770s. The technique was popular at the end of the eighteenth century in England, where it was widely used for making facsimiles of drawings. Among the artists who handled it were Thomas Rowlandson, John Sell Cotman and Sawrey Gilpin. In the early nineteenth century it was much used in the 'drawing books' by watercolour instructors such as David Cox and Samuel Prout, but by 1830 it was displaced by lithography, which could produce a similar effect very much more cheaply.

In the twentieth century there was a revival of interest in the technique, once it was realized that material of any texture could be pressed into the ground and the pattern transferred to the copper plate. It is the widespread use of textiles and suchlike for this purpose that makes many modern etchings appear so different from their predecessors.

87 *top* David Cox, *Dinas Mouthey, North Wales*, 1814. Drawing in pencil (reduced).

88 David Cox, *Dinas Mouthey*, 1814. Soft-ground etching (reduced). **87** is the original drawing made on paper laid over the soft etching ground and was thus transferred to the plate; the image is reversed in printing.

89 John Sell Cotman, *Llanthony Abbey*, 1820s. Soft-ground
etching (actual size).

Lithography

90 Jean François Millet, *The Sower*, 1851. Chalk lithograph (greatly reduced).

TECHNIQUE Lithography is based on the chemical fact that grease and water repel each other. If marks are drawn on a suitable printing surface in some greasy medium, the surface can be printed from in the following way. The surface is firstly dampened with water, which settles only on the unmarked areas since it is repelled by the greasy drawing medium. Secondly, a roller with greasy printing ink on it is rolled over the surface; the ink now adheres only to the drawn marks, the water repelling it from the rest of the surface. Finally the ink is transferred to a sheet of paper by running paper and the printing surface together through a scraper press (see below). The lithographic process is often described as surface or planographic in order to distinguish it from the relief and intaglio processes.

Such in essence is the principle of lithography. The actual operations are of

course much more complicated. The printing surface used was originally stone (whence the term 'lithography' which means 'stone drawing'); this had to be capable of absorbing grease and water equally, and the only really suitable type was the limestone quarried in the Solenhofen region of Bavaria. Later zinc (from

91 The original stone from which 90 was printed (reduced). Since this impression was printed, the stone has been cancelled by Frederick Goulding, who has scratched his initials into it.

about 1830) and aluminium (from about 1890) were employed as substitutes; there is usually no way of telling from inspection of any individual lithograph which printing surface was used. The disadvantage of stone used to be its bulk and weight and is now its unobtainability, but artists have usually preferred to use it when possible because it allows a richer range of tones.

The stone (and all that follows holds true for zinc and aluminium) can be drawn on in any way as long as the drawing medium is greasy; this explains the bewildering variety of appearances that lithographs can present. The most usual medium is chalk, for which crayons of various finenesses are available. The other methods are pen and wash. The latter can be particularly difficult to print as the wash can hold only a small proportion of grease and can thus fail to hold the printing ink; it was only successfully mastered in 1840 by Hullmandel who patented his method under the name of *lithotint*. If chalk is used the printing surface must be given a grain by grinding with an abrasive, but for pen or wash the surface has to be smooth or have only a fine grain. Other drawing techniques have been used. Toulouse-Lautrec, for example, often created a tone with 'spatter-work', by flicking lithographic wash at the stone with a toothbrush; highlights were reserved with masking paper. Other artists – for example, Manet and Menzel – scratched deeply into the stone to create highlights.

Once the drawing is finished the artist's task is done. The rest is the province of the printer, whose operations are complicated enough to make it unusual for the artist to do his own printing; he may supervise, but if he wants the full range of tone in his drawing to be brought out he needs expert aid. This fact distinguishes lithography from etching, its nearest rival as an autographic printing technique, and fundamentally affects the whole history of the medium. It is perhaps as appropriate to write a history of lithography in terms of the major lithographic printing establishments as in terms of the artists.

One difficulty is that the stone or plate has to be prepared before printing, and the exact process of preparation varies according to its surface and also the technique of the drawing. Briefly, the surface must be washed with dilute nitric acid to fix the image on the stone, and rubbed with gum arabic ('desensitized') to prevent any further grease settling on the stone. Only then can the surface be washed and inked for printing as described in the first paragraph. The 'gum etch' has to be done only once before printing, but the application of water and then ink must be repeated between each impression.

The printing press is traditionally a flat-bed scraper press. The paper is laid face down on the inked stone and rubbed along the back to transfer the ink. A modern development is offset lithography. In this the image is picked up from the stone or more usually plate, by a rubber roller which then reprints it onto paper. One advantage of this double printing procedure is that it re-reverses the image so that it is finally printed in the same direction as it was originally drawn; but the main advantage is commercial, in that it enables the printing to be done by a series of rollers which enormously speeds the operation. This has made the traditional flat-bed lithographic press obsolete for all except artists' prints. New developments in offset lithography during the past four decades have also made traditional relief letterpress printing obsolete, and almost all books (including this one) are now printed by offset.

Instead of drawing directly on the stone, the artist can use transfer paper. This is a sheet of paper that has been covered with a soluble surface layer. The artist

92 Edouard Manet, *Under
the lamp*, 1875. Wash
lithograph (greatly
reduced). This is one of a
set of illustrations to Edgar
Allan Poe's poem, *The
Raven*.

draws on this surface with a greasy medium; the transferring is done by placing
the paper face downwards on the stone and moistening it until the soluble layer
dissolves and leaves the greasy drawing adhering to the stone. Prepared transfer
paper can be purchased with various grains and textures. Its advantages are in
ease of transport and the fact that the image is automatically reversed so that the
final result is in the original direction; moreover the transferred image can easily
be reworked on the stone. But the disadvantages are serious; the stone allows
much more varied styles of drawing than the paper, and some of the image is
always lost in the transfer. A transfer lithograph can usually be distinguished
from one drawn directly on the stone by the loss of definition and the tell-tale
reproduction of the grain of the paper on which it was drawn.

A further use of transfer paper is that a relief or intaglio print can be printed
onto it in a special greasy ink and then be transferred from the paper to a stone.
This was much used from about 1850 for commercial printing (and by one ori-
ginal artist, Rodolphe Bresdin), and explains how, for example, an engraving can
appear to be lithographically printed. This technique can also be used to transfer
a lithographic image onto several printing surfaces in order to speed printing;
this was done for Daumier's caricatures for the newspaper *Le Charivari*.

A lithograph has no plate-mark of the sort shown in an intaglio print, but the area which has been flattened in the press can sometimes be made out. The ink lies flat on the paper and can often be seen under magnification to be broken. A lithograph cannot really be confused with any print produced by one of the non-photomechanical processes, but can very easily be confused with a photolithograph. They can also look very like drawings.

Lithographic stones or plates in general yield a fairly large number of impressions without deterioration, but much depends on the quality of the surface, the method of drawing, the delicacy of the work and the skill of the printer. An image with little tonal contrast can be printed indefinitely. Stones are normally reused by grinding down the surface and removing all trace of the previous image.

HISTORICAL When lithography was invented in 1798 in Munich by Alois Senefelder, it was the first entirely new printing process since the discovery of intaglio in the fifteenth century. Senefelder himself originally developed it as a means of printing music more cheaply than by engraving, but, realizing its potential for other uses, went into business with various partners to operate lithographic presses in the capitals of Europe. The full commercial impact of lithography was, however, delayed for twenty years, partly through Senefelder's lack of business acumen, and partly because of the numerous technical difficulties which had to be overcome. In these early years there is little to be found in France, and in England only the interesting series entitled *Specimens of Polyautography*, containing lithographs by many well-known artists of the day, which lasted only from 1803 to 1807. The main centre of lithography was naturally in Germany; it was there used in several weighty publications reproducing drawings and paintings in public and private collections as well as for original prints by such leading artists as Karl Friedrich Schinkel and Ferdinand Olivier, whose set of *Seven Places in Salzburg and Berchtesgaden Arranged According to the Seven Days of the Week* of 1823 is one of the masterpieces of the medium.

In France a landmark was the move by Godefroy Engelmann of his press from Mulhouse to Paris in 1816. He and others so improved the technology over the following decade that even the Germans had to go to Paris to learn the new techniques. As a result lithography was soon taken up enthusiastically by many leading French artists, so much so that by the middle of the 1820s great masterpieces were being made by Théodore Géricault and Eugène Delacroix. A parallel growth of interest in England followed Charles Hullmandel's establishment of his own printing shop in 1818, and it was in fact Hullmandel who printed Géricault's so-called *English Set* in London in 1820.

The enormous production of lithographs in this period falls into several well-defined categories. Most important was the topographical tradition. In France a new school of romantic landscape lithographers such as R. P. Bonington, Eugène Isabey and Paul Huet, grew up around the vast publication of Baron Taylor, the *Voyages Pittoresques et Romantiques dans l'Ancienne France*, which began in 1820 and was not abandoned until 1878, while in England lithography supplanted

aquatint as the preferred medium for large colour-plate books. In France the other main traditions were of scenes from the Napoleonic legend (by Carle and Horace Vernet, Nicolas Charlet and Auguste Raffet), social and political satire (by Gavarni and Honoré Daumier), and the flourishing academic school of reproductive lithographers who provided the staple fare for the lithography section of each annual Salon.

In the rest of Europe lithography flourished less spectacularly. Two remarkable artists however must be mentioned. The first is Goya, who, having made a few experiments in Madrid in 1819, returned to lithography in 1825 at the age of seventy-nine, when in exile in Bordeaux, where he produced the famous set of four scenes of bull-fights known as the *Bulls of Bordeaux*. The other is the great German painter and illustrator Adolf Menzel (1815-1905), some of whose chalk and wash lithographs make remarkable use of scratching out from dark to light in similar manner to mezzotint.

In France and in Britain the impetus that lithography had received in the 1820s had begun to languish by the middle of the century; in the commercial field it was rapidly gaining an unassailable pre-eminence, but few artists were paying it much attention. The most interesting of these was the isolated and eccentric Rodolphe Bresdin, who meticulously drew on the stone in the same way as he drew on paper. An abortive attempt in 1862 by the publisher Cadart to produce a portfolio by several artists inspired Edouard Manet to make a handful of superb prints, but it was not until the 1870s that the main revival really began, when Henri Fantin-Latour and then Odilon Redon turned to lithography. The extraordinary popularity of colour lithography in the 1890s, which is described in the section on colour printing, had a different origin in the sudden fashion for posters; it also indirectly inspired a further interest in black-and-white lithography among artists like Camille Pissarro and Edgar Degas. In this period the best-known lithographs in England were by Whistler, although most of them were drawn on transfer paper rather than directly on the stone. This practice was indirectly to lead to a celebrated and absurd libel action, when Whistler's associate Joseph Pennell sued Sickert for denying that transfer lithographs were really lithographs.

In the years around the turn of the century the most interesting European lithographs were made by Edvard Munch and the German Expressionists. The members of Die Brücke, led by E. L. Kirchner, hand-printed their plates to produce a range of most unconventional and exciting textures and effects that any professional printer would simply have dismissed as incompetent printing. In the years between the two World Wars the Americans took up lithography with enthusiasm, and produced something quite new. The best were by George Bellows (1882-1925), whose mastery of chalk and wash has rarely been equalled. His subjects cover a remarkably wide range, from dynamic boxing fights to gruesome madhouse scenes and humorous, almost satirical, depictions of aspects of American life. The concentration on the American scene, and the strong feeling that lithography, being cheap, was the democratic medium *par excellence* led

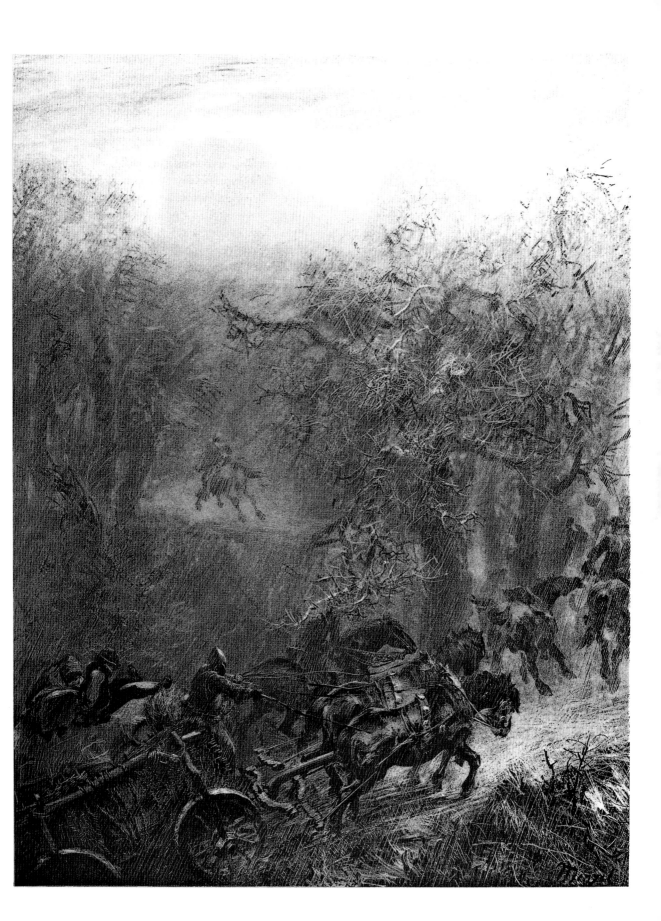

many artists to take it up in the 1930s, not just the Regionalists around Thomas Hart Benton, but also the Mexicans led by Diego Rivera.

Since the Second World War lithography has experienced its greatest popularity since the 1820s. Picasso led the way with a series of splendid lithographs printed by Mourlot in Paris from 1945 onwards, and dealers were soon commissioning more from all the leading European artists. In America several specialist lithographic workshops were founded, notably Universal Limited Art Editions, established by Tatyana Grossman in New York in 1957, while in California in 1960 June Wayne set up the influential Tamarind Workshop, where a generation of master printers was trained, among them Ken Tyler who was one of the founders of the Gemini Press in Los Angeles in 1965. Some of the leading American painters, in particular Jasper Johns and Robert Rauschenberg, made many original and very successful prints from the 1960s onwards, and inspired a lithographic fervour. Similar efforts in Britain were centred on the Curwen Studio, where many artists of the 1960s worked.

95 Ernst Ludwig Kirchner, *Hugo lying at table*, 1915. Chalk lithograph (greatly reduced).

Screenprinting

TECHNIQUE Screenprinting is a variety of stencil printing. A fine-mesh screen, fixed tautly onto a rectangular wooden frame, is laid directly on top of a sheet of paper. Printing ink is spread over the upper side of the mesh and forced through it with a squeegee (a rubber blade) so that the ink transfers to the paper on the other side. The material of the screen is usually silk (Americans call the process silkscreen or occasionally serigraphy), but can be cotton, nylon or a metal mesh.

The design is applied to the screen in various ways. The earliest technique was simply to cut out a masking stencil of paper and attach it to the underside of the screen. Another simple device is to paint out areas of the screen with a liquid that sets and blocks the holes in the mesh; but there are numerous other ways of masking that can be used to produce different effects. One important development is the use of photo-stencils, which allow the artist to incorporate photographic images into the print. The screen is coated with bichromated gelatine and placed in contact with a photographic negative or diapositive. Light is then shone through the transparency onto the gelatine, which hardens under exposure but remains soft where protected by the black areas of the transparency. When the exposure is completed, the soft areas can be washed away with warm water, leaving the hard exposed gelatine to act as a stencil.

Artists' screenprints have almost always been printed in colour. Since a single screen cannot easily be inked in more than one colour, this is usually done by successive printings, using a different screen for each colour.

A screenprint can occasionally be distinguished from a lithograph (the process most similar to it) by the mesh of the screen which is impressed into the surface of the ink. More usually it is the heavy deposit of ink through the screen that allows the build-up of flat areas of unmodulated colour. Compared with other printing processes, it is relatively crude, since the mesh of the screen does not allow much fineness in drawing or permit much in the way of tonal gradations. This has been overcome to some extent by using photo-stencils, which break down images photographically by means of a half-tone screen (see pp.122-3) into gradations of tone, or by using a multiplicity of stencils.

HISTORICAL The origins of screenprinting lie in the history of commercial printing. Stencils have been used from ancient times for lettering and for labelling objects, but the technique of attaching them to a gauze mesh seems to have been developed in Japan and brought from there to America. Recent research has

discovered that Charles Nelson Jones of Ann Arbor, Michigan, patented a process that contains all the essential elements of modern screenprinting in 1887. It was rapidly taken on for use in advertising, packaging and labelling, and machines were devised for high-speed printing through stencils. The photostencil process came into use around 1916.

Given such humble origins and the relative crudity of the images it produced, it was not surprising that artists did not immediately think of exploiting screenprinting for their own purposes. The earliest attempts at artistic screenprints were made in America in the Depression of the 1930s largely because of the cheapness and ease of the process. Attractive colour prints could be made and sold for only a few dollars. A further boost was given when a unit was set up under Anthony Velonis as part of the Works Progress Administration's Federal Arts Project for artists in New York. A recent study has calculated that at least 213 artists made over 1,600 screenprints in the United States during the 1930s and 1940s under the WPA scheme.

The 1950s marked something of a hiatus in the history of the medium. With the exception of the politically inspired screenprints of Ben Shahn and the abstract expressionist photoscreenprints of Jackson Pollock, it was not until the 1960s that it was again taken up with real interest by a large number of artists, but this time not only in America but in Europe as well, where it had been first introduced in the 1940s by travelling shows from America. The ability of screenprint to incorporate photographically derived images caused considerable agonizing among many collectors and curators, who could not convince themselves that prints that depended on photography deserved to be included among artistic printmaking processes, which had traditionally always depended on the artist's hand. This prejudice, which was always more evident in Europe than in America, only began to break down when it became clear that many of the best modern prints were screenprints. Since then it has been generally recognized that attempts to prescribe the boundaries of artistic printmaking were doomed to failure.

The rise of the screenprint in Britain is closely connected with Christopher Prater and his Kelpra Studio in London. A project by the Institute of Contemporary Arts in 1962 to commission screenprints from many of the leading British artists succeeded beyond all expectation and fired the enthusiasm of, most notably, Eduardo Paolozzi (see colour plate 12), Richard Hamilton and an American expatriate, R. B. Kitaj. Many of the leading American Pop artists, including Andy Warhol and Roy Lichtenstein, seized on the technique as it gave them precisely the context that they wanted to effect their modifications of conventional imagery. Warhol and Robert Rauschenberg in fact extended its use by printing screenprint elements onto canvas as the basis for many of their paintings.

One of the most surprising aspects of modern screenprinting is how a medium that at first sight appears to have few possibilities has in fact turned out to have many. The fact that it can print flat, unmodulated and sharply defined areas of colour has attracted hard-edged abstractionists. The possibility of incorporating

photographic imagery has proved ideally suited to the Pop artists' and others' preoccupation with the psychological and aesthetic aspects of standard commercial or political imagery. By using screenprinting, itself a commercial medium, they have managed to capture the rawness of effect of the original imagery while at the same time manipulating the viewer's responses by placing it in a fine art context. Hyper-realists such as Richard Estes have used extraordinary numbers of screens, sometimes as many as sixty, to build up the effect of layers of transparent and reflective glass in their street scenes. Jasper Johns has taken the sophistication a step further and deliberately used screenprinting to imitate the effects of the other printmaking techniques.

The success of screenprinting has been only one aspect of the remarkable development and popularity of printmaking since the end of the Second World War, and it may be worth considering some of the factors which lie behind this. The traditional connoisseur's approach to prints collapsed with the market in 1929, and took with it the individual's accumulative zeal and prejudices about states, proofs and other minutiae. The post-War print has been purchased by a wider non-specialist clientèle primarily for room decoration, and has therefore

96 Anthony Velonis, *Third Avenue 'El'*, 1939. Screenprint (reduced). Velonis taught screenprinting to many of the first American artists to use the medium.

been larger and more highly coloured than its predecessors. This has opened up new fields and made prints more interesting for the painter. But all this was true in the 1950s; the special importance of prints in the 1960s was due to the fact that the medium was taken up by the best painters of the period, and, as is always true, it is the best artist who is the best printmaker. The reason why printmaking then became of such interest to artists lies in the reaction of the 1960s against the overwhelming success of Abstract Expressionism. To escape from its personalized gestures, artists introduced hard-edge abstraction or a wide range of figurative subject-matter, and a new preoccupation with process and the way in which the medium imposes its discipline on the subject. In this exploration the lithograph or screenprint is quite as significant as a medium as the painting. In consequence the status of printmaking, as a category of artistic production, was again elevated and attained a renewed significance in the more general history of art.

1 left Anonymous, *The infant Christ amid flowers*, German, *c.*1460. Woodcut with contemporary hand-colouring (slightly reduced).

2 below Johann Jakob Biedermann, *View of the city of Bern* (detail), *c.*1800. Hand colouring over an etched outline (actual size).

3 right Ugo da Capri after Parmigianino, *Diogenes* (detail), *c*.1527 - 30. Chiaroscuro woodcut printed from four blocks (reduced).

4 below Hendrik Goltzius (?), *An Arcadian landscape*, 1580s. Chiaroscuro woodcut printed from three blocks (greatly reduced). The traditional attribution to Goltzius has been rejected by most scholars in recent years.

5 opposite top John Baptist Jackson after Marco Ricci, *Landscape with an obelisk* (detail), 1744. Colour woodcut printed from perhaps six blocks (reduced).

6 opposite below George Baxter, *The Belgian section in the Great Exhibition of 1851* (detail), 1852. Printed from one intaglio plate and ten woodblocks (reduced).

7 John Jones after George Romney, *Serena*, 1790. Stipple
printed with colour applied to the plate *à la poupée* (greatly
reduced). See **71** for an enlarged detail of an uncoloured
impression.

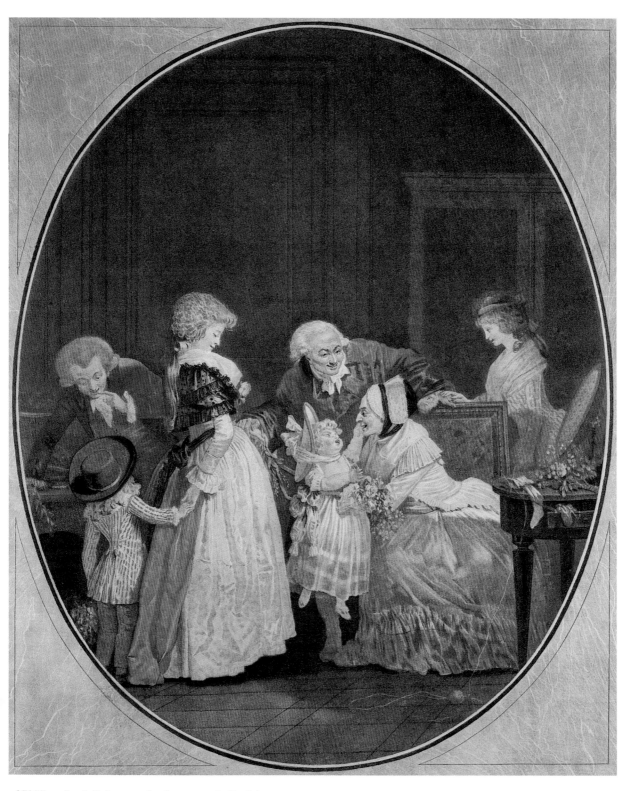

8 Philibert-Louis Debucourt, *Les Bouquets ou la fête de la grand-maman*, 1788 (reduced). Printed in colours from four plates engraved with roulettes, etc; the effect is similar to aquatint. The children are presenting bouquets to their grandmother on her birthday.

9 opposite Jakob Christoph Le Blon after van Dyck, *Self-portrait*, 1720s. Mezzotint printed from three plates (greatly reduced).

10 right Thomas Shotter Boys, *Notre Dame, Paris* (detail), 1839. Colour lithograph (greatly reduced).

11 below Pierre Bonnard, *Coin de rue,* 1895. Colour lithograph (greatly reduced). © ADAGP, Paris and DACS, London 2016.

12 Eduardo Paolozzi,
Metalization of a dream, 1963.
Screenprint (greatly reduced).
© Trustees of the Paolozzi
Foundation, Licensed by DACS
2016.

Colour Printing

There is an important distinction to be drawn between *colour* prints and *coloured* prints. A colour print has actually been printed with inks of different colours; a coloured print is printed in ink of one colour and has extra colouring added by hand. This chapter is mainly devoted to colour prints, and since the techniques of colour printing are dependent upon the printing method employed, they are described under the categories of relief, intaglio and planographic. Colour screenprints have already been discussed in the section devoted to screenprinting.

In the history of printmaking hand-coloured prints have greatly outnumbered prints actually printed in colour, and it is worth introducing this chapter with a note on this subject. Since colour now has a more ready market than black and white, many old prints have during the past century been coloured by dealers before being offered for sale to the public. This practice has dismembered thousands of books and ruined many fine prints, and is indefensible because it destroys the tonal balance of black and white with which the print was conceived. There were however certain classes of print that were regularly coloured before or soon after publication, and these can be described briefly.

Fifteenth-century single-sheet woodcuts (though rarely engravings) were often coloured; this suited their function as images of popular piety and devotion whereas engravings were aimed at a more sophisticated market (see colour plate 1). Similarly, many fifteenth-century northern European illustrated books were hand-coloured: for example, documents show that the publishers of Hartmann Schedel's *Liber Cronicarum* (Nuremberg 1493) distributed both plain and coloured copies to their retailers. Colouring in this period was sometimes done through specially cut stencils, which can often be recognized by a contour which is out of register with the lines of the design.

Although the more popular woodcuts were still coloured, in the later sixteenth and seventeenth centuries fine prints (which were usually intaglio prints) were rarely coloured. The major exceptions are certain categories of books, such as botanical and zoological works, in which most of the scientifically essential information could be conveyed only through colour. The same was true with maps and atlases.

The situation changed considerably in the second half of the eighteenth century. One entirely new use of colouring was devised. The popularity of large watercolour views and the practice of making replicas of successful compositions

gave some watercolourists the idea of saving time and trouble by making their watercolours over lightly etched outlines. This process was developed in Switzerland by J. L. Aberli, who took out a patent for the method in 1766, and soon an entire school of watercolourists was turning out views in the thousands for the tourists who were then discovering the beauties of the country (see colour plate 2). From Switzerland it was taken to Rome by Abraham Ducros who set up in partnership with Giovanni Volpato; their success inspired imitations from the French artist L. J. Desprez, who worked with Francesco Piranesi, the son of Giovanni Battista. The method was also later occasionally practised in Britain and elsewhere.

More traditional types of hand-colouring also returned to favour. Their most widespread use was made in England, where categories of prints such as satires and many single-sheet topographical views, especially optical views (see glossary) were regularly sold already coloured. Aquatints especially lent themselves to colouring, and the development of that characteristically English phenomenon, the colour-plate book, was based on the existence and capabilities of teams of trained colourists. The colourists were often helped by printing the aquatint plates in two colours, *à la poupée* (see p.118): the skies and distances were printed in pale green/greenish-blue, while the foregrounds were in brown. The fashion for colour-plate books lasted into the nineteenth century, when lithography was used as well as aquatint to supply the underlying design, but petered out in the 1830s. The Victorians loved colour, but their publications were, instead of being hand-coloured, almost invariably printed in colours lithographically.

A coloured print may readily be distinguished from a colour print. Under a magnifying glass it will be seen that the lines of ink of a colour print are themselves coloured, while white paper may be seen between them. In a coloured print the printed lines will usually be in a different colour from the overlying brushed wash which will stain the areas of unprinted paper. It should, however, be noted that prints printed in colours were very often given extra finishing touches of hand-colouring.

A more difficult problem is to distinguish modern from original hand-colouring. Sometimes the identification of the class of print will answer the question. Topographical prints extracted from books (the largest class of coloured print now on the market) are very unlikely to have been coloured at the time if they are engraved or etched. It was only aquatinted or lithographed plates that were normally coloured. Nineteenth-century steel-engraved English topographical views in books were never issued already coloured. Non-topographical prints (botanical, zoological and other scientific subjects) were often published already coloured in books, and judgement here is much more difficult. A few rules of thumb may be given. Eighteenth-century original colouring is usually bold and gaudy and applied in a slapdash manner. It is often opaque and completely obscures the lines of the design; modern colouring on such prints, being invariably in watercolour, never does this, and tends to be more carefully applied, with the result that it usually looks timid and anaemic.

In cases of doubt, some familiarity with genuine examples is usually (though not always) enough to settle the question.

Colour Woodcut

It is unusual in the European tradition (as opposed to the Japanese) to ink a woodblock in more than one colour. Normally as many blocks are used as there are colours, except in so far as a third colour is created by overprinting two colours. The usual method is to make a *key-block* with the design in outline. The artist then colours impressions from this by hand, each with one of the colours required in the final design. These sheets are pasted onto other blocks, and the woodcutter cuts away all the non-printing areas. Each block can then be inked in its appropriate colour and printed successively on one sheet of paper; the outline ('key') is usually printed last so that the lines sit above the colour and are not obliterated by it. In this operation great care has to be taken that each block prints in register with the others.

There are various ways in which the artist can handle the colour woodcut. The most obvious perhaps is the way of the Japanese; areas of pure colour are juxtaposed with extraordinary decorative effect. It is curious that this method of full-colour printing was hardly practised in Europe before the discovery of the Japanese print in the later nineteenth century led to western imitations. The standard traditional type of western woodcut, often known as a 'chiaroscuro' woodcut, was produced in imitation of a monochrome drawing made on tinted paper and heightened with white bodycolour. The inks were shades of the same colour, and for this reason the term 'tone-block' rather than 'colour-block' is usually used when describing them. The blocks were cut in such a way that areas of white paper were left amid surrounding colour in imitation of the effect of white heightening in bodycolour on the drawing.

One of the earliest uses of colour in woodcuts is found in some books printed by Erhard Ratdolt in Venice and Augsburg between 1482 and 1494. The first single-sheet colour woodcuts were made in Germany as the result of rivalry between two princes: Emperor Maximilian, who employed Hans Burgkmair in Augsburg, and the Duke of Saxony, whose court artist was Lucas Cranach. The steps by which they developed the colour woodcut from 1507 can still be retraced (despite Cranach's attempts to claim priority by putting a false date on one print), and by 1510 they had developed this into the true chiaroscuro technique in which the white highlights are cut out of the tone-block. The technique enjoyed a brief spell of popularity in the North in the work of Hans Baldung Grien, Hans Wechtlin and others, and spread from Germany to the Netherlands. In the 1580s and 1590s Hendrik Goltzius revived it in his self-conscious way, and it was sporadically used in the seventeenth century by Ludolph Businck in Paris, Christoffel Jegher (two of whose woodcuts after Rubens had colour-blocks added) and a few others (see colour plate 4).

The new technique found much greater popularity in Italy, where tradition

long held (wrongly) that Ugo da Carpi had invented it. He does seem to have been the first Italian to have practised it, and petitioned the Venetian Signoria for a copyright in 1516. Whereas the Germans had tended to use the tone-blocks as decorative adjuncts to a design already completely defined by the key-block, the Italians were bolder and so limited the key-block that the design would be unreadable without the addition of tone-blocks. By this device the medium could be used to make a convincing facsimile of a wash drawing which made little use of line (see colour plate 3).

The chiaroscuro woodcut was used as a means of dissemination by many of the leading Italian artists, starting with Raphael. In the same way as he had used Marcantonio to engrave his line drawings, he used Ugo da Carpi to turn his wash drawings into chiaroscuri. In this he was followed most notably by Parmigianino, who employed Antonio da Trento. An outstanding exception was Domenico Beccafumi from Siena, whose large woodcuts are so different from the tradition that scholars have often thought that he must have cut them himself. The technique enjoyed another spell of popularity in the late sixteenth and early seventeenth centuries, when Andrea Andreani not only made many blocks himself, but acquired and reprinted many of those made by his predecessors.

In the 1720s the technique was revived in Venice in an antiquarian spirit by Count Antonio Maria Zanetti; when he had visited London he had been amazed at the value that British collectors attached to chiaroscuri, and decided to reproduce various Parmigianino drawings which he had acquired. At the same time it was used in Paris by Nicolas Le Sueur for a few plates of reproductions of drawings which were published in the so-called 'Cabinet Crozat'. But the most original prints of all were made by the Englishman John Baptist Jackson (*c*.1701–*c*.1773). He went to Paris, learning everything he could about what was being done there, before making his way to Venice where he made a set of large landscape prints in 1745. These are not in the manner of drawings, but of highly coloured gouaches, and so are handled quite differently from Zanetti's prints. They are true colour woodcuts, with areas of strong colour built up with heavy relief from as many as six blocks (see colour plate 5).

Woodcut tone-blocks could also be used to supply colour to a design printed by some other method. This can already be found in the sixteenth century when blocks were occasionally printed over etched outlines, and became quite popular in the eighteenth century as a method of making facsimiles of old master drawings. It seems to have been popularized in England in 1722-4 by Elisha Kirkall, who printed the woodblocks over a mezzotint foundation, though his English followers, Pond and Knapton, preferred to stick to an etched foundation. The same procedure was used to quite a different effect in the nineteenth century when George Baxter and his licensees built up their highly coloured miniature paintings from numerous woodblocks printed over an engraved or etched foundation (see colour plate 6). Edmund Evans, in his famous series of children's books illustrated by such artists as Kate Greenaway, used blocks to print flat tints of colour over a wood-engraved design.

The vogue for Japanese woodcuts in the late nineteenth century attracted renewed attention to the medium and showed artists that it was not necessary to confine the use of the technique to reproducing drawings. The first to realize this was Paul Gauguin, but the most extraordinary technique was developed by Edvard Munch in the 1890s. He began by using whole planks of pine scraped down with a blade or a wire brush to emphasize the grain to print richly textured backgrounds. He then cut a single block into pieces around the main shapes of the design, which he coloured separately and rejoined for printing. Such colour woodcuts were often experimentally overprinted lithographically with other colours to produce a new range of effects.

When Picasso took up linocut in the late 1950s, he adopted and popularized another way of making a colour relief print. This is sometimes known as the 'reduce block' method, and involves successive printings from the same block onto one sheet. The lightest tones are printed first, then these areas are cut away before printing the middle tones (which will overprint and obliterate some of the lighter areas); finally the block is still further reduced and the darkest colours printed. This process may of course be repeated indefinitely as long as each new colour is sufficiently opaque to cover the previous colours.

Colour Intaglio Printing

There are two traditional ways of colour printing from intaglio plates. Either a single plate is selectively inked in different colours, or the image is built up from separate plates for each colour.

The first method is often called by its French name, *à la poupée*. It requires very considerable skill and artistry on the part of the printer, who has to press the ink into the lines of the plate using stumps of rag (a 'dolly', or *poupée*), and then wipe the surface, taking extreme care not to smudge the colours. No two impressions printed in this way can be expected to be exactly similar, and such prints were usually retouched by hand.

The second method using multiple plates is less reliant on the skill of the printer, but is more time-consuming both in the preparation of the plates and in the repeated printing operations. Exact registration of the plates is essential, both in making them and in printing from them. One method of securing this is to drill holes in the same position on each plate and line up plates and paper with pins; the round marks, either white or black, from these holes are often visible embossed on colour intaglio prints and are a certain indication of the multiple-plate method.

A third method of colour printing which uses inks of different viscosities was developed by Stanley William Hayter in Paris in the 1950s. Inks of varying viscosity will not settle if applied one above another, and this discovery can be used to print in more than one colour from a single plate bitten to different depths (see his book, *New Ways of Gravure*, London 1966).

PRINTING *À LA POUPÉE* The earliest sort of colour printing involved inking plates in a monochrome but coloured (i.e. not brown or black) ink, or printing plates onto a sheet of coloured paper. Examples of this occur sporadically through the history of intaglio printmaking, the best-known being the etchings of Segers. Etched and engraved plates however look very odd if the lines are inked in different colours, and the only artist who is known for such experiments is Joannes Teyler of Haarlem, who lived in the late seventeenth century. The technique is also found in a few natural history works with etched plates.

The full development of colour printing had to await the invention of the tonal processes. As developed in France it was closely tied to the multiple-plate method, but Britain became the home of single-plate colour printing. Some very early, though very simple, examples can be found in some mezzotints of the 1720s by Elisha Kirkall. Printing in a much wider range of colours seems to have been invented by Robert Laurie, who won a prize for it in 1776. The process rapidly became very fashionable, and was frequently used with stipple and mezzotint plates through to the early nineteenth century. The standard editions of these plates were usually printed in monochrome (the stipples often in sepia), but a number of impressions were also run off in colours, and sold at much higher prices. Such prints were intended more for framing than the collector's portfolio; the favourite subjects were 'fancy', pastoral or agricultural (see colour plate 7). Publishers seem also to have resorted to colour printing as a way of disguising wear in a mezzotint plate which would be more obvious in monochrome. This was often done in nineteenth-century reprints of earlier plates. Colouring *à la poupée* is occasionally found on the Continent, in French stipples, and on a few closely worked etchings by Francesco Piranesi in Rome.

MULTIPLE-PLATE PRINTING If we ignore a few rare prints by Abraham Bosse and François Perrier in seventeenth-century France, in which etchings on coloured paper are overprinted in white ink, the earliest multiple-plate method, using plates worked in mezzotint, was invented by the German Jakob Cristof Le Blon (1667-1741). Anticipating the discovery of the three primary colours, which was only theoretically worked out long after his death, he tried to produce facsimiles of oil paintings by scraping a separate mezzotint plate for each of the three printing inks he needed (they should have been cyan, magenta and yellow, but in fact were nearer blue, red and yellow, see colour plate 9). Le Blon's prints never really succeeded, partly because of the impurities and opacities of the pigments in his printing inks, and partly because of his inability to produce efficient colour separation plates using his eye (it is now done by filters). He later adopted a fourth plate for black, and in this anticipated the solution to the problem of opacity used in modern four-colour printing. The company Le Blon founded in London to exploit the process in 1720 went bankrupt in 1732, and he spent the last years of his life in France, where he obtained a patent from Louis XV. After his death a new patent was issued to his former assistant Jacques Gautier d'Agoty, and members of the d'Agoty family continued

using the technique to the end of the eighteenth century. Although none of their prints, with the possible exception of a set of lurid anatomical plates, are much more than curiosities, they do seem to have been responsible for implanting the tradition of multiple-plate colour printing firmly in France, even though later artists never tried to build up a full range of colours from three or four plates, but instead used whatever pigments they needed on separate plates.

A renewed interest in colour printing followed the development of the many new printmaking techniques in the mid-eighteenth century. The earliest was the so-called 'pastel-manner'; this was simply an adaptation of the crayon-manner for colour printing by Louis-Marin Bonnet, who announced his invention in 1769. He usually used it to imitate the effect of the then fashionable drawings made in three colour (*à trois crayons*), using a different plate for each of the three colours of chalk (red, blue and white). In one famous print, the *Tête de Flore* after a multi-coloured pastel of Boucher, he went much further and used as many as eight plates on a tinted paper to recreate the effect. Bonnet was followed by Gilles Demarteau, but the process fell out of fashion with the eclipse of crayon-manner at the end of the century.

The invention of aquatint and a variety of aquatint-like processes in the 1760s inevitably led to attempts to harness these techniques to colour printing, and the great masterpieces of French colour printing were in fact made by these methods. The pioneer was Jean-François Janinet, a pupil of Bonnet, in the 1770s; he used it to reproduce, not chalk drawings, but watercolours and gouaches, and the flat, crisply defined areas of colour that aquatint gives proved ideal for this. The greatest master of the technique was, however, Philibert Louis Debucourt (1755-1832), one of the most gifted engravers of all time. The fifty-six prints of his best years between 1785 and 1800 are all after his own designs, and give a wonderful view of the closing years of the *ancien régime* and the period of the Directory (see colour plate 8). He seems to have used at least ten different methods, most of which involved three colour plates (magenta/red, cyan/blue and yellow) with a fourth plate giving the key design printed on top in black. A similar technical virtuosity was shown by the wealthy Dutch amateur Ploos van Amstel (1726-98), who made a series of forty-six facsimiles of old master drawings, mostly in his own collection, in the years up to 1787. The basis of his plates was mezzotint, but he added soft-ground, roulette and every other technique known to him to build up prints of a virtuosity that is still astonishing.

Multi-plate colour printing fell into disuse after 1830, but was revived in 1891 by Mary Cassatt in a famous set of ten plates 'in imitation of Japanese methods'. With the popularity of colour prints in general in the years around 1900, colour aquatint was much used again, both by professional reproductive engravers of classic works of the eighteenth century, and by original artists such as Jacques Villon.

Colour Lithography

Since a stone, like a woodblock, can only be inked easily with one colour, colour lithography usually employs as many stones as colours, although extra colours can be created by overprinting. The artist usually first makes a preliminary sketch of the composition, and from this draws the outline of the design onto a key-stone. Impressions pulled from this stone serve to transfer the image to the colour-stones, on which the areas of each colour are drawn in. Finally the stones are inked with the desired colours, and are successively printed onto the one sheet of paper. Great care is needed both in the order of printing the colours and in the exact registration of the paper on the stones. This is often done by sticking a pin through the paper and inserting it into holes drilled at the same point in each stone. Such pin-holes can often be seen in the margins of colour lithographs.

The earliest use of a second stone in lithography was to supply a background colour; this was called a tint-stone and had the highlights scratched out. Full colour lithography came later. In 1837 Engelmann was granted a French patent for a process which worked on Le Blon's principle and used three stones (sometimes with a fourth black stone) to build up a picture in the full spectrum of colours. More effective and influential was the much simpler method of Hullmandel in London, who matched each colour in the original with a different stone. His first great work was Thomas Shotter Boys' *Picturesque Architecture in Paris, Ghent, Antwerp, Rouen*, published in 1839 (see colour plate 10). The high Victorian period saw a great flood of colour lithographs, reproductive in intention, mainly for book illustrations or handsome portfolios. When sufficiently colourful, these were called chromolithographs and were printed with immense skill: a design of apparently eight or ten colours will often be printed from no less than twenty stones. 'Chromolithograph' only began to be a term of abuse when, in the 1890s, a group of young French artists were inspired by Japanese prints to make colour lithographs using flat tints with a superbly decorative sense of design. The great masters of this were Henri de Toulouse-Lautrec, Edouard Vuillard and Pierre Bonnard (see colour plate 11), and the impetus for their interest in the medium was given by the popular success of the large commercial posters of Jules Chéret.

Since the turn of the nineteenth century most artists who have turned to lithography have as readily made colour as black-and-white prints, and as a result colour lithography ceases to have a separate history.

Photomechanical Reproduction Processes

William Henry Fox Talbot invented the Talbotype in 1840, and his method of photography, which allowed any number of positives to be produced from a negative, was itself a new method of printmaking. But the process required special paper and was very slow and expensive. By its very nature it could not itself be used in book printing: photographs could only be pasted into books, or sold as objects in their own right. Photography only began to revolutionize the print trade after a way had been discovered to enable the photograph itself to be transformed into, or be used as a base for, a printing matrix that could be printed in one of the standard traditional ways. The term 'photomechanical' (or sometimes 'photochemical') is applied to the whole group of these processes.

Many of the photomechanical printing processes are based on Poitevin's discovery in 1855 of a light-sensitive material that could be used as a resist. He used yellow bichromated gelatine, but later chemists have produced other materials. They have in common the property of hardening when exposed to light, but where shielded from light (as occurs behind the black portions of a negative) remaining soft. The soft areas can then be washed away in water, leaving the hard areas to act as a resist so that the plate can be bitten with a mordant. The other development crucial to many of the processes was the creation of a half-tone screen, which can break up a continuous tonal image into an array of discontinuous dots. There were numerous technical problems in applying these discoveries and overcoming all the practical problems of production, and it was not until the 1890s that photomechanical processes finally ousted the traditional hand processes of engraving and wood-engraving for all except artists' prints.

Processes of Relief Printing

LINE-BLOCKS The method of block making that remained standard from the 1880s to the 1950s was developed from the gillotage process (see glossary). A zinc plate is coated with bichromated albumen or some other light-sensitive material such as bichromated fishglue. This is exposed to light under a high-contrast negative of the original artwork; the plate is then rolled over with ink and the soft unexposed fishglue washed away leaving a layer which is dried and baked to form a resist. The plate is next inked, dusted with a powder which adheres only to the tacky ink, and given a light etch. The photo-engraver now has to go through a complicated and laborious process to etch away the

background of the plate so as to leave the lines of the design standing in relief. This involves 'four-way powdering', with resist powder being brushed against one side of the lines so as to protect them against being eaten away by the acid. After heating to fuse the powder, the powdering is repeated in another direction, again followed by heating. After this operation has protected the lines in all four directions, the plate is etched. This powdering and etching process is repeated as many times as is necessary to produce sufficiently deep and clear lines. The plate is finally cleaned and if necessary can be retouched manually. It can be used for printing in any relief printing press, which means that it can be printed together with type. This traditional process was superseded in the 1950s by electronic scanners and automatic etching machines. The latter too have now become redundant in the face of the triumph of digital scanners.

The line-block was immensely successful, but was always limited in that it could only reproduce line or granular originals. Printing only lines, it could not handle transitions of tone. For these, the half-tone block had to be used.

The appearance of a line-block varies depending on what original is being reproduced. It can reproduce the lines of a drawing as well as those of a woodcut. When it has been used to make a facsimile of a woodcut or wood-engraving, comparison with an original will show that the reproduction has a greater hardness of line, and often tidies up the original. There is often some loss in quality: fine black lines may be lost, and fine white lines filled in. Doubtful cases will almost always be settled by examining the paper: a sixteenth-century woodcut on nineteenth-century paper implies a line-block.

HALF-TONE BLOCKS The half-tone block is simply an adaptation of the line-block which is used in cases where the original to be reproduced shows transitions of tone through a range of greys. The procedure adopted is to photograph the original photograph or art-work through a cross-line screen of parallel horizontal and vertical lines in order to produce a negative. This is composed of an array of dots of larger or smaller size depending on the depth of tone in the original. The purpose of this procedure is to break up a tonal original into a series of black dots so that it can be used to make a block in the same way as with a line-block. The dots are so small that they are individually invisible to the human eye, except under magnification, but yet are perceived as solid blacks or varying greys, in the same way as the eye perceives the lines on an analogue television screen as a continuous tonal image.

97 Ten times enlargement showing the dots of a half-tone.

Half-tone relief blocks had one complication. It will be obvious that the closer the mesh of lines in the screen, the greater will be the accuracy of detail. But if a fine screen is used, the resulting dots are so small that the blocks become more difficult to etch, and cannot be printed unless the paper is as smooth as possible. This explains why newspapers, which have to print on coarse newsprint, were forced to use wide-mesh screens, while the high-quality plates in books were printed on a special glossy chalk-coated 'art' paper. Since this was more expensive, plates used to be blocked together in separate sections of books.

All this however is now past history, and half-tone offset lithography – the method used to illustrate this book – does not labour under the same disadvantages. Indeed the fact that offset can be used on less smooth, and hence cheaper, papers is one of the reasons why it has now gained a commercial advantage.

A half-tone print is always easy to recognize; under a magnifying glass the grid of dots of varying size will be seen.

The line-block was developed in the 1870s and was an effective commercial process from about 1880. By the 1890s it was so well established that an artist like Aubrey Beardsley was producing pen and black ink drawings designed specifically to be reproduced as line-blocks. The idea of using a screen has a long pre-history reaching back to Fox Talbot in 1852, but the first commercially successful use was patented in Germany and Britain in 1882 by Georg Meisenbach. With various later improvements, the process by 1890 was substantially as described above. Because line and half-tone relief blocks can be printed together with relief type, they account for the great majority of book illustrations from the 1880s to the 1960s.

Processes of Intaglio Printing

Note: The two processes described here are sometimes both called photogravure; this causes confusion as their appearance and method of production is very different.

HAND PHOTOGRAVURE An early version of hand photogravure was used to reproduce line rather than tonal originals. A layer of bichromated gelatine laminated to a copper plate is placed in contact with a photographic positive plate and exposed to light; in the exposed areas the gelatine becomes hard, in the unexposed areas it remains soft. The soft gelatine in the unexposed areas that were shielded from the light by the black in the positive is washed away and the plate etched, the hard gelatine acting as a resist to the acid. The etched plate is finally cleaned and is hand-inked, wiped and printed in the same way as an ordinary intaglio plate.

This process was used from the 1870s and produces the most accurate facsimiles obtainable of an engraving or an etching. Such facsimiles frequently cause problems, especially if they have been printed on old paper or otherwise doctored to give an antique appearance. If an engraving has been reproduced, there is rarely a problem: because photogravure is an etching process the character of the line is completely different. But if the original is itself an etching the reproduction can be difficult to tell apart. Sometimes it is betrayed by the discontinuous nature of the line, and the collapse of hatching in shadows. Sometimes only close comparison with an impression of the original print can answer the question. Many reproductions are identified by stamps on the verso; one frequently seen is on the facsimiles published by Amand-Durand in Paris between 1872 and 1878 (see margin, right).

A later variety of hand photogravure was used from the 1880s to reproduce

98-99 Ten times enlargement of a detail of a late sixteenth-century engraving. The top is taken from an original impression, the bottom is an enlargement of the same detail in a facsimile made by the hand photogravure process. The accuracy is remarkable, but the lines are less distinct and the effect (in the original at least) is flatter.

tonal originals, such as paintings or watercolours. In this case, the sheet of gelatine is exposed to the positive on a temporary support, such as a piece of paper, and hardens to a variable depth according to the degree of tone in the original. It is then laminated onto a copper plate which has previously been given a uniform aquatint ground. The plate is next soaked and washed in water to remove the support and the unexposed layers of gelatine, and is then bitten; the acid penetrates the copper to a varying depth which corresponds to the tone of the original. The aquatint ground serves the same purpose as the cross-line screen in machine photogravure in allowing the plate to be bitten without foul-biting, and then to be wiped without the ink spilling from one 'cell' to another.

This process was widely employed for high-quality, expensive single-sheet prints which were published in exactly the same way and by the same dealers as engravings. Since it gives very accurate reproduction of tone, it was this process that from the 1880s competed with reproductive engravers and etchers and drove them out of the market. It can easily be distinguished from other photomechanical processes since it is the only photomechanical process to leave a plate-mark, and the grain of the aquatint can always be seen under a magnifying glass. The appearance of the resulting print is quite different from traditional aquatints, which never have anything approaching the range of tones, quite apart from not originating with a photographic positive. The only problem comes if it is used to reproduce a tonal autograph print; here comparison with an original may be necessary.

Since both the method of plate making and of printing were expensive, hand photogravure had no wide commercial application outside the field of luxury facsimiles. It has hardly been used since the 1930s. The preparation and etching of the plate was a skilled business and there was considerable scope for sharpening or otherwise adjusting the final image with retouchings made with burins, roulettes and the other tools of the printmaker. The craftsman who prepared a plate often had his name engraved underneath the image, followed by the word *photosculpsit*, sometimes abbreviated to *Ph.Sc.*

In the twentieth century a few artists made original prints by reworking photogravures. One famous example is Georges Rouault's *Miserere* series of the 1920s; he had no experience of intaglio printmaking, so his publisher Vollard had his preliminary gouache drawings photo-engraved on copper plates. Rouault so disliked these that he completely reworked them and produced something entirely different.

ROTOGRAVURE (OFTEN CALLED 'GRAVURE') The process involves a photographic positive transparency, a gravure screen, and a layer of bichromated gelatine coated on a sheet of paper. First the gelatine is exposed through the screen; next it is exposed through the positive transparency. The gelatine layer is then transferred to a cylinder and the paper removed. The gelatine is then washed, so that the soft parts go and the differentially hardened ones act as a resist for the etching. After etching and cleaning, the cylinder is inked; the surplus is

wiped off the surface mechanically with a doctor blade. It is at this point that the function of the screen becomes evident: it is not like a half-tone screen, designed to capture tone. The grid prints white and does not vary intentionally in size; what varies is the depth of each square cell and thereby the amount of ink it holds, while the grid itself protects the ink from the blade and prevents it spilling from one cell to the next. In the printing the paper picks up the ink from the cavities, which is why this process is categorized as a variety of intaglio.

This process has had a very wide commercial application; in the printing industry it is referred to as gravure. Since the printing surface is a cylinder, very fast printing speeds can be obtained. The cylinders are expensive to make, but are steel-faced so that they are hard-wearing. They also print well on cheap papers. For this reason this process has normally been used for magazines and catalogues and other types of publication that have long printing runs. It is therefore unlikely ever to be used for a reproduction of a single-sheet print.

Photogravure was developed by Karl Klič in 1890 when he adapted the cross-line screen to the old hand photogravure process. He initially used it for textile printing, and began the first commercial application to printing on paper in 1895. He kept it secret, rather than patenting it, and it was reinvented by others in the years afterwards. Since the 1980s it has increasingly been replaced by offset lithography.

100 Ten times enlargement showing the grid of machine photogravure.

Processes of Surface Printing

PHOTOLITHOGRAPHY In the nineteenth century various methods of making photolithographs were used. Most were based on the discovery in 1855 of the light-sensitive properties of yellow bichromated gelatine. As in relief printing, the early methods would only produce line or granulated work, and were largely used to reproduce maps and manuscripts. The possibility of reproducing tone had to await the invention of the half-tone screen in the 1880s.

Early photolithographs are in appearance very similar to ordinary lithographs. When the process is used to make a facsimile of a lithograph, the result can be very deceptive and can only be distinguished from the original by close comparison. In the same way it will produce deceptive facsimiles of original drawings of a granular texture. Photolithographic lines and half-tone dots have softer edges and lack the sharp definition of those printed by a relief press.

In recent decades offset lithography has superseded traditional relief printing. The rubber of the offset rollers is softer than the metal plates of rotary letterpress, and so can transfer half-tone images successfully to papers that are not absolutely smooth. The results are more attractive, and save paper costs. Developments in digital composition have reinforced this advantage. They allow text and images to be integrated on the same film, so that both are transferred to the printing plate at the same time. This has allowed text and illustrations to be integrated throughout books, thus lying behind the enormous increase in the quantity of illustrations to which we have now become used. In

this environment lithography has greatly increased in importance, so much so that it has driven all the other reproductive methods described in this section out of the market for most commercial publications.

COLLOTYPE A surface (usually a sheet of heavy plate glass) is coated with bichromated gelatine and allowed to set. It is then dried with hot air, so that the surface of the gelatine reticulates. The top of each wrinkle is more sensitive to light than the sides, which allows differential hardening when the gelatine is exposed to light under a continuous-tone photographic negative. When washed and treated with glycerine, the hardest portions take most ink and least water, and vice versa for the least exposed portions. The surface can then be printed lithographically onto paper: printing ink is applied to the gelatine and is accepted in inverse proportion to the amount of moisture retained by the surface, the dry areas accepting most and printing darkest. It is this that makes collotype quite unlike the other gelatine processes. The soft gelatine is not washed away, and there is no stage when etching is involved.

A collotype can be recognized by the rich depth of tone, and the fine reticulated grain of the gelatine which wrinkles as it dries.

The first commercial collotypes were produced in 1868 in Germany by Josef Albert and in 1869 in England by Ernest Edwards. Until the introduction of the half-tone and gravure processes in the 1880s and 1890s, it was the only photomechanical process capable of reproducing tone. The making and printing of collotype plates is highly skilled and expensive work and can easily go wrong; not only are variations in humidity likely to upset the balance of moisture in the gelatine, but the surface is delicate and usually cannot produce more than a few thousand impressions. For these reasons collotype has mainly been used for single-sheet prints and luxury portfolios, and since the 1950s has been abandoned by all except a few small specialist firms. Collotype is the most accurate and attractive method of photomechanical facsimile yet invented for certain types of originals, especially watercolours and drawings. The process has also been used for reproducing prints with excellent results, although, unlike hand photogravure, it cannot give any relief to intaglio prints.

Processes of Colour Printing

The usual method of colour printing in all photomechanical processes depends on the ability of the three primary colours, magenta, yellow and cyan (often referred to as red, yellow and blue) to combine to form all other colours. A photographic negative separation of each colour is made using red, green and blue filters, and a screened half-tone negative (for letterpress and lithography) or a continuous-tone positive (for gravure) made from this is transferred by one of the processes described above to a plate. The three plates are then successively printed in the complementary colours to build up the coloured image. In modern printing a fourth plate of black is invariably added to avoid the need to have

101 Ten times enlargement showing the grain of a collotype.

too heavy a charge of ink. Effective four-colour printing was not developed before about 1920, because of the difficulty of producing sufficiently accurate photographic filters and the correct inks; the exact registration of the plates was also a problem. Since the Second World War electronic scanners have been developed, which since the 1990s have been replaced by digital scanners to produce colour separations.

A more laborious method of colour printing abandons the three- or four-colour process in favour of making specially chosen separations of colour onto as many plates as are necessary. This is in effect the same procedure as that of the nineteenth-century chromolithographer, and requires great skill and care on the part of the printer. For this reason and because the number of plates adds to the printing costs, this method has only been used in exceptional circumstances. It is most valuable for reproducing flat areas of a single colour in a gouache or suchlike original. It can give a purity and intensity of hue to which three- or four-colour printing can never aspire.

102 Jean Michel Papillon, *Flowers*, 1765. Woodcut (actual size). An example of a *cul-de-lampe* (tail-piece).

Catalogues of Prints and Books about Printmaking and the History of Prints

General print catalogues

This section is concerned with the general catalogues which cover more than one school and which are constantly referred to in the literature; the next section is concerned with catalogues that only cover a single period or school. Unfortunately, few of these catalogues are illustrated, and even fewer have anything approaching comprehensive illustrations.

The fundamental catalogue of prints was written by Adam Bartsch in twenty-one volumes, published in Vienna from 1803 to 1821. This catalogues the work of only selected printmakers active almost entirely before 1700; the title, *Le Peintre-Graveur*, a term sometimes translated as 'painter-etcher', reflects Bartsch's interest in original as opposed to reproductive prints. Volumes 1 to 5 cover Dutch and Flemish engravers, 6 to 11 the German, and 12 to 21 the Italian. Bartsch's industry and thoroughness was such that his catalogue is only superseded for parts of the Dutch, Flemish and German schools, and remains fundamental for Italian prints.

In 1978 the late Walter L. Strauss began to edit a new series, *The Illustrated Bartsch*, and a very large number of volumes have by now been published. The intention is to publish in one series a full-page reproduction of every print that Bartsch listed, and in a second parallel series a commentary volume (written by various authors) in which the prints are catalogued and discussed, and any items that Bartsch omitted are added. The volumes of illustrations are virtually complete, while only a few commentary volumes have come out. The user must be warned that as a result of the great pace of publication the illustrations are not always of the prints that they purport to be, nor always in the collections stated, and the quality of reproduction is often poor. A third series of 'supplementary' volumes give illustrations of prints that Bartsch never included: apart from volumes of a few individual printmakers (Rembrandt, Cort, Coornhert, Galle, Denon, Ensor), there are sets on German single-leaf woodcuts before 1500 (based on Schreiber) and on early German book illustration (derived from Schramm).

Brief supplements to Bartsch were published by R. Weigel (1843) and J. Heller (1844). Far more important is the supplement by J. D. Passavant, *Le Peintre-Graveur*, 6 vols, Leipzig 1860-4. This is particularly concerned with material of the fifteenth and sixteenth centuries.

The only book to make any attempt at cataloguing every print produced over a long period was compiled by Charles Le Blanc: *Manuel de l'Amateur d'Estampes 1550-1820*, 4 vols, Paris 1854-89. This is based on the collection of the Bibliothèque nationale de France in Paris and provides the only available lists of the works of many minor engravers, but is too summary and incomplete to be of much use.

Useful lists of works will be found under the individual artists' entries in two general dictionaries of artists. The earlier was G. K. Nagler, *Neues allgemeines Künstler-Lexicon*, 22 vols, Munich 1835-52. Nagler also published a supplement entitled *Die Monogrammisten*, 5 vols, Munich 1858-79, which is invaluable for identifying any print which only carries an artist's monogram. The second dictionary was by J. Meyer, *Allgemeines Künstler-Lexicon*, 3 vols, Leipzig 1872-85. This was intended to replace Nagler and contains excellent lists of engravers' works, but unfortunately never got farther than BEZZUOLI.

The British Museum has published on the web its database which describes more than 250,000 prints of all countries: see www.britishmuseum.org/research. American prints can be found on www.americanart.si and Australian ones on printsandprintmaking.gov.au

CATALOGUES OF FIFTEENTH-CENTURY PRINTS

WOODCUTS AND METALCUTS
The standard work is by W. L. Schreiber, *Manuel de l'Amateur de la gravure sur bois et sur métal au XVe siècle*, 5 vols, Leipzig 1891-1911. Volumes 4 and 5 contain a catalogue of blockbooks and incunabula with woodcut illustrations. Volumes 1 to 3 only, which list the single-sheet prints, were revised and reprinted as *Handbuch der Holz- und Metalschnitte des XV. Jahrhunderts*, 8 vols, Leipzig 1926-30. The catalogue is arranged according to the subject-matter of the print. A complete set of illustrations is being produced in the *Illustrated Bartsch* series. Early German book illustrations were described by Albert Schramm, *Der Bilderschmuck der Frühdrucke*, 23 vols, Leipzig 1920-43. These have been recast in ten volumes of the *Illustrated Bartsch*.

ENGRAVINGS
The standard work on Northern engravings is by Max Lehrs, *Geschichte und kritischer Katalog des deutschen, niederländischen und französischen Kupferstichs im XV. Jahrhundert*, 9 vols, Vienna 1908-34. This catalogue is arranged by engraver; only a few prints are illustrated. For Italian engravings the standard work is A. M. Hind, *Early Italian Engravings*, 7 vols, London 1938-48; this is classified by school, group or engraver, and is fully illustrated.

CATALOGUES OF PARTICULAR SCHOOLS (POST-FIFTEENTH CENTURY) ARRANGED ALPHABETICALLY BY COUNTRY

AMERICAN The only substantial listing of (mainly) twentieth-century prints is in the catalogue of *American Prints in the Library of Congress* by Karen F. Beall et al., Baltimore 1970. American historical prints in the collection of the Library of Congress are catalogued by Bernard F. Reilly, *American Political Prints 1766-1876*, Boston 1991.

BRITISH The only general catalogue is restricted to mezzotints: John Chaloner Smith, *British Mezzotinto Portraits from the introduction of the art to the early part of the present century*, 4 vols, London 1883. There are also two important British Museum catalogues: *Catalogue of Political and Personal Satires in the Department of Prints and Drawings*, vols 1-4 (1320 to 1770) by F. G. Stephens, 1870-83; vols 5-11 (1761 to 1832) by M. Dorothy

George, 1935-54, and *Catalogue of Engraved British Portraits in the Department of Prints and Drawings*, 1908-25, vols 1-4 by Freeman O'Donoghue and vols 5-6 by Henry M. Hake.

DUTCH AND FLEMISH Five catalogues should be mentioned:
1. J. P. van der Kellen, *Le Peintre-Graveur Hollandais et Flamand*, Utrecht 1866. This continuation of Bartsch covers the work of various seventeenth-century artists, but never went beyond the first volume, and is mostly superseded by Hollstein.
2. E. Dutuit, *Manuel de l'Amateur d'Estampes*, vols 4-6, Paris 1881-5. This keeps Bartsch's numbering, but revises his information about states. (Dutuit's first volume is about blockbooks and nielli; the second and third were never published.) It is mostly superseded by Hollstein.
3. A. von Wurzbach, *Niederländisches Künstler-Lexicon*, 3 vols, Vienna 1906-11. An excellent general dictionary of Netherlandish artists which includes important lists of engravers' works.
4. F. W. H. Hollstein, *Dutch and Flemish Etchings, Engravings and Woodcuts c.1450-1700*, Amsterdam 1949-2004. The project is now complete, and the publisher has embarked on a revised edition under the name *The New Hollstein*. This improves on the earlier volumes, both in quality of information and number of illustrations, and includes prints made after artists' designs. Volumes so far published cover van der Borcht, Bruegel, Callaert, Cort, the van Doetecums, van Dyck, Frisius, Philips Galle, the de Gheyn family, van Groeningen, van Heemskerk, Hogenbergh, Hendrick Hondius, Lucas van Leyden, Matham, van Mander, the Muller dynasty, and Stradanus.
5. T. Hippert and J. N. Linning, *Le Peintre-Graveur Hollandais et Belge du Dix-neuvième Siècle*, 3 vols, Brussels 1874-9.

FRENCH Bartsch did not include French prints, with the exception of the school of Fontainebleau (in vol. XVI). The basic catalogue is therefore A. P. F. Robert Dumesnil, *Le Peintre-Graveur Français*, 11 vols, Paris 1835-71. This work, which was completed by G. Duplessis, includes the work of artists born in the sixteenth and seventeenth centuries. It is continued for the eighteenth century by P. de Baudicour, *Le Peintre-Graveur Français continué*, 2 vols, Paris 1859-61. The work of the reproductive engravers finds a place in R. Portalis and H. Beraldi, *Les Graveurs du Dix-neuvième Siècle*, 3 vols, Paris 1880-2. The only general catalogue for the nineteenth century is H. Beraldi, *Les Graveurs du Dix-neuvième Siècle*, 12 vols plus supplement, Paris 1885-92. The work of various important artists of the late nineteenth and early twentieth century is catalogued by L. Delteil, *Le Peintre-Graveur Illustré*, 31 vols, Paris 1902-26.

The Bibliothèque Nationale in Paris is in the process of publishing a vast inventory of its collection of French prints, the *Inventaire du Fonds Français*, of which the first volume was published in 1930. At present the sixteenth century is complete (2 vols); the seventeenth century as far as LEPAUTRE (12 vols), with one advance volume (no. 17) for MELLAN; the eighteenth is at LEQUIEN (14 vols); and the nineteenth at MARVILLE (15 vols). The Bibliothèque Nationale has also published an important catalogue of a collection of French historical prints which was given to it: *Collection de Vinck*, of which 8 volumes have been published (1909-68), from the Ancien Régime to the Second Empire.

GERMAN The work of Bartsch was continued by A. Andresen, *Der deutsche Peintre-Graveur ... von dem letzten Drittel des 16. Jahrhunderts bis zum Schluss des 18. Jahrhunderts*, 5 vols, Leipzig 1864-78. This in turn was continued by A. Andresen, *Die deutschen Maler-Radierer des 19. Jahrhunderts*, 5 vols, Leipzig 1878.

These are replaced for the years up to 1700 by the entries in F. W. H. Hollstein, *German Engravings, Etchings and Woodcuts c. 1400-1700*, Amsterdam 1954, continuing. Seventy-three volumes are so far published from A to SPECKLIN. Like the companion Hollstein volumes on Dutch and Flemish prints, these are well illustrated. Although far from complete, the publishers have embarked on a replacement for some of the less adequate earlier volumes under the title *The New Hollstein*. Volumes have so far been published for Von Aachen, Aldegrever, Altdorfer, Amman, Beck and Breu.

There are three catalogues of woodcuts after 1500. Max Geisberg, *Der deutsche Einblatt-Holzschnitt in de ersten Hälfte des XVI. Jahrhunderts*, Munich 1923-30, was recast by Walter L. Strauss in *The German Single-leaf Woodcut 1500-1550*, 4 vols, New York 1974. It is continued by the same author in *The German Single-leaf Woodcut 1550-1600*, 3 vols, New York 1975, and by Dorothy Alexander, *The German Single-leaf Woodcut 1600-1700*, New York 1977.

German broadsides are being catalogued by John Roger Paas, *The German Political Broadsheet 1600-1700*, Wiesbaden 1985, continuing; and by Wolfgang Harms, *Deutsche illustrierte Flugblätter des 16. und 17. Jahrhunderts*, Tübingen 1985, continuing. One special class is catalogued by Ingrid Faust, *Zoologische Einblattdrucke und Flugschriften vor 1800*, 5 vols, Stuttgart 1998-2003.

ITALIAN The only continuation of Bartsch is A. de Vesme, *Le Peintre-Graveur Italien*, Milan 1906. This includes the most important etchers and engravers of the eighteenth century. Eight volumes have been published of the *Catalogo Generale della Raccolta di Stampe Antiche* of the Pinacoteca Nazionale in Bologna (1973-93). These illustrate many prints not reproduced elsewhere.

General books on the history and techniques of printmaking

The following list is highly selective and is restricted as far as possible to books written in English. Despite great advances in recent years, the literature of prints is still very patchy, and many subjects and periods have received no modern study; a few titles on special subjects are given in the glossary. The scholarly journal *Print Quarterly* has published many important articles since it was founded in 1984. Two ten-year indices are available.

GENERAL

Technical
W. M. Ivins, Jr, *How Prints Look*, New York (Metropolitan Museum of Art) 1943 (this and the next book are recommended to those who wish to learn to recognize particular processes)
Bamber Gascoigne, *How to Identify Prints, a complete guide to manual and mechanical processes from woodcut to ink jet*, London 1986

Felix Brunner, *A Handbook of Graphic Reproduction Processes*, Teufen 1962 (this has excellent photographs of the stages of making prints)

Historical

Linda C. Hults, *The Print in the Western World*, Madison (University of Wisconsin Press) 1996

A. Hyatt Mayor, *Prints and People, a social history of printed pictures*, New York (Metropolitan Museum of Art) 1971

Michel Melot *et al.*, *Prints, history of an art*, Geneva 1981

David Landau and Peter Parshall, *The Renaissance Print 1470-1550*, New Haven and London 1994 (the standard work on printmaking in Italy and Germany)

Susan Dackerman, *Painted Prints, the Revelation of Color*, Baltimore (Museum of Art) 2002

Jan van der Waals, *Prenten in de gouden eeuw, von Kunst tot kastpapier*, Rotterdam (Boijmans Museum) 2006

Stephen Bann, *Parallel Lines: printmakers, painters and photographers in XIX century France*, New Haven 2001

Riva Castleman, *Prints of the Twentieth Century, a history*, London 1976

Pat Gilmour, *The Mechanised Image, an historical perspective on twentieth-century prints*, London 1978

Susan Tallman, *The Contemporary Print from Pre-Pop to Post-Modern*, London 1996

Deborah Wye, *Artists and prints, masterworks from the Museum of Modern Art*, New York 2004

Print collecting

Joseph Maberly, *The Print Collector*, London 1844 (still the best handbook for collectors of old master prints)

Frits Lugt, *Les Marques de Collections de dessins et d'estampes*, Amsterdam 1921 (with supplementary volume 1956) www.marquesdecollections.fr

Mark McDonald, *The Print Collection of Ferdinand Columbus 1488-1539*, London (British Museum) 2004

Christopher Baker *et al.* (eds), *Collecting Prints and Drawings in Europe c.1500-1750*, Aldershot 2003

Antony Griffiths (ed.), *Landmarks in Print Collecting: connoisseurs and donors at the British Museum since 1753*, London (British Museum) 1996

Book illustration

John Harthan, *The History of the Illustrated Book: the Western tradition*, London 1981

Antony Griffiths, *Prints for Books: French book illustration 1760-1800*, London (British Library) 2004

Eleanor M. Garvey and Philip Hofer, *The Artist and the Book 1860-1960 in Western Europe and the United States*, Boston (Museum of Fine Arts) 1961

W. J. Strachan, *The Artist and the Book in France: the 20th century livre d'artiste*, London 1969

Joanna Selborne, *British Wood-Engraved Book Illustration 1904-1940*, Oxford 1998

Various

W. M. Ivins, Jr, *Prints and Books, informal papers*, Cambridge, Mass., 1927

A. Hyatt Mayor, *Selected Writings and a Bibliography*, New York (Metropolitan Museum of Art) 1983

Walter Sickert, *The Complete Writings on Art*, ed. Anna Greutzner Robins, Oxford 2000 (includes his amusing and provocative views about prints)

S. W. Hayter, *About Prints*, London 1962

Andrew Robison, *Paper in Prints*, Washington (National Gallery of Art) 1977

W. M. Ivins, Jr, *Prints and Visual Communications*, Cambridge, Mass., 1953

Susan Lambert, *The Image Multiplied: five centuries of printed reproductions of paintings and drawings*, London 1987

RELIEF PRINTS

D. P. Bliss, *A History of Wood-Engraving*, London 1928 (this is in fact a general history of relief prints)

Max J. Friedländer, *Der Holzschnitt*, 4th edn, revised by H. Möhle, Berlin 1970

Peter Parshall and Rainer Schoch, *Origins of European Printmaking, Fifteenth-century Woodcuts and Their Public*, Washington (National Gallery of Art) 2005

Hellmut Lehmann-Haupt, *An Introduction to the Woodcut of the Seventeenth Century*, New York 1977

J. J. Jackson and W. A. Chatto, *A Treatise on Wood Engraving*, London 1839 (2nd edn 1861)

INTAGLIO PRINTS

A. M. Hind, *A Short History of Engraving and Etching*, 3rd edn, London 1923

Anthony Gross, *Etching, Engraving and Intaglio Printing*, London 1970

S. T. Prideaux, *Aquatint Engraving, a chapter in the history of book illustration*, London 1909

Carol Wax, *The Mezzotint, history and technique*, London 1990

LITHOGRAPHY

Felix H. Man, *Artists' Lithographs, a world history*, London 1970

Michael Twyman, *Lithography 1800-1850, the techniques of drawing on stone in England and France and their application in works of topography*, London 1970

Michael Twyman, *Breaking the Mould: the first hundred years of lithography*, London (British Library) 2001

Pat Gilmour (ed.), *Lasting Impressions: lithography as art*, Canberra (Australian National Gallery) 1988

Marjorie Devon, *Tamarind Techniques for Fine Art Lithography*, New York 2009

SCREENPRINTING

Dave and Reba Williams, 'The early history of the screenprint', *Print Quarterly* III (1986), pp.286-321, and IV (1987), pp.379-403

Brian Elliott, *Silk-Screen Printing*, London 1971

COLOUR PRINTING

R.M. Burch, *Colour Printing and Colour Printers*, London 1910

Bamber Gascoigne, *Milestones in Colour Printing 1457-1859*, Cambridge 1997

Walter L. Strauss, *Chiaroscuro, the clair-obscur woodcut by the German and Netherlandish masters of the 16th and 17th centuries*, London 1973

Otto M. Lilien, *Jacob Christoph Le Blon, inventor of three- and four-colour printing*, Stuttgart 1985

PHOTOGRAPHIC PROCESSES

Brian Coe and Mark Haworth-Booth, *A Guide to Early Photographic Processes*, London 1983

Harold Curwen, *Processes of Graphic Reproduction in Printing*, 4th edn, London 1966

Charles Newton, *Photography in Printmaking*, London (Victoria and Albert Museum) 1979

Geoffrey Wakeman, *Victorian Book Illustration, the technical revolution*, Newton Abbot 1973 (invaluable for the odd nineteenth-century processes)

Otto M. Lilien, *A History of Industrial Gravure Printing up to 1920*, London 1972

AMERICAN PRINTS

Una E. Johnson, *American Prints and Printmakers*, New York 1980

James Watrous, *A Century of American Printmaking 1880-1980*, Wisconsin 1984

Clinton Adams, *American Lithographers 1900-1960*, Albuquerque 1983

Riva Castleman, *American Impressions, prints since Pollock*, New York 1985

David Acton, *A Spectrum of Innovation: color in American printmaking 1890-1960*, Worcester, Mass., 1990

David Acton, *The Stamp of Impulse: abstract expressionist prints*, Worcester, Mass., 2001

Stephen Coppel, *The American Scene, Prints from Hopper to Pollack*, London (British Museum) 2008

Esther Sparks, *Universal Limited Art Editions, a history and catalogue*, Chicago (Art Institute) 1989

Pat Gilmour, *Ken Tyler, Master Printer, and the American print renaissance*, New York and Canberra (Australian National Gallery) 1986

BRITISH PRINTS

Richard T. Godfrey, *Printmaking in Britain: a general history from its beginnings to the present day*, Oxford 1978

Antony Griffiths with the assistance of Robert Gerard, *The Print in Stuart Britain 1603-1689*, London (British Museum) 1998

Timothy Clayton, *The English Print 1688-1802*, New Haven 1997

Sheila O'Connell, *The Popular Print in England*, London (British Museum) 1999

Diana Donald, *The Age of Caricature: satirical prints in the reign of George III*, New Haven 1996

Anthony Dyson, *Pictures to Print: the nineteenth-century engraving trade*, London 1984

Frances Carey and Antony Griffiths, *Avant-Garde British Printmaking 1914-1960*, London (British Museum) 1990

Stephen Coppel, *Linocuts of the Machine Age: Claude Flight and the Grosvenor School*, Aldershot 1995

DUTCH AND FLEMISH PRINTS

Jan van der Stock, *Printing Images in Antwerp: the introduction of printmaking in a city, XV century to 1585*, Rotterdam 1998

Timothy Riggs and Larry Silver, *Graven Images, the rise of professional printmakers in Antwerp and Haarlem 1540-1640*, Evanston (Northwestern University) 1993

Eddy de Jongh and Ger Luijten, *Mirror of Everyday Life: genre prints in the Netherlands 1550-1700*, Amsterdam (Rijksmuseum) 1997

Nadine M. Orenstein, *Hendrick Hondius and the Business of Prints in XVII Century Holland*, Rotterdam 1996

Clifford Ackley, *Printmaking in the Age of Rembrandt*, Boston (Museum of Fine Arts) 1981

Stephen Goddard, *Les XX and the Belgian Avant-Garde: prints, drawings and books c.1890*, Lawrence, Kansas (Spencer Museum of Art) 1992

FRENCH PRINTS

H. Zerner, M. Grivel and C. Burlingham, *The French Renaissance in Prints*, Los Angeles (University of California) 1994 (also in French translation)

Henri Zerner, *The School of Fontainebleau, etchings and engravings*, London 1969

Marianne Grivel, *Le Commerce de l'Estampe à Paris au XVIIe siècle*, Geneva 1986

Sue Welsh Reed, *French Prints from the Age of the Musketeers*, Boston (Museum of Fine Arts) 1998

François Courboin, *Graveurs et Marchands d'Estampes au XVIIIe Siècle*, Paris 1914

Victor I. Carlson and John W. Ittmann, *Regency to Empire, French printmaking 1715-1814*, Baltimore Museum and Minneapolis Institute of Art, 1984

Nicole Garnier, *L'Imagerie Populaire Français*, 2 vols, Paris 1990-6

Janine Bailly-Herzberg, *Dictionnaire de l'Estampe en France 1830-1950*, Paris 1985

Michel Melot, *The Impressionist Print*, New Haven 1996

Jacqueline Baas and Richard S. Field, *The Artistic Revival of the Woodcut in France 1850-1900*, Ann Arbor (University of Michigan) 1983

P. D. Cate and S. H. Hitchings, *The Color Revolution: color lithography in France 1890-1900*, Santa Barbara and Salt Lake City 1978

P. D. Cate and Marianne Grivel, *From Pissarro to Picasso: color etching in France*, New Brunswick (Zimmerli Art Museum) 1992

Stephen Coppel, *Picasso and Printmaking in Paris*, London (Hayward Gallery, South Bank Centre) 1998

GERMAN PRINTS

Richard S. Field, *Fifteenth Century Woodcuts and Metalcuts*, Washington (National Gallery of Art) 1965

Alan Shestack, *Fifteenth Century Engravings from Northern Europe*, Washington (National Gallery of Art) 1967

Campbell Dodgson, *Catalogue of Early German ... Woodcuts in the British Museum*, London 1903 and 1911

Giulia Bartrum, *The German Renaissance Print*, London (British Museum) 1995

Stephen H. Goddard, *The World in Miniature: engravings by the German Little Masters 1500-1550*, Lawrence, Kansas (Spencer Museum of Art) 1988

Antony Griffiths and Frances Carey, *German Printmaking in the Age of Goethe*, London (British Museum) 1994

Frances Carey and Antony Griffiths, *The Print in Germany 1880-1933, the age of Expressionism*, London (British Museum) 1984

ITALIAN PRINTS

J. A. Levenson, K. Oberhuber, J. L. Sheehan, *Early Italian Engravings*, Washington (National Gallery of Art) 1973

David Rosand and M. Muraro, *Titian and the Venetian Woodcut*, Washington (National Gallery of Art) 1976

Michael Bury, *The Print in Italy 1550-1620*, London (British Museum) 2001

Sue Welsh Reed and Richard Wallace, *Italian Etchers of the Renaissance and Baroque*, Boston (Museum of Fine Arts) 1989

Jane Martineau and Andrew Robison (eds), *The Glory of Venice: art in the XVIII century*, London (Royal Academy) and Washington (National Gallery of Art) 1994

Martin Hopkinson, *Italian Prints 1875–1975*, London (British Museum) 2007

OTHER COUNTRIES

Roger Butler, *Printed Images in Colonial Australia 1801-1901*, Canberra (National Gallery of Australia) 2007; and *Printed Images by Australian Artists 1885-1955*, Canberra (National Gallery of Australia) 2007

Frances Carey, *Modern Scandinavian Prints*, London (British Museum) 1997

Irena Goldscheider, *Czechoslovak Prints from 1900 to 1970*, London (British Museum) 1986

John Ittmann, *Mexico and Modern Printmaking*, Philadelphia Museum of Art, 2006

Catalogues of and monographs on individual printmakers

Timothy A. Riggs, *The Print Council Index to Oeuvre-Catalogues of Prints by European and American Artists*, Millwood, N.Y. (Kraus International) 1983, lists under the name of each artist the catalogues that have been published of their work up to the end of 1972. It is extremely thorough and reliable, and is continued on the website of the Print Council of America (www.printcouncil.org).

In the following list are included under (a) only the most commonly used catalogues of the printed oeuvre of a few of the major western printmakers, and under (b) one or two monographs or exhibition catalogues, especially those written in English, that pay particular attention to their prints.

MAX BECKMANN (1884-1950)
(a) James Hofmaier, *Max Beckmann, catalogue raisonné of his prints*, Bern 1990
(b) *Max Beckmann*, St Louis and Los Angeles County Museums of Art, 1984

WILLIAM BLAKE (1757-1827)
(a) David Bindman, *The Complete Graphic Works of William Blake*, London 1978

(b) David Bindman, *Blake as an Artist*, Oxford 1977. Robert N. Essick, *William Blake Printmaker*, Princeton 1980. Joseph Viscomi, *Blake and the Idea of the Book*, Princeton 1993

JACQUES CALLOT (1592-1635)
(a) Jules Lieure, *Jacques Callot, catalogue de son oeuvre gravé*, 3 vols, Paris 1924-7
(b) H. Diane Russell, *Jacques Callot, prints and related drawings*, Washington (National Gallery of Art) 1975. *Jacques Callot 1592-1635*, Nancy (Musée Historique Lorrain) 1992

HONORÉ DAUMIER (1808-79)
(a) Loys Delteil, *Le Peintre-Graveur lllustré XX-XXIX*, Paris 1925-30

EDGAR DEGAS (1834-1917)
(a) Jean Adhémar and Françoise Cachin, *Degas, the complete etchings, lithographs and monotypes*, London 1974
(b) Sue Welsh Reed and Barbara Shapiro, *Edgar Degas, the painter as printmaker*, Boston (Museum of Fine Arts) 1984

ALBRECHT DÜRER (1471-1528)
(a) Joseph Meder, *Dürer-Katalog*, Vienna 1932. R. Schoch, M. Mende and A. Scherbaum, *Albrecht Dürer, das druckgraphische Werk*, 3 vols, Munich 2001-3
(b) *Albrecht Durer, master printmaker*, Boston (Museum of Fine Arts) 1971. Giulia Bartrum, *Albrecht Dürer and his Legacy*, London (British Museum) 2002

PAUL GAUGUIN (1848-1903)
(a) E. Mongan and E. W. Kornfeld, *Paul Gauguin, catalogue raisonné of his prints*, Bern 1988
(b) Richard S. Field, *Paul Gauguin Monotypes*, Philadelphia (Museum of Art) 1973. *The Art of Paul Gauguin*, Washington (National Gallery of Art) and Chicago (Art Institute) 1988

JAMES GILLRAY (1756-1815)
(b) Richard Godfrey, *James Gillray, the art of caricature*, London (Tate Gallery) 2001

HENDRIK GOLTZIUS (1558-1617)
(a) W. L. Strauss, *Hendrik Goltzius, the complete engravings, etchings, woodcuts*, New York 1977
(b) Nancy Bialler, *Chiaroscuro Woodcuts, Hendrik Goltzius and his time*, Amsterdam (Rijksmuseum) 1992. Huigen Leeflang, Ger Luijten *et al.*, *Hendrik Goltzius, drawings, prints and paintings*, Amsterdam (Rijksmuseum) 2003

FRANCISCO GOYA (1746-1828)
(a) Tomás Harris, *Goya: engravings and lithographs*, Oxford 1964
(b) Juliet Wilson Bareau, *Goya's Prints*, 2nd edn, London (British Museum) 1996. Eleanor A. Sayre, *The Changing Image, prints by Francisco Goya*, Boston (Museum of Fine Arts) 1974

DAVID HOCKNEY (b.1937)
(a) Andrew Brighton (ed.), *David Hockney's Prints 1954-1977*, Edinburgh (Scottish Arts Council) 1979
(b) *David Hockney, a retrospective*, Los Angeles (County Museum of Art) 1988

WILLIAM HOGARTH (1697-1764)
(a) Ronald Paulson, *Hogarth's Graphic Works*, 3rd edn, London 1989
(b) David Bindman, *William Hogarth*, London 1981

WENCESLAUS HOLLAR (1607-77)
(a) Richard Pennington, *A Descriptive Catalogue of the Etched Work of Wenceslaus Hollar*, Cambridge 1982
(b) Richard T. Godfrey, *Wenceslaus Hollar, a Bohemian artist in England*, New Haven (British Art Center) 1994

JASPER JOHNS (*b*.1930)
(a) Richard S. Field, *Jasper Johns Prints 1960-70*, Philadelphia (Museum of Art) 1970. Richard S. Field, *Jasper Johns Prints 1970-77*, Middletown, Conn., 1978
(b) *Jasper Johns, working proofs*, Basel (Kunstmuseum) 1979

ERNST LUDWIG KIRCHNER (1880-1938)
(a) A. and W.-D. Dube, *Ernst Ludwig Kirchner, das graphische Werk*, Stuttgart 1967, 2nd edn 1980
(b) Jill Lloyd and Magdalena Moeller, *Ernst Ludwig Kirchner, the Dresden and Berlin years*, Washington (National Gallery of Art) 2003

KÄTHE KOLLWITZ (1867-1945)
(a) Alexandra von dem Knesebeck, *Käthe Kollwitz, Werkverzeichnis der Graphik*, Bern 2002
(b) Elizabeth Prelinger, *Käthe Kollwitz*, Washington (National Gallery of Art) 1992

LUCAS VAN LEYDEN (?1489-1533)
(a) Jan-Piet Filedt Kok in *The New Hollstein*, 1996
(b) Ellen Jacobowitz and S. L. Stepanek, *The Prints of Lucas van Leyden and His Contemporaries*, Washington (National Gallery of Art) 1983

EDOUARD MANET (1832-83)
(a) Jean C. Harris, *Edouard Manet, the graphic work, a catalogue raisonné*, San Francisco 1990
(b) Jay McKean Fisher, *The Prints of Edouard Manet*, Washington (International Exhibitions Foundation) 1985

ANDREA MANTEGNA (*c*.1431-1506)
(a) Hind V, 1948
(b) *Andrea Mantegna*, London (Royal Academy) 1992

MARCANTONIO RAIMONDI (*c*.1480-before 1534)
(a) Bartsch XIV, 1813
(b) Innis H. Shoemaker and E. Brown, *The Engravings of Marcantonio Raimondi*, Lawrence, Kansas (Spencer Museum of Art) 1981

MASTER OF THE HAUSBUCH (active *c*.1470-1500)
(a) and (b) J. P. Filedt Kok, *Livelier than Life, the Master of the Amsterdam Cabinet or the Housebook Master*, Amsterdam (Rijksmuseum) 1985

HENRI MATISSE (1869-1954)
(a) M. Duthuit-Matisse and C. Duthuit, *Henri Matisse, catalogue raisonné de l'oeuvre gravé*, Paris 1983

EDVARD MUNCH (1863-1944)
(a) Gerd Woll, *Edvard Munch, the complete graphic works*, London 2001
(b) Elizabeth Prelinger, *Edvard Munch, master printmaker*, New York 1983. Elizabeth Prelinger and Michael Parke-Taylor, *The Symbolist Prints of Edvard Munch*, Toronto (Art Gallery of Ontario) 1996

EMIL NOLDE (1867-1956)
(a) Gustav Schiefler, revised by C. Mosel, *Emil Nolde, das graphische Werk*, Cologne 1966
(b) Clifford Ackley *et al.*, *Emil Nolde, the painter's prints*, Boston (Museum of Fine Arts) 1995

PABLO PICASSO (1881-1973)
(a) Brigitte Baer, *Picasso Peintre-Graveur*, 8 vols, Bern 1986-96. Fernand Mourlot, *Picasso Lithographe*, 4 vols, Monte Carlo 1949-64
(b) Brigitte Baer, *Picasso the Printmaker*, Dallas (Museum of Art) 1983. Felix Reusse, *Pablo Picasso, die Lithographie*, Münster (Graphikmuseum) 2000

GIOVANNI BATTISTA PIRANESI (1720-78)
(a) John Wilton-Ely, *Giovanni Battista Piranesi, the complete etchings*, San Francisco 1994. A. Robison, *Piranesi, early architectural fantasies*, Washington (National Gallery of Art) 1986
(b) Jonathan Scott, *Piranesi*, London 1975

REMBRANDT VAN RIJN (1606-69)
(a) Christopher White and Karel G. Boon, *Rembrandt's Etchings, an illustrated critical catalogue*, Amsterdam 1969
(b) Christopher White, *Rembrandt as an Etcher*, 2nd edn, London 1999. Erik Hinterding, *Rembrandt as an etcher*, Ouderkerk, 2006

MARTIN SCHONGAUER (*c*.1450-91)
(a) Hollstein, XLIX, 1999
(b) Tilman Falk and T. Hirthe, *Martin Schongauer, das Kupferstichwerk*, Munich (Staatliche Graphische Sammlung) 1991

HERCULES SEGERS (1589/90-*c*.1635)
(a) E. Haverkamp-Begemann, *Hercules Segers, the complete etchings*, The Hague 1973
(b) John Rowlands, *Hercules Segers*, New York 1979

HENRI DE TOULOUSE-LAUTREC (1864-1901)
(a) Wolfgang Wittrock, *Toulouse-Lautrec, the complete prints*, London 1985
(b) *Toulouse-Lautrec, prints and posters from the Bibliothèque Nationale*, Queensland Art Gallery 1991

JAMES MCNEILL WHISTLER (1834-1903)
(a) E. G. Kennedy, *The Etched Work of Whistler*, New York 1910. Harriet K. Stratis and Martha Tedeschi (eds), *The Lithographs of James McNeill Whistler*, 2 vols, Chicago (Art Institute) 1998
(b) Katherine A. Lochnan, *The Etchings of James McNeill Whistler*, New Haven and London 1984

Abbreviations and Lettering

In this and the following sections translations of technical terms into French and German are only given in the more important cases. The fullest such dictionary, which covers German, French, English, Italian and Dutch, is to be found in Walter Koschatzky, *Die Kunst der Graphik*, Salzburg 1972. The best glossary available is H. W. Singer, *Die Fachausdrücke der Graphik*, Leipzig 1933.

Numerous abbreviations and other terms have been used on the lettering of prints and these have to be understood in order to find out the roles of the various names in the production of the print. The following section is intended to explain the more important and obscurer terms. They have been arranged in five groups; the normal abbreviations are in brackets.

PRINTMAKER AND RELATED CRAFTSMEN
(usually placed beneath lower right-hand corner of image)
Aquaforti (aqua.) 'By acid'; used of the etcher.
Caelavit (cae.) 'Engraved'.
Direxit (direx.) 'Directed' (the engraving); found on some eighteenth- and nineteenth-century prints, especially in France, where a master was directing the operation of a workshop.
Fecit or *faciebat (f., fec.* or *fac.)* 'Made'; used by engraver or etcher.
Impressit (imp.) 'Printed'; only found from the eighteenth century. In the late nineteenth and early twentieth centuries the printer sometimes signed his name in manuscript.
Incidit or *incidebat (inc.)* 'Engraved'.
Lithog. This is an ambiguous term; it can be used either by the man who drew the image on the stone, or by the lithographic printer.
Photosculpsit (ph. sc.) Sometimes used by the craftsman who prepared a hand photogravure plate.
Scripsit (scrip.) 'Wrote'; used by the specialist writing engraver, and found in the eighteenth and nineteenth centuries.
Sculpsit or *sculpebat (sc.* or *sculp.)* 'Engraved'; the most usual term used by the engraver. Occasionally a woodcutter will place his name beside a miniature knife.

PAINTER AND DRAUGHTSMAN
(usually placed beneath lower left-hand corner of image)
Ex archetypis 'From the original' painting, drawing, etc.
Composuit (comp.) 'Designed'; used of originals of many types. It is also occasionally used by the author of the verses found under mannerist prints; an alternative in these cases is *lusit*.
Delineavit (del. or *delin.)* 'Drew'; used when the engraver was working from a drawing. This might be a copy of a painting made by an intermediate artist especially for the engraver.
Descripsit 'Drew'; the same as the above but rarer.

Designavit (desig.) 'Designed' or 'drew'.
Effigiavit (effig.) 'Drew'; equivalent to *delineavit*.
Figuravit (fig.) 'Drew'; usually this has the same implication as the above.
Invenit (inv.) 'Designed'; the most common term for original compositions of all sorts.
Pinxit or *pingebat (pinx.* or *ping.)* 'Painted'.

PUBLISHER
Appresso 'At the house of' (Italian).
Apud (The Latin for the above).
Chez (The French version; often in form *se vend chez*).
Divulgavit (divulg.) 'Published'.
Excudit (ex. or *excud.)* 'Published'; the most common term.
Ex officina 'From the workshop'.
Ex Typis 'From the printing house'; often used in Italy.
Formis 'At the press' (Latin); where the printer is also the publisher.
Gedruckt zu 'Printed by'; normally found on German woodcuts.
Per 'Through'.
Sumptibus 'At the expense of'; used of a patron or a publisher.

COPYRIGHTS *('privileges')*
1. Great Britain. *Published According to Act of Parliament* (From 1735).
2. France. *Cum Privilegio Regis (CPR)* or *Avec Privilège du Roi (APDR)* (Until 1792); *Déposé à la Direction* (1795-9); *Déposé à la Bibliothèque Impériale* (1804-14); *Déposé à la Bibliothèque Royale* or *Nationale* (1815 onwards).
3. Germany. *Cum Privilegio Sacrae Caesaris Maiestatis (CPSCM)* (Used in the area within the jurisdiction of the Holy Roman Emperors).
4. Italy. (a) *Superiorum permissu* or *Con licenza de' superiori* (Used by the ecclesiastical censorship in Rome; although privileges were granted, this in itself does not imply one).
(b) *Cum Privilegio Excellentissimi Senatus (CPES)* (A Venetian privilege).
5. America. *Entered according to Act of Congress.*

MANUSCRIPT ANNOTATIONS
Artist's proof (AP) A few 'artist's proofs' are usually printed in addition to the main edition of a print. See p.149.
Bon à tirer 'Good to print'; the artist's indication to the printer that that particular impression should act as standard for a whole edition. In English the term 'Good to pull' is sometimes used.
Épreuve d'artiste 'Artist's proof'.
Épreuve d'essai 'Trial proof'.
Épreuve d'état 'State-proof'; used when working is not yet completed.
Épreuve de passe Sometimes found written on an extra impression printed beyond the stated number of the edition.
Handdruck 'Printed by hand' (German); implies that the impression was printed by the artist himself.
Hors Commerce (HC) 'Not for sale'; usually of an extra impression beyond the stated limits of an edition.
Probedruck 'Trial proof' (German).

Keelings Pastry,

At the Cock in New Bond Street,

L,ONDON.

Makes all sorts of Rich Cakes,
Dyet Bread &c. Godiveau Pies,
Patties &c. Croquantes, Baskets,
Snuff-Boxes, & all sorts of Cutt
Work done in the neatest manner,
Lemon, Orange, Tansey, & all
other sorts of Puddings, Potted
Wheat Ears, Fine Orange
Gingerbread, Captains
may be Serv'd with Fruit
& Mince Meat
for Sea.

103 J. Austin, *Trade card of William Keeling, c.*1767. Etching
(actual size). A fine example of a rococo trade card. On the
reverse is a manuscript receipt for 2s 8d for a month's
supply of buns to the Earl of Guildford. See p.154.

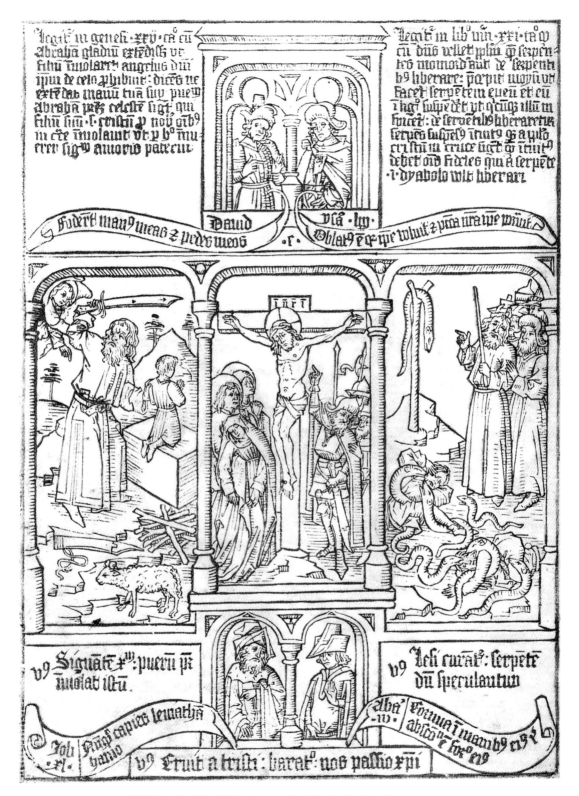

104 Netherlandish, *Biblia Pauperum* blockbook, *The Crucifixion*,
c.1465. Woodcut (reduced). The scene is flanked by two Old
Testament parallels, Abraham's sacrifice and the raising of the serpent.
At the top and bottom are quotations from four prophets.

Glossary

Address A term used generally of any lettering on a print which gives the name of the publisher (qv).

Album In the sixteenth and seventeenth centuries collectors almost always kept prints pasted into albums. In the later eighteenth century they were often mounted on cards which were stacked in portfolios. The sunk mount, which is so often used today, was only developed in the 1840s.

Almanacs An almanac is in essence a calendar for a year, to which is added other sorts of information. Many were small booklets, but some were large sheets designed to be hung on the wall. In France, especially in the later seventeenth century, such sheets could carry as decoration very large and impressive engravings. See Maxime Préaud, *Les Effets du Soleil, Almanachs du Règne de Louis XIV*, Paris 1995.

Altered plates A phenomenon most often found among portrait prints. A publisher, to save expense, would simply burnish out the face and lettering of a disused plate and substitute new features. One famous plate began as Cromwell, was turned into Louis XIV, was turned backed into Cromwell and then became Charles I before finally returning to Cromwell again. See G. S. Layard, *Engraved British Portraits from Altered Plates*, London 1927.

Anastatic printing This is in essence a method of transfer lithography, and was occasionally used between about 1840 and 1900 to print from a manuscript or printed book. The page was soaked to loosen the grease in the ink and the image was transferred to a zinc plate, which was then printed lithographically.

Aquatint (French *manière de lavis*) An intaglio method in which tone is created by etching around grains of resin. See pp.89ff.

Artists' prints A term applied to those prints which are (in some sense) original graphic creations by an artist. It is used interchangeably with 'original print' in its second meaning as defined on p.10.

Autography Although sometimes found in English, this is not really an English term. It is a translation of the French 'autographie' which means transfer lithography (qv).

Autotype A process occasionally used in Victorian book illustration. Autotypes are in fact not prints, but a variety of photograph, also called a carbon print.

Banknotes Like postage stamps, banknotes are not usually considered as being within the province of the connoisseur of prints. They do however often exhibit the most sophisticated of mechanical engraving techniques. See A. D. Mackenzie, *The Bank of England Note*, Cambridge 1953.

Baxter George Baxter in 1835 patented a printing technique under his own name. It involved overprinting an intaglio key-plate with numerous wood or metal blocks inked in oil colours. Although after 1849 he sold licenses to others (of whom the best were Le Blond, Kronheim and Dickes), the process was abandoned after 1865. See p.116.

Bevelling See sv. plate-mark.

Blind-stamping See sv. embossing.

Blind-stamps Print publishers and a few printmakers have on occasion since the late eighteenth century used individual blind-stamps on their products. Many of these are listed by Lugt (cf. sv. collectors' marks). In recent decades printers have also often added their blind-stamps. American publishers have taken to calling these stamps 'chops' (a term borrowed from its original context with Japanese prints).

Blockbooks The name given to a group of books produced in the fifteenth century in the Netherlands and Germany. Unlike normal books, both text and image were printed from woodblocks. The labour of cutting letters on a block ensured that the process was only used for popular best-sellers such as the *Biblia Pauperum* (Paupers' Bible) and the *Ars Moriendi* (Art of Dying). In the nineteenth century there was great interest in blockbooks as they were thought to pre-date the invention of movable type, but it has now been shown that most if not all are later. They remain, however, most interesting, and some designs have been attributed to major Netherlandish artists.

Blueprint A type of photograph (a cyanotype) which has been used as a method of printmaking by some artists since the 1930s. A drawing on transparent paper is printed down onto paper prepared with iron salts, which turn blue under the action of light. The process is most often used for duplicating architects' plans.

Book-plates (often called ex-libris) The custom of producing a personal or official book-plate can be traced back to the 1480s. Millions have been designed, both woodcut and engraved; the majority simply bear coats of arms. There is a very large collection in the British Museum.

Broadsides Illustrated broadsheets have formed an important category of print production from the sixteenth to the early nineteenth centuries. Above came the print, which was

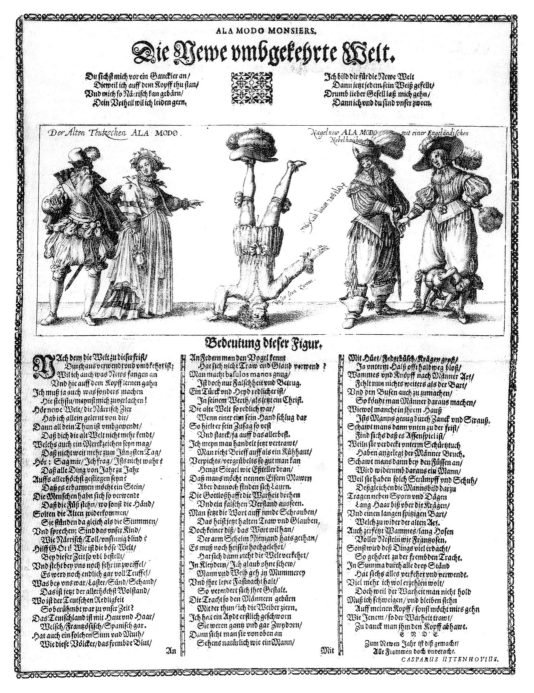

105 Anonymous, German broadside of 1629; the etched
plate is surrounded by letterpress (greatly reduced). The
poem below contrasts the honesty and simplicity of old
German dress (on the left) with the new corrupt Frenchified
fashions (on the right). The fool in the centre shows how the
world has been turned upside down.

engraved, etched or in woodcut; below was a descriptive text in letterpress. Broadsides covered a very wide range of subjects and were aimed at a wide range of purchaser.

Burin (German *Grabstichel*) The basic tool of the engraver. See p.38.

Burr The ridge of copper raised by a drypoint needle, which prints as a rich smudge. See p.71.

Cancelled plates When the printing of a limited edition (qv) of prints has been completed, it is usual to deface the plates or stones to ensure that there is no possibility of their being reprinted. A few 'cancellation' impressions are often run off to prove the cancellation and reassure speculators. It has happened that impressions even from cancelled plates have been marketed (e.g. with Degas), or that the cancellation marks have been carefully removed and impressions marketed as if they were pre-cancellation (e.g. with Manet and Whistler).

Carborundum print A process similar to aquatint.

Chalcography There are three national chalcographies in the world, all of which maintain large stocks of engraved plates from which impressions are printed as ordered by the public. The first was founded by Clement XII in Rome in 1738 with the stock of the Rossi family of publishers; it also holds almost all the plates of Piranesi, purchased from Firmin-Didot in Paris in 1839. The Madrid chalcography followed in 1789, and owns most of Goya's plates. The one in Paris was founded in 1797, but used as its basis the stock of plates manufactured for the *Cabinet du Roi* since 1667. The Italian and French establishments have habitually identified their productions with blind-stamps.

Chalk-manner Another term for crayon-manner (qv).

Chapbooks Small and cheap books, usually 8 to 16 pages in length, meant for the popular market. They are often of interest to print historians for their crude woodcut illustrations.

Chemitype An unusual process, used between 1846 and about 1890. It was a method of transforming an intaglio plate into a relief block. The etched lines on a zinc plate were filled with a molten metal that was able to resist the action of acid; the zinc was then etched down to leave the other metal standing in relief.

Chiaroscuro woodcut (French *camaieu* or *clair-obscur*; German *Helldunkelschnitt* or *clair-obscur*) A colour woodcut used to suggest the effect of a monochrome tonal drawing. See p.115.

Chromolithograph A colour lithograph; often reserved for application in a derogatory sense to high Victorian productions. See p.120.

Cliché-verre A process which has as much in common with photography as with printmaking, but which is usually regarded as a printmaking technique because it involves the artist's hand rather than the lens of a camera, and was used by Corot, Millet, Rousseau and Daubigny (but few others) in the period from 1853 to 1874. The artist draws with a point on a glass plate coated with an opaque ground, from which positive photographic prints are printed on sensitized paper as from an ordinary photographic negative. The process was taken up again in America in the 1970s. See E. Glassman and M. E. Symmes, *Cliché-Verre, a Survey of the Medium from 1839 to the Present*, Detroit 1980.

Collagraph A print taken from a printing surface which has elements collaged to it. This method was developed by Rolf Nesch in the 1940s, and needs very thick paper to take the heavy embossing.

Collectors' marks Many collectors have stamped their prints and drawings with a personal mark of possession. Such marks are listed by F. Lugt, *Les Marques de Collections*, Amsterdam 1921 (*Supplément*, The Hague 1956). www.marquesdecollections.fr

Collotype (French *phototypie*; German *Lichtdruck*) A photomechanical process. See p.126.

Colour printing See pp.113ff.

Compound-plate printing A process used from 1820 for printing banknotes and suchlike; an engraved steel plate was divided into pieces which were separately inked before being rejoined and printed. A variety of this method had already been used by Fust and Schoeffer in the coloured initial letters of the Mainz Psalter of 1457, and it was later adapted to woodcut by Edvard Munch. See p.117.

Copper plate The usual kind of plate used in the intaglio printmaking processes; for this reason their products are sometimes referred to as copper-plate prints.

Copy This word is dangerously ambiguous. In the sense in which we talk of a *copy* of a book, the word *impression* should be used of a print. The term *copy* in prints should be strictly reserved for a redrawing of an original done by another hand. If done by the original designer, such a copy is referred to as a *replica*. Most copies are straightforward piracies, made in centres outside the range of any possible enforcement of copyright. The most notorious of these were Augsburg and Nuremberg, where huge numbers of seventeenth- and eighteenth-century French and Italian prints were pirated. Other types of copy are more complicated. There are astonishingly exact contemporary copies of many prints by Marcantonio and Lucas van Leyden; it is sometimes unclear which is the original and which is the copy, and frequently uncertain whether the copy is a piracy or an autograph or studio replica. Further problems occur in other areas, such as sixteenth-century German woodcut portraits and Italian topographical prints. The demand for these was so large that copies of copies were turned out in many variants, and it is very difficult to reconstruct the complete sequence.

Copyright Copyrights (or 'privileges') for a limited number of years have been given to books and prints by many governments since the fifteenth century. Artists and publishers have signalled such protection to potential pirates by adding copyright lines to their blocks and plates. A partial list of these is given on p.134.

Counterproof A counterproof is an offset from a print (or a drawing) onto another sheet of paper. It is made by running the print, before the ink has dried, through a press against another damp sheet. The resulting image is in reverse to the print, but in the same direction as the plate, and is often used by the artist in making corrections (see **108**). Occasionally with ornamental prints only half of a design was engraved and printed, and the

other half completed by folding the sheet in halves and making a matching counterproof. Another use of counterproofs is sometimes found to reverse a reproductive print to the same direction as the original painting; some prints were actually published in this form.

Crayon-manner An intaglio method which uses tools to make a facsimile of a crayon drawing. See p.81.

Culs de lampe The French term used for the small decorative tail-pieces printed at the end of each chapter in an illustrated book. They are most often found in eighteenth-century books and are wood-engraved or etched. See **102**. The corresponding designs at the beginning of chapters are called *vignettes*.

Dotted prints (French *manière criblée*; German *Schrotblatt*) A class of fifteenth-century metalcut with punched decoration. See pp.29-30 and fig. 18.

Drypoint (French *pointe sèche*; German *Kaltnadel*) The intaglio method in which a plate is directly scored by a needle. See pp.71ff.

Échoppe The tool by which Callot made etchings look like engravings. See p.63 and figs 52, 53.

Editions In the early centuries of printmaking plates were kept in the possession of the artist or publisher who ran off more impressions as needed until the plate wore out. In this period it is only possible to talk of an edition of a print if it was published in a book or if at some stage it changed publisher; in the latter case editions can be distinguished by a change of address in the lettering. Occasionally it is possible to group impressions together which share a common watermark, and distinguish them as an edition. In the eighteenth century in France and Britain it became customary to issue prints in various states, for example in the etched state (see p.54) or before and after letters. These can reasonably be called different editions. The word's current significance only arose in the later nineteenth century as a result of the practice of artificially limiting the supply of a print. A print would be published in an *edition* of (say) fifty, with a guarantee that the plate would be cancelled (qv) afterwards. This device has now been adopted almost universally for marketing purposes, and its success has only been possible because of the investor (or, rather, speculator) mentality of buyers and the premium misguidedly placed on rarity (qv). One consequence has been that publishers trying to get round their own limits have multiplied so-called printer's and artist's 'proofs' (see sv. proof).

Electrotype An electrotype is an exact duplicate of a block or plate which has been produced by electrolysis. The process was invented in 1839, and soon made stereotyping (qv) obsolete. In the later nineteenth century wood-engravings made for book illustration, etc., were almost invariably printed from electrotypes of the blocks in order to safeguard the unique original in case of damage or loss.

Embossing A printmaking method in which a design is impressed into paper without the use of any ink. Embossing is occasionally found throughout the centuries, and was often used in Victorian Christmas cards and suchlike. J. B. Jackson in the eighteenth century and later Munch and the German Expressionists used it to give relief to their woodcuts (see fig. 10) and it has been employed in pure form in some prints of the 1950s and 1960s.

Engraving (the process) (French *gravure en taille douce*; German *Grabstichelarbeit*) The method of working metal with a burin. Although most frequently used for making plates for printing purposes, engraving has also always been employed as a method of decorating metal (especially silver). Hogarth was first apprenticed to an heraldic silver engraver, and many minor engravers must have spent as much of their time on these objects as on plates for printing. The engraving of gems and glass was a different trade, with its own special skills.

Engraving (the object) (French *gravure*; German *Kupferstich*) Properly only used of a print taken from an engraved plate. The term is however often used loosely to cover all intaglio prints. See pp.38ff. and the note on p.39.

Etching (French *eau-forte*; German *Ätzung* [process] and *Radierung* [object]) The second most important intaglio method, in which the lines are bitten by acid. See pp.56ff.

Etching à la plume A variety of sugar-aquatint which produces the effect of a pen line. See p.90.

Experimental processes A large number of short-lived processes were tried in the nineteenth century. Most of these are described in G. Wakeman, *Victorian Book Illustration*, Newton Abbot 1973; others can be found in E. M. Harris' articles in the *Journal of the Printing Historical Society*, nos 4 and 5 for 1968 and 1969.

Fakes and falsifications The earliest 'fakes' were simple piracies; the most famous are Marcantonio's copies from Dürer (see p.46). True fakes only appear with the rise of the collector. These were sometimes very exact copies masquerading as originals (especially of Dürer and Rembrandt), and sometimes pastiches in a master's style (though the pastiches by an engraver such as Goltzius were made to show off his skill, not to deceive). Occasionally genuine blocks or plates by minor masters had the signature of a more important artist added. The invention of photomechanical reproduction processes produced a new type of fake: the reproduction printed on a sheet of old paper or otherwise doctored to look like an original. Falsifications are, however, more dangerous and deceptive than outright fakes. Damaged originals can be so thoroughly and expertly repaired as to go far beyond any legitimate restoration; thus a cut print will have areas made up in ink and margins added. More often an impression will be 'improved'. Drypoints are said to 'have their faces lifted' by adding 'burr' with ink wash, and a worn print will have the lines strengthened with the pen. Another type of falsification tries to turn a later state of a print into a desirable early one. Sometimes letters or areas of working are simply scratched off the surface of a print, but more often the deception takes place during the printing itself. Areas of the design or lettering are left uninked or are covered with slips of paper so that they fail to print. Such 'masked' impressions can be identified by the impress of the uninked letters or the edge of the slip of paper. A final type of falsification is mentioned in the entry on cancelled plates. See Max Schweidler, *The Restoration of Engravings, Drawings, Books, and Other Works on Paper*, ed. Roy Perkinson, Los Angeles 2006.

Flock prints A curious and very rare class of fifteenth-century woodcut. The block was 'inked' with glue and printed onto paper, on which fluff of minced wool (flock) was then dusted. The process has since been used for wallpaper.

106–108 Rembrandt, *Jan
Lutma*, 1656. Etching and
drypoint (greatly reduced).
106 is a normal impression;
107 is a maculature; 108 is
a counterproof. Lutma's
son invented a method of
punched engraving (see
p.78).

Foul-biting This occurs whenever an etching ground collapses and allows the acid to attack the plate indiscriminately. See p.56.

Foxing The term used for scattered spots, chiefly rust-red in colour, which mar the appearance of the paper of many books and prints. Foxing is believed to be the result of a fungal and/or metal-induced degradation of paper, and is fostered by damp conditions. Protecting paper from damp can slow down or even prevent the development and spread of foxing. Good quality papers, manufactured with high magnesium or calcium carbonate content, are less prone to develop foxing.

Gaufrage A French term for embossing (qv), often used by writers on Japanese prints.

Gillotage A process, now obsolete, invented in 1850 by Firmin Gillot, which turned a lithographic plate into a relief plate. A lithographic drawing was made on or transferred to zinc and dusted with resin which acted as a resist. The plate was then etched to make a relief block. Many of Daumier's lithographic plates were treated in this way before their publication in newspapers. The technique of producing a *gillotage* is very similar to that of a line-block; the main difference is that the design is not transferred photographically.

Glass prints In the late seventeenth and eighteenth centuries mezzotints were often glued face down onto glass, and rubbed from behind to remove all the paper. The film of ink was then hand-coloured and the glass framed (see fig. 109). Such decorative items are often called glass prints, but they are of course completely distinct from the *cliché-verre* (qv). See Ann Massing, *Print Quarterly*, VI 1989, pp.382–93.

Glyphography A process invented by Edward Palmer and patented in 1842. A drawing was made through a white composition spread over a metal plate. When finished, the surface of the plate was raised by adding material wherever the composition remained. The block was then electrotyped and the electrotype used as a mould from which to cast a relief printing block. An earlier variety of this process called *gypsography*, in which the drawing was made through a block of plaster mounted on a metal base, was patented in 1837.

Gravure A term often used for machine photogravure or rotogravure. See pp.124–5.

Half-tone A method of breaking up a continuous-tone image into dots of varying size by photographing it through a cross-lined screen. It is a fundamental part of many of the photomechanical printing methods. See pp.122–3.

Hectography An early method of duplicating invented around 1880, but now obsolete. A text or design is written in a special ink on a sheet of paper, and then transferred on to a jelly compounded of glycerine and gelatine by being placed face down on top of it. Wet sheets of paper are then rolled over the surface of the jelly, and the design is transferred to them. Hectography was mostly used in offices before the invention of photocopying; the Russian Futurists were almost the only artists to make use of it in some of their illustrated books. Its successor, the photocopying machine, has also recently been used for printmaking by some American artists.

Heliogravure A French term, sometimes adopted into English, for what is here called hand photogravure. See pp.123–4.

Impression To be distinguished from a copy (qv).

Ink Printing ink is an oil-based fluid, quite distinct from the water-based liquid used for writing. It was apparently invented, or at least developed, by Gutenberg, and was as essential to his success as his invention of the printing press and movable type. The ink is made by grinding lamp black very fine and mixing it with oil; less oil is used in a relief or typographic ink than in intaglio ink in order to make it more viscous so that it will not run into the hollows. Lithographic ink has to contain grease to resist the water – the fundamental principle of lithography. In screenprinting the ink can be almost anything that will pass through the mesh and adhere to paper; thus many quite different fluids are suitable, which is one reason why screenprints can look so different from other sorts of print. See Colin Bloy, *A History of Printing Ink*, London 1967.

Intaglio In print literature, the class of metal-plate printing processes, which share a common printing method, in which the ink is pulled out of grooves made in a plate. See pp.31ff.

Laser or digital print A computer-generated image which has been printed by laser in colours onto paper. The development of computer technology since the 1980s has been harnessed by artists to create new kinds of print.

Lavis A term adopted here for biting a plate with localized areas of acid. See p.90 and fig. 83. It was so used by Tomás Harris in his catalogue of Goya's prints published in 1964. The French term *manière de lavis* is used more widely to refer to any method of achieving the effect of a wash drawing; thus it includes aquatint as well.

Leech The English caricaturist John Leech (1817-64) used a bizarre process to make some paintings which were exhibited in 1862. An impression of one of his wood-engravings for *Punch* was printed onto a piece of india-rubber and then enlarged eightfold by stretching the rubber. The design was then transferred to a lithographic stone from which impressions were printed on canvas. The artist finally coloured these with oil paints.

Lettering A term used to refer to any printed letters on a print; manuscript annotations can be referred to as 'inscriptions'. The lettering on a print was usually entrusted to a specialist writing engraver (see fig. 110). His skill was recognized in the name of one type of script – 'copperplate'. Very occasionally the writing engraver's contribution was acknowledged in the lettering. In the elaboration of states and proofs (qqv) which became a feature of print publishing in the later eighteenth and nineteenth centuries, lettering played an important role. Prints are sometimes found with titles in two or more languages. This was done by publishers in order to sell the print in more than one country.

Letterpress A term used for all book printing done from a relief press. Although it was the only method of book printing before the nineteenth century, it has been made commercially obsolete since the 1970s by the development of phototypesetting and offset lithography. The term is also used for the textual element of a book as opposed to the illustrations.

109 Richard Purcell after François Boucher, *The charms of the Spring, c.*1760. Mezzotint pasted to glass and coloured by hand (a 'glass print') (greatly reduced).

110 Detail (much reduced) of a French print of the late 18th century, showing engraved lettering of a very high standard.

111 John Bate, *William Cheselden*, *c*.1885. Detail of a medal engraving after a medal by William Wyon (enlarged).

Lift-ground etching Another term for sugar aquatint. See p.90.

Line-block A photomechanical process. See pp.121-2.

Line-engraving A term sometimes used to avoid the possible ambiguity of 'engraving'. See p.39.

Linocut An abbreviation for linoleum cut; the same process as woodcut except that linoleum is used instead of a block of wood. See p.22.

Lithography (French *lithographie*; German *Steindruck* [process] and *Lithographie* [object]) A method of printing based on the fact that grease repels water. See pp.100ff.

Lithotint A type of wash lithography patented in 1840. See p.102.

Maculature After an impression has been printed from a block or plate, there are usually traces of ink left on it; these can be removed by printing the plate again on a clean sheet of paper. Such a ghostly impression is called a maculature (see **107**).

Manière criblée See sv. dotted prints.

Maps Before this century maps were always produced by the standard printmaking techniques, and many print publishers were also map publishers. See Peter Barber and Christopher Beard (eds), *Tales from the Map Room*, London 1993; and also Bagrow, *History of Cartography*, revised edn by R. A. Skelton, London 1966.

Margins Any area outside the plate-mark (qv) of an intaglio print or outside the drawn border of other classes of print is the margin. Owners before the eighteenth century almost invariably trimmed margins off their prints in the process of pasting them into albums. A print trimmed just outside the plate-mark is often described as having *thread margins*. In the nineteenth century collectors began to place a quite irrational premium on margins; as a protest against this, Whistler, from about 1880, trimmed all his prints himself, leaving only a tab for his butterfly monogram. A distinct category is formed by some nineteenth-century book illustrations, which were given huge margins so that the unsightly plate-mark could be cut off when the book was bound.

112 Edgar Degas, *Reclining nude*, *c*.1883/5. Monotype
(greatly reduced).

Masked impressions See sv. falsifications.

Mattoir A tool with a rounded spiked head. See **69**, and
p.78.

Medal engraving A method of producing an amazingly
accurate two-dimensional representation of a coin or medal,
using a tracing machine invented by Achille Collas in 1831.
It is sometimes called anaglyptography. See **111**.

Metalcut A relief printing method using a metal plate rather
than a wooden block. See pp.29ff.

Mezzotint (French *manière noire*; German *Schabkunst*) An
intaglio process which works from dark to light by scraping
down a roughened metal plate. See pp.85ff.

Mixed method The term used in despair to describe those
nineteenth-century intaglio prints produced from a mixture
of many intaglio methods. See p.87.

Monograms Many printmakers have signed their work with
a monogram; the invaluable dictionary of these marks by
Nagler of 1858-79 is listed on p.128.

Monotype An unworked metal plate can be painted with ink
by an artist and printed onto paper; the ink will usually allow
one strong and one weak impression. Because it involves
printing, a monotype is traditionally regarded as a print.
The process was invented by G. B. Castiglione in the 1640s;
it was taken up in the nineteenth century, notably by Degas,
and has continued to appeal to artists for the remarkable
effects that can be obtained. See *The Painterly Print,
Monotypes from the 17th to the 20th Century*, New York
(Metropolitan Museum of Art) 1980. A second variety of
'traced' monotype is made by placing a sheet of carbon paper
(or similar) between two plain sheets. The drawing made on
the top sheet is discarded in favour of the transferred line on
the lower sheet. The imprecision and random smudges have
appealed to artists such as Gauguin and Klee.

Music printing Most music was printed from engraved
plates between about 1700 and 1870, on account of the

113 Alois Auer, *A small plant*, 1850s. Nature printing (reduced).

difficulty of typesetting notes on staves. See A. Hyatt King, *Four Hundred Years of Music Printing*, 2nd edn, London (British Museum) 1968.

Nature printing One of the most ingenious of Victorian inventions; some vegetable object (usually a plant or a leaf) was impressed under considerable pressure into a soft lead plate. This was then stereotyped or electrotyped, and the plate printed in intaglio to produce an astoundingly accurate image of the original. The process was developed by Auer in Vienna in 1852, patented in England by Henry Bradbury in 1853 and much used until the 1890s when developments in photomechanical methods made it uneconomic. It had a sort of predecessor in the eighteenth century when flat objects (especially textiles and leaves) were themselves inked and handprinted onto paper.

Niello A niello is a piece of engraved metalwork (usually silver), the lines of which have been filled with a black metallic amalgam (Latin *nigellum*, whence the Italian *niello*). This method of decorating metal has been used continuously since antiquity, but was especially popular in Florence and Bologna in the years between about 1450 and 1520. It is of interest to the print historian because these metal plates, before being filled with niello, were sometimes printed onto paper to preserve a record of the design (a niello print). For

114 Anonymous, *A female martyr saint*, Italian, *c.*1475. Engraved silver plaque, the lines being filled with niello (enlarged).

a long time following Vasari these were thought to explain the beginning of intaglio printing in Italy. A niello print is distinguishable from a normal engraving by its very small size and minute manner of working. They were presumably originally printed to guide the silversmith in his work or to preserve a record of a design, but so many prints survive, some with their lettering in the correct direction, that it is certain that plates were also made in this style for printing.

Numbering A number such as 34/75 on a print means that it is the thirty-fourth in a limited edition of seventy-five. The limited edition is not found before about 1880, and developed at the same time as artists began to sign their prints; numbering of individual impressions followed at the beginning of this century. A number such as 1/75 on a print does *not* imply that it was the first to be printed; the prints are usually assigned numbers as they come to hand in random order. Nor does it imply that there are only 75 impressions in existence; there will almost certainly be numerous additional artist's and other proofs (qv).

Offset An accidental offset from wet ink onto another sheet of paper is sometimes seen; in the case of a counterproof (qv) such offsetting is deliberate.

Offset lithography A development of lithographic printing, often referred to simply as 'offset'. See p.102.

Oleograph A nineteenth-century process whereby an ordinary colour lithograph was varnished and sometimes impressed with a canvas grain before publication in order to make it look like an oil painting. It has many modern successors; in one style an ordinary four-colour process reproduction is coated with a thick varnish applied in such a way that it has the effect of the impasto of paint.

Optical views See sv. perspective views.

Original print The various meanings of this term are discussed on pp.9-12.

Ornamental prints A large class of print which served an essential purpose from the mid-fifteenth to the nineteenth century. They were intended to suggest patterns of decorative ornament to craftsmen in all fields of the applied arts, and were usually published in small sets. Often very pretty in themselves, they are of vital importance to a history of ornament. The national collection is appropriately in the Victoria and Albert Museum. The standard catalogues are D. Guilmard, *Les Maîtres Ornemanistes*, Paris 1880-1, and the *Katalog der Ornamentstichsammlung der Staatlichen Kunstbibliothek Berlin*, Berlin 1939.

Pantograph A machine by means of which an accurate enlargement or reduction of a print or drawing can be made.

Paper The traditional way of making paper is to beat rags into a liquid pulp. Into this the papermaker scoops a tray of crossed wires on to which he settles a thin layer of fibres. This is then turned out and pressed and dried between felt blankets (from which the imprint of the hairs can often be seen on early paper). What we have at this point is in effect blotting-paper; to turn it into paper for writing or printing, it has to be sized with gelatine or glue. There are two main classes of paper. *Laid paper* (French *papier vergé*; German *Büttenpapier*) shows the pattern of the vertical 'wire-marks' and the horizontal connecting 'chain-lines' of the wires in the papermaker's tray. *Wove paper* (French *papier vélin*; German *Velinpapier*) is made from a tray with the wire mesh so tightly woven as to leave no marks visible; it was developed in 1755 in order to provide a smoother surface, but did not come into common use until about 1790. Both laid and wove papers can be given a watermark (qv) by fastening a wire

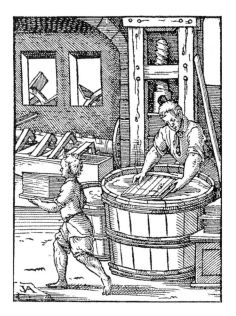

115 Peregrino, *Three dancing women*, c.1500. Print from a plate engraved in the niello manner, but intended for printing (actual size).

116 Jost Amman, *The Paper Maker*, 1568. The papermaker is lifting his tray from a vat of pulp; his assistant bears off a pile of sheets to dry. The machine in the background is beating rags into pulp.

pattern to the mould. The invention of the papermaking machine in 1798 speeded production but led to a shortage of supplies of rags. Following much experimentation, wood was found as a satisfactory and abundant substitute, and was widely used from the middle of the nineteenth century. Unfortunately a mechanical as opposed to chemical process of preparing woodpulp, combined with imperfect bleaching or sizing with alum and rosin, led to many papers becoming brittle and discoloured. Although most European prints have been printed onto paper of these types, other surfaces have been used. These include vellum, silk and linen; the most commonly used papers of foreign manufacture are Japanese (of mulberry fibres) and Chinese (a very thin paper usually laid down in printing onto a backing of another sort of paper, and known incorrectly in Britain as India laid). Some familiarity with paper is essential for the print historian; European papers can usually be approximately dated from their appearance and feel, and a restrike or facsimile can often be detected in this way. See Dard Hunter, *Papermaking*, New York 1947 and A. Robison, *Paper in Prints*, Washington (National Gallery of Art) 1977.

Paste prints A rare class of fifteenth-century woodcut. A layer of paste was spread evenly over a sheet of paper and covered with a layer of tin foil. The design was printed on top of the foil in ink, the foil giving a glittering background. About 150 examples are known, almost all very badly damaged. See E. Coombs, E. Farrell and R. S. Field, *Pasteprints, a Technical and Art Historical Investigation*, Harvard University Art Museums, 1986 (this study makes all earlier literature obsolete).

Pastel-manner A method of colour printing using multiple plates engraved in the crayon-manner. See p.119.

Perspective views Sometimes known as optical views. A class of eighteenth-century engraving, usually hand-coloured and of a topographical subject, which can be distinguished by having its title written in mirror-writing. They were intended to be viewed through a special device, known as an optical diagonal machine or a 'zograscope'. This produces a reversed and magnified image with the background of the picture apparently situated at a considerable distance from the foreground. See J. A. Chaldecott, *Annals of Science*, IX, 1953, pp.315-22.

Photography Although photographs are collected by many European and American print departments, they can scarcely be called prints in the conventional sense. This is a purely semantic point, and is not intended to belittle the status of photography in any way. It is however intended to justify its exclusion from this book.

Photogravure A photomechanical process. See pp.123ff.

Photomechanical processes Any process by which a printing surface is produced by a method based on photographic technologies rather than manually.

Planographic Any method of printing from a flat surface which has no variation in depth. The word was originally coined to go with relief and intaglio in order to distinguish the third method of printing constituted by lithography.

117 Adriaen van Ostade, *Old man leaning on a stick*, c.1675. Etching (actual size). An early impression before the strong plate-tone in the upper corners had worn off. The initials in the top right-hand corner are of William Esdaile, an early nineteenth-century collector.

Screenprinting might be classed as a planographic process, but is better considered as a fourth method.

Plaster cast A plaster cast can be taken from an inked metal plate, and this has occasionally been done since at least the eighteenth century when no printing press was to hand. In the 1930s and 1940s S. W. Hayter and some of his associates used the process to make unique objects, which were further carved and coloured after casting.

Plate-mark The line of indentation in the paper where it has been pressed into by the edges of an intaglio plate. See p.31. From the mid-nineteenth century the edges of plates were often given a wide bevel (i.e. smoothed down at a 45° angle). Occasionally prints, although printed in relief or lithographically, have been impressed with a meaningless plate-mark from a blank metal sheet for aesthetic effect.

Plate tone A new copper plate will often have faint scratches and marks on its surface which will pick up ink in the wiping; this is called plate tone. The scratches wear down very quickly, and so plate tone is a sign of a very early impression. It is to be distinguished from surface tone (qv).

Playing cards Documents show that many of the earliest European woodcuts were playing cards, although few of them survive. Many fine fifteenth-century engravings are also cards, but after the sixteenth century their design tends to become standardized and the quality drops. See fig. 121 and C. P. Hargrave, *A History of Playing Cards*, Cambridge (Mass.) 1930.

Pochoir The French word for a stencil. During this century many School of Paris prints have been coloured through carefully cut stencils; sometimes the entire design is created from the stencils. The term pochoir is often applied to these.

Polyautographs The name used by the publisher for the earliest lithographs made in England. See p.104.

Polygraphs A rare type of print of very large size manufactured in England in the late eighteenth century first by Francis Eginton and later by Joseph Booth as imitation oil paintings. The process was based on colour-printed aquatints transferred to prepared canvas. See E. Robinson and K. R. Thompson, 'Matthew Boulton's Mechanical Paintings', *Burlington Magazine*, 1970, pp.497-507.

Popular prints Ever since the fifteenth century, there has been a flourishing market in popular prints largely independent of the market for fine prints which has been described in the historical sections of this book. Being intended for an unsophisticated market, they had to be cheap and thus were usually woodcuts; they appear on chapbooks, broadsheets, ballads and so on. Few survive from earlier than the nineteenth century. They have for a long time been studied in France; for nineteenth-century British popular prints, see T. Gretton, *Murders and Moralities, English Catchpenny Prints 1800-1860*, London 1980.

Postage stamps For many years after the introduction of prepaid postage stamps in 1840 all plates had to be hand-engraved. Although, like banknotes, rarely thought of as part of the history of engraving, these designs often exhibit extraordinary skill. The name of the engraver can sometimes be found in the bottom right-hand corner of French stamps.

Posters These have only been taken seriously as an art form since the brilliant achievements of Toulouse-Lautrec and others in the 1890s. Most of them at that time were hand-drawn and printed lithographically from huge slabs of stone. More recent ones have been produced photomechanically. See Bevis Hillier, *Posters*, London 1969.

Presses Each of the four main types of printing process requires a different sort of press, and each is discussed in its own section. For the relief press see James Moran, *Printing Presses*, London 1973.

Print room A room decorated with prints pasted to the walls in the manner of wallpaper. The fashion began about 1750 and lasted into the Regency period; publishers supplied printed frames, borders and festoons in order to create decorative ensembles. Examples can still be seen in several English country houses such as Stratfield Saye and Woodhall Park. Some were highbrow; others were filled with caricatures. The term is now also used for museum print study rooms.

Printsellers' Association A body set up by the print publishers of Britain in 1838 in order to regulate the number of proofs (qv) printed before the main edition of a plate. Members had to declare the exact number of proofs of every plate, and each impression was marked with the Association's oval blind-stamp, containing three letters in the centre which form a code identifying the particular edition. A blind-stamp is therefore a certain sign that a print is a proof. The Association published complete lists of its members' publications, and these are an invaluable index to Victorian print production.

Private plates In the eighteenth and nineteenth centuries plates, usually of portraits, were quite often commissioned privately from an engraver. The engraver would be paid an outright fee and the prints printed and distributed at the expense of the commissioner among his friends and acquaintances. Such plates were often lettered 'private plate', and did not carry the normal copyright line as no commercial interest needed protection.

Privileges See sv. copyright.

Process prints A term for any photomechanically produced print, often applied in particular to relief prints. A wider use of the term covers all prints made by any non-manual method.

Proof In its loose sense this word can be used for *any* impression of a print; for example the catalogue of Pennell's prints states that a print was published in an edition of 25 proofs. It should strictly be reserved for application only to those impressions which are printed before the regular edition. As explained in the entry for 'edition', this term has changed its significance in the course of time, and the significance of 'proof' has changed with it. In the early days a proof was an impression printed before work on the block or plate was complete – a 'working', 'progress' or 'trial' proof. Sometimes such a proof was corrected by hand by the artist himself (a 'touched' proof). In the eighteenth century the concept became stretched when proofs of a finished subject but in 'uncompleted' states began to be published in what were really editions. In England this happened in the first place with mezzotints, a type of print in which it is very important to see an early impression before the bloom wears off; these were regularly issued before any letters, with scratched letters and finally with the proper engraved lettering (the last category often being called a 'print' to distinguish it from the others which were 'proofs'). Further refinements in the nineteenth century were the signed 'artist's' or 'engraver's' proof, the 'open letter' proof, the multiplication of proofs on different sorts of paper (e.g. 'India paper' proofs), and the habit of actually lettering a print with the word 'proof'. In at least one case these letters were never removed, so that every single impression of that print is a self-described 'proof'. In another case (Frith's *Paddington Station*) precisely 3,050 proofs preceded the main edition. What little justification such proofs had disappeared with the introduction of the practice of numbering and limiting an edition, because printing would have finished before the plate had a chance to wear. However, in order to get round the awkward restrictions on the numbers of impressions, publishers have retained the so-called 'artist's' proofs, to which have now been added 'printer's' proofs, which are identical to impressions of the regular edition except for the manuscript annotations which identify it as a proof. On occasion the number of artist's proofs issued of a print has approached that of the main edition, but this is regarded as unethical.

118 Francisco Goya, *Por que fue sensible*, 1799. Aquatint (actual size). An unusual example of a plate worked entirely in aquatint. This impression is one of the earliest printed from the plate; it is one of only three known proofs before the lettering was added.

119 A late impression of 118, showing the disastrous effect of the wearing of the aquatint grain.

Por que fue sensible.

Publisher Although some artists have marketed their own prints, most have worked through or for publishers. These have often put their address (i.e. name and place of publication) on the plate (see sv. lettering). In the twentieth century the engraved address has normally been replaced by a blind-stamp on each impression of a print. Publishers are in general one of the most important and neglected elements in the genesis of most prints. Cf. sv. edition.

Punched prints A technique invented by Jan Lutma. See p.78.

Quality The quality of any impression of a print depends on three factors: the condition of the printing surface at the time of printing, the skill with which it was printed and the care taken to preserve it through the centuries. A cracked block or a worn plate will always produce an inferior impression; on the other hand even a block or plate in perfect condition can be poorly inked or badly printed. Finally the paper of an impression may have been torn, abraded or bleached, and however skilfully it has been repaired, the impression will always remain inferior.

Rarity The availability of a print depends on two factors; its rarity (i.e. the total number of impressions surviving), and the demand for it. But demand increases as well as reduces supply. More than 90% of European print production is so unfashionable that it is unfindable. Rarity has often been artificially created, and it seems worth stating the obvious—that rarity has nothing to do with the quality of a print, although it may increase interest in it.

Registration The alignment of the various plates used in multiple-plate colour printing. See p.117.

Relief The class of printmaking process in which the printing surface stands in relief above the rest of the block. See pp.13-30.

Relief etching A plate designed to be printed in relief from which the background has been etched away. See pp.29-30.

Remarques A 'remarque' is a scribbled sketch made by the artist in the margin of a plate outside his main design, to which it is often unrelated (see fig. 120). The practice seems to have begun in the late eighteenth century as a way of testing the strength of etching acid on a plate before risking a biting of the main design, and was always burnished away before printing the main edition. This gave rise later to the deliberate manufacture of 'remarque proofs' where the remarque served no purpose whatsoever; remarques were even made on lithographs. At the end of the nineteenth century a few artists such as Félix Buhot made etchings where the remarques acted as a counterpoint to the main design and were left on throughout the edition.

Resist Another term for a ground (qv).

Restrike Any reprint of a plate made later than the main edition; it is often applied to printings made after an artist's death. A restrike will usually, but not necessarily, be an inferior impression, and will often be on inappropriate paper.

Retroussage A technique used in wiping a plate to soften the line. See p.35 and figs 23, 24. The English term sometimes used is 'dragging up'.

Reversing images A print will be in reverse to the plate or block from which it is printed. To get a print in the same direction as the plate, it has to be printed offset or a counterproof (qv) has to be taken. A reproductive engraver, in order to get a print in the same direction as the original, had to reverse the image on his plate. This was usually done with a large mirror, which can be seen in many old views of the engraver in his workshop (see fig. 43).

Rework A term used for any additional working done to a block or plate; it is often used with the implication that the new working has been added later in order to strengthen a worn plate, and has nothing to do with the original printmaker.

Rocker The tool used to roughen a plate for a mezzotint. See **72** and p.83.

Rotogravure A term sometimes used for gravure. See p.124.

Roulette A wheeled tool used in some of the dot processes. See **69** and p.78.

Ruling machines Parallel lines, either straight or wavy, were often laid onto plates in such areas as the sky; usually they were put on grounds and etched in. The ruling machines to do this were invented at the end of the eighteenth century in France by Conté and in England by Wilson Lowry. They found their widest employment in banknote engraving.

Screenprinting (French *sérigraphie*; German *Serigraphie*) A method of stencil printing through a mesh. See pp.109-112.

Serigraphy An attempt has been made to distinguish commercial from artistic screenprinting by christening the latter type *serigraphy* and this term is often used on the Continent. Since there is no difference whatsoever in technique between screenprinting and serigraphy, the term only causes confusion. There is also the problem of deciding when a print can properly be called 'artistic'.

Siderography A process to produce an unlimited number of exact replicas of an engraved plate by making a cylindrical mould of case-hardened steel. This was essential for the production of banknotes and postage stamps.

Signatures From the earliest period artists have added their monograms or names to the design on their blocks or plates. This seems to have been regarded as a sort of copyright mark, for it was only Dürer's monogram that Marcantonio was forbidden to pirate (see p.46). Manuscript signatures on printed impressions first appear very occasionally in the eighteenth century. The practice was only systematically developed for the benefit of collectors in the 1850s, when unlettered proofs of large reproductive engravings were published signed by both artist and engraver. Seymour Haden and Whistler are said to have been the first etchers to have signed their prints. The custom rapidly spread in the 1880s, and for a short period around 1900 the printer sometimes added his signature as well. The practice is today so common that it is often (quite wrongly) taken as a

120 Daniel Chodowiecki, *Friendship and compassion*, 1794.
Etching (reduced). The three illustrations are etched on one
plate and have small *remarques* between them. Chodowiecki
only began to add *remarques* to his plates in late years in
order to satisfy the demands of fanatical collectors of his
work.

defining characteristic of an artist's print, and a print without
a signature loses much of its value commercially (see
pp.11-12). Picasso was hounded for years by dealers trying to
get him to sign prints. Those who persist in thinking that
signatures have significance may reflect on the story of the
pile of sheets of paper seized on the Spanish border by
French customs officials, which were all blank except for the
signature 'Dali'.

Silk From the sixteenth century onwards, special impressions
intended for presentation have been printed on silk rather
than paper. These rarely survive.

Silkscreen The term usually used in America for
screenprinting; the British term however seems preferable
since the mesh used is not necessarily of silk.

Soft-ground etching (French *vernis mou*; German
Weichgrundradierung) The process in which a drawing is
made on a sheet of paper on a soft etching ground and
thence transferred to the plate by etching. See p.97.

Spatter The technique of creating tone in lithography by
spattering lithographic wash on the stone. See p.102.

Staging-out Another term for stopping out (qv).

States In the process of making a print an artist often prints
a few proofs at different stages of his working to check
progress; any impression which shows additional working on
the plate constitutes a different state, and catalogues of an
artist's prints have traditionally confined themselves to the
business of describing as many states as they can find. The
classic case of this is with the prints of Rembrandt; the major
and minor changes he made to his plates have been minutely
described in (so far) fifteen catalogues, and it has now
become a triumph to find a new state. Rembrandt himself
does not seem to have gone through more than eleven states
on one print; Degas went up to twenty. In the nineteenth
century some artists exploited collectors' desire to own rare
states by deliberately and unnecessarily multiplying them. It
should be mentioned that there are numerous complications
in describing and defining states. It is generally agreed that
only intentional changes to a plate count – not accidental
scratches. But one difficulty arises when different editions of
prints show no change of state (e.g. Piranesi, Goya), in which
case editions have to be described independently from states.
Another difficulty occurs in eighteenth- and nineteenth-
century reproductive prints; with these, progress proofs are
so multiplied that it becomes hopeless (and fruitless) to try to
describe them all, and it has been customary to hive these off
as 'proofs' and to say that the first state begins with the first
published edition – which will (to complicate matters still
further) usually be an impression before letters and before
the regular lettered edition. In these cases a state becomes
something quite different from a Rembrandt state, since
Rembrandt's prints were never passed to a letter engraver
and rarely reached a publisher.

Steel-facing (French *aciérage*; German *Verstählung*) A
process patented in 1857 whereby an extremely thin coating
of iron is deposited by electrolysis on a copper plate. This

immediately revolutionized the print business because plates could no longer become worn; if the iron did wear out another layer could be added, and at any time the iron could be simply removed by reversing the electric current. Connoisseurs have disagreed whether steel-facing causes deterioration in the quality of an impression. The answer depends on how carefully it was done, and how well the plate was printed. See p.71.

Steel plates These were introduced in the 1820s and were mainly used for mezzotint and engraving. In the case of engraving they allowed a much closer manner of working, and as a result steel engravings can usually be easily recognized. See 28 and p.39.

Stencil Prints have in the past often been hand-coloured through specially cut stencils, and this still happens in France (see sv. pochoir). A new application of stencils has been in screenprinting. See p.109.

Stereotypes A metal cast made, especially from wood-engravings, by means of a mould. The process was patented in France in 1829 and was vitally important for the development of wood-engraving since it dispensed with wood in favour of metal which could be printed in the new machine presses. Stereotyping was made obsolete by the invention of electrotyping in 1839.

Stipple An intaglio process in which tone is added by numerous dots. See pp.81ff.

Stopping out The technique used in etching to make the acid bite to different depths. See p.57.

Sugar (-lift) etching A method of defining areas to be aquatinted on a plate. See p.90.

Sulphur Sulphur has been used in the field of prints in two quite different ways. (1) In Italy in the fifteenth century sulphur casts were sometimes made of niello plates. (2) In the seventeenth and eighteenth centuries sulphur was sometimes used in a similar way to aquatint for giving tone to a plate; prints from such plates may be referred to as sulphur prints, or as prints with sulphur tone. See p.90.

Surface printing The method of lithography. An alternative term is planographic printing.

Surface tone Tone created in an intaglio print by leaving films of ink on the plate in the wiping; this can be accidental and due to the incompetence of the printer, or deliberate as with many impressions of Rembrandt. See 26. It is to be distinguished from plate tone (qv).

Taking out A term often used of the removal of sections of an image from the printing surface; it is applied especially to the removal of the lettering from a print. Letters can, for example, be taken out to create a false state before letters.

Textile printing Western textiles have from very early times been decorated by means of printing from woodblocks or (from the mid-eighteenth century) copper plates. This area of the history, like wallpaper, is customarily ignored by the print historian. See Peter Floud, *English Printed Textiles*, London (Victoria and Albert Museum), 2nd edn, 1972.

Tint-stone A second stone often used in early lithography to add relief and colour. See p.120.

Tone-block Used to make a chiaroscuro woodcut. See p.115.

Tradesmen's cards Many engraved or etched designs survive from the eighteenth and early nineteenth centuries carrying the name, address and business of a tradesman. These were apparently used for bills and distributed as advertisements, and as a result no pains were spared to make them attractive and appealing. See 103. Two fine collections, mostly of British cards (the Banks and Heal), are in the British Museum. See Ambrose Heal, *London Tradesmen's Cards of the XVIII Century*, London 1925.

Transfer lithography The process whereby the artist draws his image on specially prepared transfer paper from which it is transferred to the lithographic stone. See pp.102-3.

Transfer printing A method of decorating enamels and ceramics; an ordinary engraved plate is printed on a thin tissue paper in a special ceramic ink. The image is then pressed against the surface of the object to be decorated and thus transferred. The process was invented in England in 1753 and widely practised.

Transparent prints A process invented and published by Edward Orme in his *Essay on Transparent Prints*, London 1807. An ordinary etching or engraving was hand-coloured both on the front and on the back. The highlights were then varnished on both sides, and thus the paper became translucent when held up against the light.

Trimming See sv. margins.

Tusche The German word for liquid ink; tusche lithography is simply lithography where the image is drawn in wash. See p.102.

Vignette The name applied in English to all small decorative prints without definite border lines used in book illustration. When placed at the beginning of chapters they can be called head-pieces; when at the end, tail-pieces or *culs de lampe* (qv). The great age of the vignette was in France in the eighteenth century, when some highly talented artists devoted almost all their energy to their production. In France the term *vignette* was used only for a head-piece, while a whole-page book illustration was called an *estampe*.

Wallpaper Woodcut blocks were used for printing wallpaper from the sixteenth century; colouring was often added through stencils and flock was sometimes used for decoration. Some important woodcut artists were closely involved in the wallpaper business, including J. M. Papillon in France and J. B. Jackson in England. See E. A. Entwisle, *The Book of Wallpaper*, 2nd edn, Bath 1970.

Watch papers Circular engravings, made from about 1740 to 1840 and about an inch in diameter, which were intended to be used as liners placed between a watch and its outer case. They often show subjects of topical interest. See fig. 122.

Watermarks From an early period in the history of papermaking, manufacturers have often distinguished their product by means of watermarks (see sv. paper). These can

sometimes yield valuable information about the origins or dating of a print. The standard dictionary is C. M. Briquet, *Les Filigranes*, 4 volumes, Geneva 1907, but this only goes up to about 1600 and has to be supplemented by W. A. Churchill, *Watermarks in Paper in Holland, England, France . . . in the XVII and XVIII Centuries*, Amsterdam 1935, and E. Heawood, *Watermarks Mainly of the XVII and XVIII Centuries*, Hilversum 1950. Briquet assigned dates to his watermarks on the basis of dated documents in the archives of Europe. For this reason they can only be regarded as approximate. Furthermore watermarks can only give a *terminus post quem* for prints and drawings, and it is always dangerous to use them as grounds for any precise dating. The danger is less with the paper made in England by Whatman which often has the actual year of manufacture in the watermark. But the date 1742 found on some French paper is a trap: it merely shows that the paper was made in compliance with some regulations imposed in that year. The study of watermarks is proving of great value to print historians in allowing impressions to be grouped together within the oeuvre of a single printmaker, and thus be associated together by date of printing.

White-line wood-engraving Writers have sometimes drawn a sharp distinction between black- and white-line wood-engraving. The difference depends on whether the design is carried by black lines set against white (the usual woodcut way), or by white lines incised in a black field (which has been regarded as the 'true' method of wood-engraving). The two types, however, become indistinguishable when the black and white are of equal weight, and for this reason, and because the white-line method can be used in woodcuts as well (see fig. 9), it seems a mistake to lay too much emphasis on what is a distinction of design rather than of technique.

Woodburytype An image half-way between a print and a photograph, and in appearance much like an autotype (qv). A relief carbon photographic print was impressed into a lead mould. Prints were obtained from this by pouring in gelatine and laying paper on top. These prints of hardened gelatine had an uneven surface but considerable depth of tone. The process was much used in Victorian book illustration.

Woodcut (French *gravure sur bois*; German *Holzschnitt*) A process in which the lines of the design are left standing in relief on the block. See pp.13ff.

Wood-engraving (French *gravure sur bois debout*; German *Holzstich*) A version of woodcut using an end-grain block and a burin. See pp.22ff.

Xylography A term very occasionally used for woodcut (*xylon* being Greek for wood).

Zincography A term sometimes adopted from the French, who habitually draw a distinction between a lithograph on stone and one on zinc. Since the two sorts of print can very rarely be distinguished from their appearance the distinction is not worth making, except for the purist who feels himself unable to call something printed from zinc a lithograph (literally, a 'stone drawing'). In the same way 'algraph' is sometimes used for a lithograph from an aluminium plate.

121 *top* Anonymous, *Jack of Goats*, French, published by Christian Wechel, 1544. Woodcut (actual size). One of a set of learned playing cards made for an educated Humanist public. Colour was applied through a stencil, as can clearly be seen on the sleeve at the right.

122 Anonymous, *William, Duke of Cumberland*, English, *c.*1750. Engraving (actual size). By cutting along the indentations, the print can be made to fit into a rounded watch case.

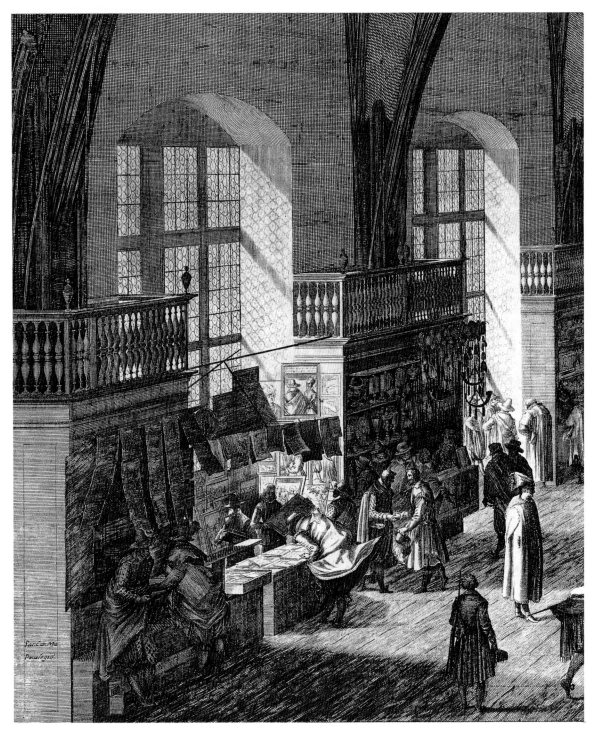

123 Aegidius Sadeler, *The great hall in the castle at Prague*,
1607. Engraving (detail). One of the earliest views of a stall
of a printseller.

Index

Numbers in *italics* refer to page numbers of black-and-white illustrations; colour plates are indexed in **bold** as **col.pl.** followed by their plate number.